Mediated Au

This book is part of the Peter Lang Media & Communication list.
Every volume is peer reviewed and meets
the highest quality standards for content and production.

PETER LANG
New York • Bern • Frankfurt • Berlin
Brussels • Vienna • Oxford • Warsaw

Gunn Enli

Mediated Authenticity

How the Media Constructs Reality

PETER LANG
New York • Bern • Frankfurt • Berlin
Brussels • Vienna • Oxford • Warsaw

Library of Congress Cataloging-in-Publication Data
Enli, Gunn.
Mediated authenticity: how the media constructs reality / Gunn Enli.
pages cm.
Includes bibliographical references and index.
1. Mass media—Social aspects. 2. Authenticity (Philosophy) in mass media.
3. Mass media—Technological innovations. 4. Mass media and culture. I. Title.
HM1206.E55 302.23—dc23 2014037495
ISBN 978-1-4331-1486-1 (hardcover)
ISBN 978-1-4331-1485-4 (paperback)
ISBN 978-1-4539-1458-8 (e-book)

Bibliographic information published by **Die Deutsche Nationalbibliothek**.
Die Deutsche Nationalbibliothek lists this publication in the "Deutsche
Nationalbibliografie"; detailed bibliographic data are available
on the Internet at http://dnb.d-nb.de/.

The paper in this book meets the guidelines for permanence and durability
of the Committee on Production Guidelines for Book Longevity
of the Council of Library Resources.

© 2015 Peter Lang Publishing, Inc., New York
29 Broadway, 18th floor, New York, NY 10006
www.peterlang.com

All rights reserved.
Reprint or reproduction, even partially, in all forms such as microfilm,
xerography, microfiche, microcard, and offset strictly prohibited.

Printed in the United States of America

CONTENTS

Acknowledgments		vii
Chapter 1.	The Paradox of Mediated Authenticity	1
Chapter 2.	Genres as Authenticity Illusions: *The War of the Worlds*	23
Chapter 3.	Money, Fraud, and Deception: *The Quiz Show Scandals*	45
Chapter 4.	Ordinariness as Authenticity: *The Reality TV Genre*	65
Chapter 5.	Fake Personas and Blog Hoaxes: *Illusions in Social Media*	87
Chapter 6.	Performed Authenticity: *The Obama Campaigns*	109
Chapter 7.	Towards a Theory of Mediated Authenticity	131
References		139
Index		159

ACKNOWLEDGMENTS

The concept of authenticity is everywhere. It's a buzzword used in sales slogans for everything from jeans and coffee to holiday destinations and lifestyle coaching. Yet, authenticity is also about socially constructed notions about what is real, and the media play a key role in this construction of authenticity. My aim with this book is to investigate the notion of authenticity in relation to mediations of reality.

I have not investigated the notion of mediated authenticity without support from the research community and fellow media researchers. My sincere gratitude goes to the highly competent scholars Daniel Dayan, Knut Lundby, Peter Lunt, Hallvard Moe, Ole J. Mjøs, Vilde S. Sundet, Trine Syvertsen, and Espen Ytreberg. Thanks for the inspiring comments.

A key to success is the publisher, and I am indeed thankful for the pleasure of working with editor Mary Savigar at Peter Lang Publishing. Likewise I have had the pleasure of working with brilliant people, such as language editor Nils Nadeau, research assistant Anne Nordheim, and my colleagues at the Department of Media and Communication, University of Oslo.

I dedicate this book to my three favourite people: my daughter Oda, my son Johannes, and my partner Kjell-Olav. Thanks for encouraging me to write the book, and for being a perfect support team.

Oslo, January 2015

· 1 ·

THE PARADOX OF MEDIATED AUTHENTICITY

Sincerity—if you can fake that, you've got it made.

—George Burns

The paradox of mediated authenticity is that although we base most of our knowledge about our society and the world in which we live on mediated representations of reality, we remain well aware that the media are constructed, manipulated, and even faked (Boorstin, 1987; Weaver, 1994; Luhmann, 2000; McChesney, 2013; Ladd, 2012). With this paradox as its starting point, this book seeks to launch and discuss the concept of mediated authenticity, which refers to how authenticity is a currency in the communicative relation between producers and audiences. Mediated authenticity is a social construction, but it traffics in representations of reality.

Mediated authenticity is achieved through production techniques and *authenticity illusions*, which range from minor adjustments such as lighting and sound effects to drastic post-production editing and photoshopping. In the process, raw material is manipulated so as to be compatible with the aim of reaching a large audience and fulfilling the media format's criteria. Authenticity illusions are, for the most part, both accepted and correctly interpreted by the audience. For example, TV viewers understand that canned laughter, or the laugh track, is a technique for enhancing a comedy show, not the

unavoidable outbursts of a real audience. I define this tacit understanding or agreement between producers and audience as an *authenticity contract*, but it remains a social construction, one that is based on a set of genre conventions, as well as established practises and expectations. When the authenticity contract is challenged, or broken, we face an *authenticity scandal* or, less dramatically, an *authenticity puzzle*. These two concepts both refer to a situation where the audience is uncertain of what is real and what is fake, but "the scandal" differs from "the puzzle" in that the former is about various degrees of deception, while the later is about various degrees of ambiguity.

This chapter has four main parts. Following this part, the next defines mediated authenticity and discusses its primary subcategories—trustworthiness, originality, and spontaneity. The third part further elaborates on the book's main concepts—authenticity illusions, the authenticity contract, and authenticity scandals/puzzles—and outlines the key arguments related to these terms. The fourth, and last, part presents a brief plan for the book and a chapter outline.

Mediated Authenticity

Authenticity is a dominant tendency of contemporary culture, and our obsession with "the real," "the genuine," and "the authentic" interests scholars in various disciplines (Dovey, 2000; Fine, 2003; Guignon, 2004; Baudrillard, 2008). A common treatment of the term *authenticity* in academic literature is to position it in opposition to whatever is fake, unreal, or false, and further to acknowledge its multiple meanings. Authenticity is also seen to be an ultimately evaluative concept, and even though we try to develop value-free methods for evaluation, there are always subjective judgments involved (Van Leeuwen, 2001, p. 392; Lindholm, 2008, p. 2). Likewise, and quite paradoxically, in context of the media, authenticity is generally seen to be positive, and audiences appreciate seemingly raw and unscripted moments.

The concept of authenticity is deeply rooted within cultures, and as culture changes—and with it, tastes, beliefs, values, and practises—so too do the definitions of what constitutes "the authentic." As such, authenticity is a moving target, meaning that the concept is continually adapting to changes and trends, and it is impossible to capture its meaning with any single, static definition (Vannini & Williams, 2009, pp. 2–3). One result of the multiple meanings of authenticity and its various applications in various academic disciplines, is that many scholars choose not to define it but rather to simply

acknowledge its complexity, such as Sarah Banet-Weiser (2012), who wrote: "The authentic is tricky to define. Its definition has been subject to passionate debates involving far-ranging thinkers, from Plato to Marx, from Andy Warhol to Lady Gaga" (p. 10). There are, nevertheless, comprehensive definitions of the term, such as the specification of a genealogical or historical (origin) meaning, whereby something's origin defines its authenticity, or a reference to identity and correspondence with facts (content) meaning, as with an original signature or document (Lindholm, 2008, p. 2; Vannini & Williams, 2009, p. 2). In their highly practical orientation, however, these definitions are less suitable to analysing the media than to analysing, for example, someone's legitimate right to the royal throne (Geary, 1986) or the viability of a Munch painting.

In order to encompass the media as an institution of meaning production and an arena for the negotiation of symbolic power, I will suggest the term *mediated authenticity* to define the media's relationship to this complex notion. Because mediation requires a refinement of the original, the term "mediated authenticity" does not imply any idea of an original to be classified as unchanged or unprocessed. Instead, it refers to mediated communication as carried out through the use of information communication technology and in the forms of mediated personal communication, interactive communication, and mass communication (Lundby, 2009). In the context of the media, authenticity is defined through as a communicative process, and the degree of authenticity depends on symbolic negotiations between the main participants in the communication. More specifically, the negotiations concern aspects of trustworthiness, originality, and spontaneity.

Authenticity as Trustworthiness

The media are a key source of knowledge about the world, and an essential point of navigation in our everyday world. Contemporary modern societies are highly complex, and we use various mediated sources in order to navigate our manifold roles in what Zygmunt Bauman (2000) labelled "liquid modernity." The complexity of our modern lives demands our reliance upon a variety of sources outside our own experience to support our decisions, opinions, and actions as social human beings, and the media are the most important among them. The media are normatively supposed to provide the people with trustworthy, balanced, and neutral information about the world. Though we all know that this is not always the case, we have to rely on the media nevertheless

(Luhmann, 2000). In the digital age, we depend on it for nearly everything we do, and to a degree, we live both through and in the media. In what Mark Deuze (2012) labelled the "media life," our actual lives have become inseparable from the media and its technologies as they surround us and influence our activities, socialising, and decision-making. The media might even inform our social competence and relational skills, such as the sitcom *Seinfeld*, which, among other things, reminded us that double-dipping chips is frowned upon and regifting is unheard of within a circle of friends. The media influence our everyday lives in various ways, and questions of the media's authenticity and trustworthiness are accordingly among the most urgent topics in contemporary society.

The significance of a trustworthy media becomes even more evident when crises affect public health and safety, such as infectious diseases (e.g., the spread of swine flu in 2009), natural disasters (e.g., the earthquake and tsunami in Japan, 2011), or terrorism (e.g., the September 11 attacks in New York, 2001). In such unpredictable circumstances, the mass media serve many functions, of which the most important are distributor of information and supplier of answers to the public's questions, but also provider of an arena for collective crisis psychology through public debate and ritual grief.

A critical question raised, particularly in the field of news studies, however, concerns the degree to which the information provided by the media is in fact correct, accurate, and trustworthy. An extensive body of research in the field of news media has been concerned with exploring various forms of manipulated reality in news production (White, 1950; Tuchman, 1978; Gans, 1979; Schudson, 1995; Jaramillo, 2009), and in order to more thoroughly explore the notion of authenticity as trustworthiness I will now discuss the key findings and perspectives within this tradition.

Perspectives: News studies

In media and communications research, news studies enjoy a prominent position and have even, to a degree, legitimized the academic field itself. This influence is a result of the news media's privileged discourse, or what Morse (1986, p. 55) defined as the genre's "special relation to the Real." The news media are expected to serve audiences as citizens; to inform and enlighten them; and to empower them in ways that enable participation in a deliberative democracy (Habermas, 1984). In the field of media and democracy

studies, impartial, trustworthy, and balanced news reporting is regarded as a prerequisite for the proper functioning of democracy.

The legitimation of news journalism as a vital force in contemporary democracy increased significantly after the Watergate scandal (1972–1974), which was characterised by Michael Schudson (1995, p. 165) as "the unavoidable central myth in American journalism," because the scandal found "a president guilty of crimes, waist-deep in deception, and forced him from office." In recent studies of this journalistic myth, it has been argued that the journalists' impact upon the Watergate scandal was significantly overrated, and that the investigative journalism was less heroic and less influential than the myth made it out to be. Yet the narrative—and the fictional movie *All the President's Men* (1976)—contributed to an increase in the public prestige of news journalism throughout the subsequent decades (Zelitzer, 1993). As a result, the news media has since been linked with the idea of the investigative reporter as public watchdog, which further implies that journalists serve on the behalf of the citizenry to defend their civil rights and access to trustworthy information.

A large share of news studies has examined to what degree those high expectations are actually manifested in news reporting. A key concern in this research is that idealistic journalism is under pressure from the commercial imperative of the media industry, and that reporters are often tempted to prioritise sensation over sincerity. Examinations of news production have found sustainable support for this theory and documented news stories as the products of the so-called "news factory," where they are manufactured rather than simply reported (White, 1950; Tuchman, 1978; Schudson, 1995; Jaramillo, 2009; McNair, 2009). Among the key contributions in this debate is Daniel Boorstin's (1987) definition of a "pseudo-event," which points to a tendency whereby the media report on stories that they have constructed for themselves. In this sense, the media make events happen, then report on them as if they were real news.

News journalism is never just about reporting facts but also about choosing an angle and creating a story: "No reporter just 'gets the facts.' Reporters make stories. Making is not faking, not lying, but neither is it a passive mechanical reporting. It cannot be done without play and imagination" (Schudson, 1995, p. 96). There is always a balance, however, between the weight given to factuality and the weight given to imagination, and a body of research sees the emphasis on compelling storytelling in news reporting

as undermining the accuracy of the news. Weaver (1994, p. 14) claimed that the narrative storytelling in news reporting creates a "culture of lying," in that "the lies are technically modest enough to win easy acceptance" but still substantial enough to manipulate reality.

Television news depends upon genre conventions, and elements such as music, studio décor, and anchors play such a prominent role in these performances that they can lend credibility to the news station simply by making 'the news look like news.' Relatedly, the degree of storytelling in the respective TV news production depends upon factors such as editorial policy and available resources. Comparative academic studies of the presentation of selected events on different TV channels are therefore useful for pinpointing aspects of storytelling's impact on the accuracy of the news. One key example is Deborah Jaramillo's (2009) analysis of 2003 Iraq invasion coverage by US broadcasters CNN and Fox News Channel, respectively. The study showed that television news made the war into what Jaramillo called a "high concept" affair, meaning that the raw material from the events was packaged and narrated by both channels according to the conventions of Hollywood film productions. Accordingly, studies of the media's trustworthiness are interested in the potential for bias in news reports, and look at the ways in which political or economic interests might influence journalism and thus reduce its authenticity. As such, it is clear that mediated authenticity demands a fairly high correlation between events or facts and their mediated representations.

Authenticity as Originality

A second dimension of mediated authenticity is the question of originality, which is often associated with nostalgia. Authenticity is an evaluative term, and being characterised as "original," "genuine," and "real" is considered positively in most contexts. This explains the advertising and marketing industry's extensive use of the term to distinguish products and thus gain an advantage in overcrowded market areas (Gilmore & Pine, 2007; Lindholm, 2008). As early as 1908, the Coca Cola Company started to use slogans such as "get the genuine" in their ads for the beverage (Orvell, 1989, p. 229). In the present day, the terms "authentic," "pure," and "original" are used to promote products and services such as blue jeans and luxury wines, as well as restaurants and travel destinations.

The nostalgia for authenticity is, as a rule, connected with the binary link between commercial/inauthentic and non-commercial/authentic, though this dichotomy has now been demonstrated to be both reductive and generally irrelevant (Banet-Weiser, 2012). Yet, as pinpointed above, definitions of authenticity do tend to reflect contemporary political and intellectual trends, and during the 1930s and 1940s, critical and anti-capitalist perspectives propelled the work of social theorists associated with the Frankfurt School, a neo-Marxist interdisciplinary centre inspired by thinkers such as Freud, Kant, Hegel, and Marx. Prominent intellectuals such as Theodor Adorno, Walter Benjamin, and Max Horkheimer developed a critical theory whereby the power of the mass media was questioned, and authenticity understood as unaffected by the logic and constraints of commercialism, a force that was determined to process and standardise art, products, and services at the expense of their genuine and original qualities.

This understanding of authenticity was not least a reaction to the contemporary development of mass communication, including radio broadcasting and mass-distributed advertising. The Frankfurt School criticised mass media and the reproduction of artworks as inauthentic in key works such as Benjamin's *The Work of Art in the Age of Mechanical Reproduction* (1969/1936). This classic treatise debates authenticity specifically in the context of reproduction and concludes that the "sphere of authenticity is outside the technical," thus implying that the original artwork is independent of its copy. Accordingly, the act of reproduction removes the artistic value, or "aura," from the original by changing its context.

Popular culture reproduction was regarded as not only reductive in comparison with the work's original qualities but also as deceptive to, and even manipulative of, the mass audience. A key statement of this perspective was the book by Adorno and Horkheimer (2002/1944) titled *The Culture Industry: Enlightenment as Mass Deception*. Here, their main argument was that popular culture and standardised media products such as films, television, and magazines are used by the ruling class to manipulate the masses into passivity, because the pleasures of popular culture make people forget about their political and economic situations. Adorno and Horkheimer ultimately regarded the popular mass media as a capitalist instrument of deception that cultivated psychological needs that could be fulfilled by consumption and more products. Along these lines, Boorstin (1995, p. 144) claimed that advertisements promoted "a paradise in which things were more real than in our everyday world," thus

marking the dawn of a "culture forever wedded to a dialectic between authenticity and imitation" (Benjamin, 1969/1936). The perfectionist version of reality in advertising aesthetics was a key critical argument against popular culture in the post-war era's social theory.

The notion of the mass media as presenting a phony version of reality, and of the public as prone to believing these imitations to be more real than reality, was further developed in the context of postmodernist philosophy and semiotics in the 1970s and 1980s. Partly as a reaction to commercialisation and Americanisation of European culture, the term *hyperreality* was introduced to describe the condition in which the real and the fictional are interchangeable (Eco, 1973, 1986; Baudrillard, 1981). A prominent critic who engaged with hyperreality was the French sociologist and philosopher Jean Baudrillard (1981), who argued that the media-saturated world asks us to relate to *simulacra* and *simulation*, because copies have largely replaced originals. Arguing that the Disneyland amusement park is more real than America, he claimed that plastic imitations now stand for reality in postmodern society. Likewise, the Italian semiotician and philosopher Umberto Eco directed his criticism of hyperreality towards what he defined as "America's obsession with simulacra and counterfeit reality." Eco's essay "Faith in Fakes" (Il costume di casa) was later revised into the book *Travels in Hyperreality* (1986), where he noted that "the American imagination demands the real thing and, to attain it, must fabricate the absolute fake" (p. 8). Taking Disneyland as a cue, I will now turn to tourism studies to explore the notion of authenticity as something original, as opposed to the constructed landscape of, for example, an amusement park.

Perspectives: Tourism studies

Tourism studies, or the sociology of tourism, is a research field in culture and communication studies that investigates aspects of authenticity. A key interest in tourist studies is to uncover how seemingly authentic places, live music, or local foods are in fact staged according to principles derived from both globalisation and commercialism. A pioneer in the sociology of tourism is Dean MacCannell (1973); in the article "Staged Authenticity: Arrangements of Social Space in Tourist Settings," he argued that the contemporary tourist seeks "authenticity" with a religious fervor

that evokes the quest for a holy place. In contrast, the tourist industry is staffed with tourism operators, guides, and marketers devoted to encircling the consumer in a compelling but fabricated "tourist space." Even as the concept of authenticity has been refined, these context studies of tourism remain concerned with the paradoxes of this staged authenticity. A key insight is that when we travel, we search for authentic experiences and not a feeling of being a "tourist," and the travel industry increasingly seeks to fulfil our needs through commercial authenticity, and even constructed authenticity (Cohen, 1988; Golomb, 1995; Wang, 1999; Olsen, 2002). Media and culture audiences' search for authentic experiences parallels the touristic search for authenticity, as they both involve paradoxes and pitfalls, such as the risk of mistaking stereotypes and dilapidated conditions as marks of authenticity. An anthropological study of blues clubs in Chicago, for example, found that club owners were reluctant to book white blues artists, because they contradicted fans' expectations. Factors such as location and interior decoration also proved relevant to a blues club's status among true fans; an authentic club would be typically situated outside the tourist area, preferably on a dark, secluded side street, and its interior would be shabby and dim (Grazian, 2004).

The growing industry of media tourism—through which film and TV locations are turned into what Nick Couldry (2000) defined as "sacred places" to which audiences and fans make pilgrim journeys—demonstrates that audiences seek *physical manifestations* of the fictional universe in the real world. Firms such as On Location Tours offer trips to the "other side," and thereby celebrate the paradox of mediated authenticity. Media tourism is a result of the culture industry's recognition of the paradox that viewers find pleasure in visiting these locations to see, and even touch, the physical manifestations of a fictional universe. A study of guided on-location tours to the long-lasting daily British soap opera *Coronation Street* demonstrated that the series' fans were very interested in actually walking down the street that they had become so familiar with. Additionally, the fans enjoyed making calls from the on-location phone booths, thus forming a symbolic link between the "media world" and the "real world." The paradox of media tourism as a hybrid space between reality and fiction illuminates the complexity of authenticity, because these visits to "authentic" locations are propelled by love for a fictional narrative.

Authenticity as Spontaneity

The third general dimension of mediated authenticity is spontaneity, which is paradoxical because the performers in the media are often expected to "be themselves" and "act natural," but also always be compatible with the format criteria. Erving Goffman (1959) has written extensively on how we perform our roles in everyday life, and his works in particular pinpoint the paradox of pre-planned spontaneity. For example, a sports commentator needs to seem surprised and spontaneous rather than calculated and prepared when the national football team wins (Scannell, 2002; Ytreberg, 2008). Even though it might seem contradictory, a thoroughly planned performance might seem more spontaneous than a truly improvised performance.

Authenticity in TV performances is a paradox not least because of the pre-planned production process, and the scripting of studio shows, that the platform entails (Carpentier, 2001; Ytreberg, 2004). As argued above, performances can be formatted and scripted to *seem* spontaneous, and participants in, for example, game shows are often instructed to behave according to format criteria. In most cases, participants loyally follow these instructions, and this becomes particularly evident when participants work against the format, as in the stunt performance by comedian Andy Kaufman on *The Dating Game* (ABC, 1965–1973). This dating show's formula was to help identify a possible "match" between two contestants, who would then go on a date: typically, a woman questioned three bachelors who were hidden behind a wall and, on the basis of their answers, chose one of them. The questions were often characterised by their crudeness and sexual innuendo. When Kaufman was asked such questions, he did not reply according to the format criteria but instead appeared to misunderstand the key premise that the potential partners could not see one another, repeating: "But I don't know what she looks like, can I see her?" When pressed, he then answered the woman's questions completely literally rather than playing along with their flirty undertones, producing absurdist comedy along the way. At the end, when the bachelorette did not select Kaufman to be her date, he acted truly heartbroken, insisting: "But I won! I won! I answered all the questions right." This likewise went against the format's conventions, which discouraged demonstrative outrage among the losing contestants. Although the producers must have know what to expect when they invited the experimental comedian, Kaufman's protest in the studio might be interpreted as a protest against the TV genre's preference for staged authenticity, and a desire to show real human feelings rather than to play along with the requirements from the commercial TV industry.

Accordingly then, Andy Kaufman's performance illustrates the modern problem of the conflict between acting true to one's inner self, and acting adequately according to social norms; and the ethics of authenticity is a peculiar feature of modern culture that originated in the Romantic period as a moral concept (Taylor, 2001). The ideal of authenticity arose out of people experience of the first wave of modernization in the West. In a pre-modern society, there had been little room for self-searching and searches for the "real reality" underneath the surface. Indeed, "authenticity has no place in the vocabulary of human ideals," and it was modernism that brought with it an environment where it seemed imperative *to be oneself in the world* (Berman, 2009, pp. xxvii, 57). In earlier times, individuals had to connect with something outside themselves, such as a cosmos or a God; the Romantics asked the individual to connect with his or her inner core. This idea of authenticity as being true to oneself emerged in the late eighteenth century and was propelled forward thanks to the work of Danish philosopher and theologian Søren Kierkegaard (1813–1855) and, later, French philosopher Jean-Paul Sartre (1905–1980). Their existentialism was concerned with questions of an authentic existence and life that was in accordance with one's true self rather than external social norms.

This notion of authenticity as inwardness is manifested in modernism and the immense subjective turn in modern culture, and we have become increasingly aware of our self-presentation over the past century. The modern ideal of authenticity is related to the idea of being true to oneself, but it also implies the goals of self-fulfilment and self-realisation, as is clear from the industry of self-help courses, guidance books, and lifestyle coaching. Mediated communication is a core arena in which such ideals are exposed, debated, and exploited. The ideology of an autonomous self, independent of social relations, norms, and traditions, however, is problematic for several reasons. First, the ideal of an authentic individual could be taken to validate ugly extremes of social exclusivism, such as nationalism, racism, and sexism (Eriksen, 2002; Lieberman & Kirk, 2004). It might also work in tandem with ignorant self-interest and thus become an obstacle to the realisation of a community version of the authentic—one in which genuine social commitment would be considered superior to self-realisation (Sjørslev, 2013, p. 116). Lastly, the ideal of an authentic self collides with the ever-expanding possibilities for self-improvement in post-modern society—for example, through enhancement technologies such as Prozac and facelifts (Elliott, 2003, p. 85). In the music industry, the emphasis on image, style, and looks has become increasingly central since the 1950s, but yet, the claim to authenticity is a selling point. I therefore will take the above discussion

about the complexity of performed spontaneity as an authenticity marker a step further by drawing on insights from music studies.

Perspectives: Music studies

Authenticity is a central concept in music studies, as well as anthropological and sociological studies of music as an identity marker and fan cultures (Kivy, 1995; Frith, 1996; Pattie, 1999; Moore, 2002). A major strand of research investigates the notion of authenticity within music genres such as hip-hop (Hess, 2005; McLeod, 2006), country music (Peterson, 1997), blues (Grazian, 2004), rock 'n' roll (Dettmar & Richey, 1999; Weisethaunet & Lindberg, 2010), and punk (Lewin & Williams, 2009). A common finding across these studies is that the performances are regarded as authentic if they respond faithfully to genre conventions, but also include spontaneous elements or improvisation.

Hip-hop artists claim authenticity through a formula of autobiographical lyrics about racism, crime, and drug abuse, with which they establish an ethos, or "street cred" (Moore, 2002; Hess, 2005). The demand for artists to "stay real" rather than to adjust to mainstream culture is not only rooted in genre conventions but also in a moral expectation of the artist to be a representative voice, meaning that the performance is a genuine artistic expression and not a plastic product. Successful hip-hop artists who become rich and famous either need to redefine some claim to authenticity that is other than a "voice from the ghetto" or face the verdict that they are "sell out" or fraud (McLeod, 2006). Authenticity is often undermined by success (Dettmar & Richey, 1999, p. 20), and many artists solve this dilemma by adjusting their image accordingly, so that, for example, fame and fortune is a part of their storytelling as an artist. An example is the hip-hop artist Jay-Z, who has replaced his "voice from the ghetto" cred with a cred based on a glamorous lifestyle.

In Moore's (2002, p. 209) definition of authenticity the artists should "speak the truth of their own situation," "speak the truth of the situation of (absent) others," and also "speak the truth of their own culture, thereby representing (present) others." These threefold criteria demand of the artists to invest their feelings and lived life in the music; because if music, like other symbolic practices, is to mean something to people, it must support some sort of architecture of authenticity. An artist who seems to lose control or improvise on stage will always seem more authentic to the audience than an

artist who seems to keep strictly to the concert plan (Firth, 1996, p. 275). Obviously, the audience will believe in an artist who seemingly believes in his or her own songs, but for popular artists the engaged performance might also turn into a staged routine, and the emotional engagement might be just a part of the professional stage routine.

The paradox of authenticity is moreover evident in the moral judgment of artists as representatives for a movement or a subculture. Take, for example, the punk and grunge genres, both of which claim authenticity as alternative and anti-establishment and in opposition to the ruling mainstream culture. From the start, the punk culture had a deeply confused attitude towards authenticity, and it always included simulation and artificial elements, and these elements came to be seen as authentic (Barker & Taylor, 2007). Similarly, the grunge movement cultivated the anti-establishment attitude, even to the point where it became destructive to be a successful grunge artist, as exemplified by the tragic death of Kurt Cobain. The lead singer of the 1990s grunge band Nirvana, Cobain killed himself, and, as he explained in his suicide note aimed at his fans: "The fact is, I can't fool you, any one of you. It simply isn't fair to you or me. The worst crime I can think of would be to rip people off by *faking it* and pretending I am having a 100% fun" (Barker & Taylor, 2007, p. 24). The demands for seemingly authentic performance might make it hard for artists to live up to their image, especially if their stage persona diverges significantly from their inner selves.

In the field of media studies, the term authenticity has recently merited little of the attention shown by scholars of other disciplines, even though media are often used as examples of an inauthentic popular culture. The aim of this book is to compensate for this research gap, and outline a tentative theory of mediated authenticity. In the next part I will define the main concepts in this theory.

The Main Concepts and Arguments

The book aims to explore the concept of authenticity, and its potential as a prism for understanding the media and its role in the construction of reality. In the following, I will discuss the three main components of the tentative theory of mediated authenticity: authenticity illusions, the authenticity contract, and authenticity scandals/puzzles.

Authenticity Illusions

The concept of "authenticity illusions" refers to the fact that mediated communication is *representations of reality* and thus bases its communication on illusions of authenticity. As described earlier in the chapter, this aspect is essential for news journalism and factual genres that claim to represent the real world through text, images, or sound. Typical authenticity illusions in factual genres include news conventions such as on-the-scene reports and eyewitness interviews, which are often used to underline the sincerity of a story (Scannell, 1996).

Yet, the characteristics of an authenticity illusion become even clearer when it is used to manipulate a representation of reality. A crowning example of the eyewitness as an authenticity illusion is the fake "man on the street," Greg Packer, who over the course of 10 years was quoted as an eyewitness source more than 100 times in various publications, including *The New York Times*. His strategy was to arrive early at media events, identify journalists in attendance, and make himself available: "I'm the best person to come to—anywhere. I always give time and I always have an answer" (Geraci, 2004). After his strategy was exposed, the Associated Press instructed journalists to stop quoting Packer in their news stories, and Sheryl McCarthy, columnist for New York's *Newsday* even argued that the "man-on-the-street interviews are worthless" in the wake of Packer's deception (Geraci, 2004).

Authenticity illusions are no less important in fictional media such as novels, TV dramas, and movies than they are in fact-based media. In literature, the opposite of fiction is non-fiction; while the former is based on imagined and invented events, the latter is based on real and factual events. Some scholars have contested the notion of a distinction between fiction and non-fiction (Nichols, 1994; Underwood, 2008; Hustvedt, 2013). The Norwegian American author Siri Hustvedt (2013), for example, denounced the idea of the fiction writer as a "professional liar," because fiction is based on personal experiences and memories as well as imagination and storytelling. This argument is in line with Underwood's (2008) finding that the works of many canonical authors, including Charles Dickens, Mark Twain, and Joan Didion, are actually based on journalistic research and reporting. Certainly, fiction draws partly on real experiences, and the degree to which stories are entirely imagined differs greatly among authors.

The extreme version of an authentic novel is perhaps the six-volume *My Struggle* (*Min Kamp*, 2009–2011) by the Norwegian author Karl-Ove

Knausgård, who "has recast the confessional novel in hyperbolic form" (Meaney, 2014). Knausgård wrote about his life from his childhood to the present day, lingering over his troubled relationship with his alcoholic father and the everyday struggles of being a father, a husband, and an ambitious author. Because the books reveal intimate details about people in the author's circle, including his mother, children, wife, and friends, they were publicly debated and criticized as well as acclaimed. As an autobiographical novel, *My Struggle* is genre defying, and its relationship to reality is perhaps best understood in light of Roland Barthes's (1968) term "the reality effect." With this term, Barthes referred to elements in fiction, such as the descriptive details of a particular chair or a view from a window, that do not serve any direct purpose in the narrative, except to link the text to the real world. *My Struggle* includes a series of such signifiers of the real that are based on the author's memories but also partly reconstructed and invented for the purpose of the work. I define these strategies for signifying the real in both fiction and non-fiction as authenticity illusions.

While textual authenticity illusions are used in literature, audio-visual authenticity illusions are used in movies and television, some of the most common of which are the use of exterior sets, where streets, parks, or houses are reconstructed. This illusion is enhanced by the coordination of exterior facades with interior studio sets, including matched-up windows and doors. Such geographical anchoring of a fictional narrative is a frequent authenticity illusion in genres such as the sitcom, soap opera, and drama. Even though most of the scenes in series such as *Friends*, *Seinfeld*, or *Sex and the City* are filmed in studios with interiors set up as apartments, exterior shots are used to contribute to the illusion of an authentic location in New York City.

The key authenticity illusion in *Seinfeld* was that it claimed to be a show about nothing, meaning that it sought to appear unpretentious, honest, and transparent; likewise, its comedy was derived from life's mundane details, which resonated with the everyday experience of its viewers. Another authenticity illusion in the show was its display of real brands and reference to real products in its dialogue. This product placement obviously had commercial purposes as well, but the relevant point here is that it would be hard for a series that portrayed the complexities of consumerism and individualism in an urban environment to seem authentic if the characters were using fictitious brands.

Authenticity illusions in historic drama series stand in contrast to *Seinfeld*'s contemporary realism. For example *Downton Abbey* (BBC) was crafted with the assistance of historians with expertise on early century Britain,

as they could advise on etiquette, dishes, props, clothes, and so on. Similarly, *Mad Men*'s emblematic use of 1960s objects and clothing, as well as the casting of actors without a strong presence in the public consciousness, constructs a historical specificity, which is also underlined by episodes set on specific dates. *Mad Men* inscribes historical costumes, make-up, and hair design upon fictitious characters, but also entreats the viewers to examine its historic accuracy, as it mixes genuine 1960s artefacts with fraudulent, manufactured ones (Butler, 2011). In *Mad Men*, historical sources are used selectively and idiosyncratically, in a mix with popular media and undocumented myths. For instance, the producers paid $250,000 for rights to use the Beatles song "Tomorrow Never Knows" (1966) in an episode in season 5, because the creator's stringent requirements for period accuracy demanded an authentic beat (Itzkoff and Sisario, 2012). As such, "an overwhelming wealth of authentic details" will drown any anachronistic noise and make the viewers believe in the illusion of period reality (Butler, 2011, p. 58). To conclude this part, I will underline that authenticity illusions in both fiction and factual genres are based on elements of both fact-based and fiction elements, but that the claim to represent reality, and thus also closeness to empirical realism, is higher in factual genres, and that this difference is manifested in the authenticity contract.

The Authenticity Contract

In this section, I will first discuss the roles of the main stakeholders in this symbolic contract, then define it as a result of the genre system and established practises, but also a degree of irrationality, and discuss its relevance for mediated communication.

The main stakeholders in the authenticity contract are the producers, the audiences, and the regulatory authorities. In the context of the contract, the concept of the "producer" encompasses a range of roles, from executive director and chief editor to the hybridized functions of digital media described as, for example, "prosumers" (Toffler, 1981) or "prousers" (Bruns, 2008). The roles have in common that they influence, one way or another, the production of the media content in question. Likewise, the concept of the audience as a stakeholder in the authenticity contract is broad and interchangeable with viewers, spectators, and users. While the roles of producer and audience can overlap, I will draw upon British cultural studies scholar Stuart Hall's (1973) twin concepts of encoding and decoding to distinguish them by defining the

role as producer in the practise of encoding, and the role of the audience in the practise of decoding. A key insight from Hall's work is that though the producer encodes a text in a certain way to encourage a "preferred reading," the audience will always decode, or interpret, the text through personal filters that are in turn defined by their social and cultural backgrounds. Media content, however, is seldom interpreted in solitude and usually involves dialogue with others, so that audiences will often verify the accuracy of, for example, a news story by consulting with friends and family (Katz & Lazarsfeld, 1955). The third stakeholder, the regulatory authority, plays an important role in twists about authenticity, such as when a TV company is fined for using fake footage in a documentary, or when a newspaper is found guilty of fabricating celebrity interviews.

These three stakeholders have in common that they turn to the *genre system* for guidance in their respective affairs. Genres can be seen as constituting a kind of tacit contract between authors and readers (Chandler, 1997, p. 6). The genre system is multidimensional, touching upon textual features as well as production values, market strategies and audience expectations. Moreover, genres evolve over time, and their mingling can result in new genres as well (Miller, 1984; Todorov, 1990; Neale, 2000). In spite of this ongoing process of reinvention, key genre features are always "stable, static and bounded," because otherwise "they would not have any meaning at all" (Mittell, 2004, p. 176). I regard the genre system as fundamental to mediated authenticity, because producers use genre conventions as a way of avoiding misunderstanding, and the audience interprets media according to its genre expectations. The development of new genres is often a result of dated and over-used conventions, combined with a need for an adjustment to the existing genre system, even when this causes tension among the stakeholders.

In addition to the genre system and its established conventions, the authenticity contract is based on a certain irrationality, because audiences choose to believe in the illusions created by producers, in part because they want or need the pleasure of believing. To a degree, that is, the authenticity contract requires a "suspension of disbelief" (Coleridge, 1817), a longstanding concept in literary and art theory that describes the audience's tendency towards believing, even when they know it is an illusion. From a philosophical perspective, we might agree with the French psychoanalyst Jacques Lacan (2006) that authenticity belongs to the field of belief (in truth-as-authenticity), and, as such, modern, profane life inevitably includes elements of religiosity. In

line with this argument, Peters (2000) has discussed the parallel between broadcast media and the idea of a God, pinpointing that both disseminate without any request for response and expect belief and trust without physical manifestations.

In mediated communication there is a void—or a missing link—between sender and receiver, because they are invisible to each other and lack a shared physical presence. The authenticity contract accordingly compensates for this void.

Authenticity Scandals and Puzzles

The notion of the authenticity contract is informed by genre studies, literature studies, production studies, and reception studies. The authenticity contract is based on genre conventions, as well as other norms for mediated communication, which are historically negotiated between producers and audiences. However, there are times when the agreement collapses, and miscommunication results. In such situations, producers might miscalculate the audience's media literacy and interpretative skills, or they might deliberately and suddenly change the rules of mediated authenticity.

I divide between two categories of miscommunication, the first of which is the *authenticity scandal*, meaning that the mediated communication fails and further introduces problems for audiences, as well as society at large. An authenticity scandal often involves deception in the sense that the media company, the producers, or both, deliberately mislead the audiences for the purpose of, for example, economic profit or related motives, such as political or creative. Alternatively, the scandal can result from novel production techniques and thus also authenticity illusions and their unfamiliar effect on the audience, for example making them confused about how to interpret the mediated message.

The second category of miscommunication is the *authenticity puzzle*, when the media producers present a puzzle for the audience. The puzzle is characteristically playful and complex, as it combines elements of trustworthy and original material with inauthentic and simulated material, and includes scripted spontaneity. As such, the audience is invited to actively participate in solving the puzzle; to identify and separate the authentic elements from the fake elements, and thus engage in meaning production, but also in a kind of media criticism.

Plan for This Book

The book presents five case studies of authenticity scandals and authenticity puzzles, each of which is selected to illuminate a change in the relation between producers and audiences. The case studies draw on a combination of methods, including textual analysis of radio and TV programs, and social media posts, supplemented by analysis of media coverage and secondary literature. Each chapter in the book is dedicated to an introduction of a new media technology, a new media format, or a new media persona, which imposes a renegotiation of the authenticity contract. Drawing on McLuhan (1995/1964), I will analyse mediated authenticity as a historical development, in which the introduction of new media technologies requires a renegotiation of the authenticity contract. The historical phase of a novelty—when a new media technology is in the process of being established and incorporated as an "extension of man"—is of particular interest, as this is the phase when the negotiation of authenticity is at its most intense and most decisive for further media-audience relations.

Chapter Outline

Chapter 2: Genres as Authenticity Illusions: *The War of the Worlds*

The chapter explores radio broadcasting as a new phenomenon, and the relation between producers and listeners as a new "sociable relation," and discusses the *authenticity illusions* in radio. In this era of radio's novelty, the most infamous *authenticity scandal* in the history of broadcast media occurred with the radio drama *The War of the Worlds* (1938), during which a significant share of radio listeners mistook the artistic use of genre conventions for a real news bulletin about alien invasion. The chapter analyses the radio play as a negotiation of the *authenticity contract* between producers, audiences, and public institutions such as the press and the police.

Chapter 3: Money, Fraud, and Deception: *The Quiz Show Scandals*

Twenty years after *The War of the Worlds*, the novelty of television had significantly mitigated the initial fascination with radio. This chapter explores audio-visual *authenticity illusions* as a new turn in the relation between broadcasters and their publics. One of the most spectacular *authenticity scandals* in

the history of television transpired with the US quiz shows of the late 1950s, in which it came to light that producers had manipulated competitions. The chapter explores the scandal, and the negotiation of the *authenticity contract* between producers, audiences, and public institutions such as the court and the regulatory bodies.

Chapter 4: Ordinariness as Authenticity: *The Reality TV Genre*

By the end of the twentieth century, television was influenced by the "participatory turn," not least fuelled by the fast growth of the Internet. This chapter explores the *authenticity illusions* in reality TV and explores the notion of ordinariness and how it is constructed in TV productions. The case study of the construction of the *Britain's Got Talent* (ITV) participant Susan Boyle as an ordinariness icon, explores reality TV as *authenticity puzzles*. Subsequently, the chapter investigates the negotiation of the *authenticity contract* in debates of the show in particular, and the reality TV genre in general.

Chapter 5: Fake Personas and Blog Hoaxes: *Illusions in Social Media*

In tandem with the emergence of reality TV, the participatory web emerged as a prominent arena for representations of reality. This chapter explores the emergence of web phenomena such as blogs and social media, and how these have become central elements in the new media ecology. Through a case study of three fake blogs, the chapter investigates key *authenticity illusions* in social media. The chapter demonstrates that *authenticity puzzles* are an inherent factor in social media and user-generated content, and that the reception mode is concerned with solving puzzles. Accordingly, the chapter shows how users engage as key stakeholders in the negotiation of the *authenticity contract*.

Chapter 6: Performed Authenticity: *The Obama Campaigns*

This chapter illuminates the construction of a politician as authentic, and analyses Barack Obama's election campaigns as examples of how politicians perform as trustworthy, original, and spontaneous personalities in order to appeal to voters. The case study pinpoints the key *authenticity illusions* in the Obama campaigns in 2008 and 2012. The chapter argues that gender, class, and race play central roles in the crafting of an authentic president, but that these factors are also partly deconstructed, as if they were *authenticity puzzles*,

by the press and the voters. In a way, the approval ratings might be a sign of how the promised *authenticity contract* constructed in the media is reflected in politics.

Chapter 7: Towards a Theory of Mediated Authenticity

This concluding chapter brings together the empirical findings of the case studies, and outlines a tentative theory of mediated authenticity. The theory builds on the triplet concepts of authenticity illusions, authenticity contract, and authenticity scandals/puzzles. The conclusion demonstrates that mediated authenticity is constructed by illusions of trustworthiness, originality, and spontaneity, and that these illusions are essential in mediated communication. Moreover, the chapter takes a step back and discusses the historical development of mediated authenticity, and argues that it has become one of the most urgent questions in contemporary media and communications research.

Reader's Guide

The book's case studies are primarily based on empirical material from the USA, supplemented by examples from Europe, such as Britain and the Nordic region. The Anglo-American focus is chosen because media technologies have traditionally been implemented early in these regions. The author is Norwegian and draws on examples from Scandinavia, in order to expand the scope of the analyses and discussions.

The chapters could be read individually and in any order the reader prefers, but the "preferred reading" is to read the chapters chronologically, as this will benefit the reader with a historical and cumulative insight into the notion of mediated authenticity. In total, this book provides a history of mediated communication during the almost 100 years between the introduction of broadcast radio in the early twentieth century and the spread of social media in the early twenty-first century. So, please, let's start with the beginning, and join me in time travelling back to the 1930s, and the early years of broadcast radio.

· 2 ·

GENRES AS AUTHENTICITY ILLUSIONS

The War of the Worlds

> Whoever controls the media, controls the mind.
>
> —Jim Morrison

Radio broadcasting was once a new invention, both as a communication technology and as a social institution, and it was not given that the audience would interpret the radio as a relevant and trustworthy medium. They could have dismissed the new medium as irrelevant, dangerous, and manipulative, in line with the critical approach of academics such as Max Horkheimer (1895–1973) and Walter Benjamin (1882–1940). This chapter investigates the construction of the radio as a relevant medium, and explores the reasons why the radio was embraced by audiences.

The chapter will use medium theory to identify the characteristics of radio, and how it addressed the audiences in order to build an *authenticity contract*, in which the listeners established a relation to the radio as their most important source of information and entertainment. Moreover, the chapter will investigate the use of *authenticity illusions* in radio programming as a strategy to come across as trustworthy and genuine. Lastly, I will use *the authenticity scandal* caused by the radio play *The War of the Worlds* (Welles, 1938)

as a case to illuminate how the *authenticity contract* was broken, but also renegotiated, in the early phase of radio broadcasting.

Structurally, the chapter consists of two main parts. The first part explores the rise of radio broadcasting as mass communication and the initial establishment of the authenticity contract in radio. In the second part, I will investigate the *The War of the Worlds* authenticity scandal, and examine the key implications of this scandal.

The Rise of Radio Broadcasting

In its early phase, radio was envisioned as "point-to-point communication" (such as from ship to shore) rather than the "one-to-many communication" that it eventually became. The development of radio as a technology was based on experiments with the transmission of messages over distances, first by means of wireless telegraphy and later by wireless telephony (Crisell, 1994, p. 17). These experiments were conducted by scientists from many nations throughout the nineteenth and early twentieth centuries, among whom the Italian Guglielmo Marconi was the most prominent. Marconi's breakthrough in 1895 was built upon existing experiments with wireless communication, including Heinrich Hertz's prototypes of a radio transmitter that demonstrated the existence of Maxwellian electromagnetic waves.[1] Marconi was later joined by scientists such as Reginald Fessenden, who created an important thermal detector and managed to broadcast music and speech from a wireless telegraph company's station in Massachusetts. By 1907, Fessenden could transmit speech over a distance of 200 miles, thus "inventing" radio (as opposed to wireless telegraphy), though, except from wireless operators on ships, "nobody was listening" to it at the time (Winston, 1998, p. 75). The fact that nobody noticed radio at first emphasises the distinction between the technological invention of radio as communication and the social "invention" of radio as broadcasting. Brian Winston (1986,

1 A spark transmitter and a device described as a resonator or "revealer" were used to detect the waves. In the transmitter, two rods with a small ball at the one end and a large plate or ball at the other were connected to the terminals of a sparking coil. A spark was created that jumped the gap between the two smaller balls, creating an oscillating current. This current produced electric and magnetic fields causing radio wave emission. (Winston, 1998, p. 67)

p. 67) argued that radio is the most prominent example of a machine that comes quietly into existence but is not at first acknowledged as such.

The later "invention" of radio as a social institution was closely related to political and cultural factors that included the general population's ability to move beyond the idea of radio as point-to-point communication only, which inhibited the growth of wireless communication until after World War I. With the technical advances in sound telegraphy that had been accomplished for the military during the war, radio began to represent something more than before; by the 1920s, new economic opportunities likewise occasioned new social definitions for the technology (Williams, 1975/1990, p. 25).

In the early experiments with broadcast radio, it was a usability drawback that the senders did not know anything in advance about who would receive the signals, or if anybody was listening to the transmission. The use of wireless point-to-point communication during the catastrophe on the *Titanic* as a tool to inform people on land about the situation on the ship gave a clear indication of how the technology might be used to communicate important messages across geographical distances. A person whose name has been associated with the invention of radio as a social institution is David Sarnoff, who was one of several wireless operators who sent out reports on the *Titanic* sinking. Sarnoff envisioned what we today understand as broadcast radio when he aimed to make radio into "a music box in every home," and a "household utility" in the same sense as the piano or phonograph (Benjamin, 1993).[2] This vision for the radio pointed in the direction of the development of a mass medium, which later became a reality, but which required more than a technical invention.

The radio was called the "wireless" in this transition phase between radio as a technology and radio as a social institution because this was the term for the technological innovation that emerged from "wireless telegraphy" (Crisell, 1994, p. 17). The term "radio" had already circulated in the 1910s, but was not used in everyday language until the 1920s, when the radio medium had entered the mainstream (Douglas, 1999, p. 48), while "broadcasting," the elegant eighteenth-century term for sowing seeds, "was being applied for the first time in 1922, as a definition of America's first radio station (KDKA),

2 When American Marconi was sold to General Electric in 1919, Sarnoff joined the newly formed Radio Corporation of America (RCA). Even though his emblematic status as the inventor of broadcasting might be overrated, according to Winston (1998, p. 76), "There is no question that he understood that within the culture, music was listened to collectively and radio would have to allow for that if it were to become a mass medium."

launched in 1920" (Winston, 1998, p. 77). The term radio broadcasting combines the technological and the social invention, and signalizes that the technology was more than a mere transmission of sound, but that it also redefined communication, and thus also society. Importantly, the social functions of broadcast media were made possible by technological innovations, but not predetermined by technology. Radio, and later television, was developed for transmissions to individual homes, though there was nothing in the technology that made this quality inevitable (Williams, 1975/1990, p. 24). Accordingly, the invention of radio broadcasting as we know it today was not given from the start but required an *authenticity contract* between the producers and the audiences.

A New Sense of Authenticity

Radio broadcasting marked a pronounced communicative shift from earlier Western models of cultural interaction. The evolution of electronic media such as radio and TV decreased the significance of physical presence in our daily experience of events and people, and has changed our social environment dramatically (Meyrowitz, 1985). Broadcast media brought with it new social phenomena, of which the most important are "intimacy at a distance" (Horton & Wohl, 1956), where audiences could feel that they knew people who spoke to them in broadcast media, and a "tribal drum" (McLuhan, 1964/1995), which promoted a sense of collectivism among members of its audience. Broadcasting technology made it possible to address a new mass audience all at once, creating a community without a required physical proximity.

Broadcast communication is, according to Paddy Scannell (1996, p. 23), a "sociable relation," meaning that the relation between the broadcaster and the audiences is based on a social commitment. The social commitment in broadcasting is stronger than it is in other communicative forms because of the physical absence between sender and receiver. Broadcasting indeed created a new sense of authenticity from the start, based on the unremarkable ordinariness of everyday life, as well as sincere talk and eyewitness accounts (Scannell, 1996). John Durham Peters (2000) labelled the relationship between broadcasters and their public an "authentic connection," meaning that audiences tend to experience the connection with a radio broadcast as real and genuine.

Among those who pinpointed the potential consequences of the radio as a mass medium was Raymond Williams (1975/1990), who diagnosed radio as "a new and powerful form of social integration and control. Many of its main

uses can be seen as socially, commercially, and at times politically manipulative" (p. 23). The broadcasting era began around 1920, and with it came new opportunities to "manipulate the hearts and minds of the masses" (Barnouw, 1990, p. 23; Chapman, 2005, p. 143). In every nation where broadcast radio was launched, the populace reacted to the new medium with exceptional enthusiasm. By 1930, radio had successfully become a mass home medium over almost all the developed world; as the first broadcast medium it represented quite a novelty for the listeners (Winston, 1998, p. 87; Crisell, 1994, p. 19).

The manipulative potential of the radio was related to its ability to immediately and simultaneously reach the masses with one message. This potential was exploited much differently in dramatically disparate political and socio-cultural contexts—think of the propaganda aims of Nazi Germany, the ambition to enlighten and educate the people in Great Britain,[3] and the interest in capitalising upon new commercial markets in the US (Chapman, 2005, pp. 147–158). As such, the radio had different purposes in different social and cultural contexts. In the following, I will focus on the US and explore the changes imposed by radio on the American culture.

The Zen of Listening: A Cognitive Shift

The power of broadcasting became increasingly clear as radio began to challenge the status of all of the existing culture industries and became a favoured destination for information, enlightenment, and entertainment (Winston, 1998). During its first decade, however, access to radio was limited to more heavily populated urban areas, but seemingly everyone wanted to join the new trend, which turned into a "radio bonanza" when the enthusiasm for it peaked during the "golden age" of radio in the 1930s and 1940s (Barnouw, 1990, p. 23; Chapman, 2005, p. 151).

Radio broadcasting contributed significantly to the growth of mass culture in the Western world starting in the 1920s. The radio was central in the establishment of a mass culture as it enabled people to stay in their homes yet be included in public life and engage with entertainment and information. Mass culture had already evolved over the past century and a half, through a process involving the concentration and standardisation of media products

3 In Great Britain, the number of radio licences issued by the post office in the UK, with listeners paying a fee for listening to the radio, exploded between 1924 and 1939 (Crisell, 1994, p. 19).

such as newspapers, but radio offered a more immediate communicative ethos, and invited a more intimate mode of reception.

The new social practise of radio listening has been characterised as the "zen of listening," a term that directs attention to "the transporting qualities of auditory processing. It stems also from the unfathomable and magical nature of radio propagation" (Douglas, 1999, p. 36). Broadcast radio represented an unprecedented means of mass communication, and it required new media literacy skills to comprehend. Broadcast media created a shift from "print situations" to "electronic situations," and thus impacted on a broad range of our social roles and how we relate to each other and society (Meyrowitz, 1985; Douglas, 1999). As there were no established social conventions for radio listening, people were relatively insecure about the expectations that surrounded it, and many discussions centred upon how to perform the role of "radio listener." There were even matters of anachronistic formality to be dispensed with, such as whether one should remove one's hat and rise from one's chair at home when official leaders gave speeches over the airwaves (Peters, 2000).

The "zen of listening" was as viable as it would ever be during this experimental phase in radio broadcasting, when neither the social practise nor the genre conventions of the new medium were yet established. In terms of social practise, it is hard to imagine that the radio, as an invisible and taken-for-granted medium (Lewis & Booth, 1989; Lewis, 2000; Hendy, 2000), had once been a new medium and challenged established communicative rules. Broadcast radio represented a cognitive shift towards an emphasis on audio communication, which had begun to take place with the introduction of the telephone and then the phonograph. The cognitive shift was largely about emphasising the listener's imagination, and the listeners are compelled to "supply" the visual data for themselves, which in turn implies a significant potential for communication failure. This is why in all radio much effort is expended on overcoming the limitations of the medium, on establishing different kinds of context that we would generally be able to see for ourselves (Crisell, 1994, pp. 5–7).

In terms of genres, the novelty of radio, in its interlude between debut and consolidation, can be illustrated by the 1930 radio newscast during which, when faced with a dearth of stories, the announcer simply admitted to all, "There is no news tonight" (Bell, 1991, p. 1). Today, this would be absurd, as the genre convention for radio news does not allow for there to be "no news" to report on, and because the production of news in itself generates

news. The novelty of radio is reflected in its lack of medium-specific content; as there were no established codes defining a "radio program" and contrasting previous media, radio was primarily devised for transmission and reception as abstract processes, with little or no definitions of preceding content. Consequently, radio became a "parasitical medium," which based its productions on distributions of, for instance, public sporting events and theatres. The supply of broadcasting facilities preceded the demand; and also the means of communication preceded their content (Williams, 1975/1990, p. 25). The radio was a technology and a social institution in search of content, and thus also an identity as a mass medium.

The search for identity started with experiments integrating public speeches and theatre plays into radio productions, which were made for radio, and not simple transmissions. In the next parts, I will first explore how radio became a medium for political communication in the US by analyzing how the political speech was turned into a radio format in the so-called *Fireside Chats* (1933–1944), and second, explore the radio play *The War of the Worlds* (CBS Radio, 1938) about an invasion from Mars that became infamous for its effect rather than its content.

Political Communication: The "Fireside Chats"[4]

The neat parallel between the radio's breakthrough and Franklin D. Roosevelt's formative years and later presidency makes it fruitful to investigate the role of authenticity in his series of radio speeches referred to as the "fireside chats." Roosevelt was 15 years old when Guglielmo Marconi took out his patent for the "wireless telegraph": "The radio and the boy became came to maturity together" (Buhite & Levy, 1992, p. xiii). Roosevelt is said to have understood the potential of the radio as a tool for political communication better than any political figure, not least because he grew up in tandem with the growth of radio broadcasting.

President Franklin D. Roosevelt's "fireside chats" comprised 30 public evening radio addresses he gave between 1933 and 1944 on all of the national

4 "Fireside chats" was not a term coined by Roosevelt himself but by Harry C. Butcher of CBS, who used it in a network press release before the particular fireside chat of May 7, 1933. The term was quickly adopted by the press and the public, and the president himself later used it (Buhite & Levy, 1992, p. xv).

radio networks. They proved to be highly influential because they resonated with radio's ongoing cognitive shift; the term "fireside chat" itself indicates a new approach to political communication that was intimate and direct rather than formal and distant (Buhite & Levy, 1992). According to Roosevelt's adviser and speechwriter, Samuel I. Rosenman, the president's genuine personality was always evident in the speeches: "No matter who worked with him in the preparation, the finished product was always the same—it was Roosevelt himself" (Rosenman, 1952, pp. 5–6). Secretary of Labor Francis Perkins, who was an eyewitness to the broadcast from the White House, has explained that the president engaged with his imagined audience when he delivered the live speeches: "His face would smile and light up as though he were actually sitting on the front porch or in the parlor with them. People felt this, and it bound them to him in affection" (Perkins, 1946, p. 72). These accounts point out that Roosevelt's speeches seemed authentic because he engaged emotionally and acted as if he was talking to his friends; he communicated as if there was no microphone and airwaves between him and the listeners. In fact, President Roosevelt even compared himself to an actor in a conversation with the actor and director Orson Welles, who was a regular guest in the White House during Roosevelt's presidency: "You and I are the best actors in the country" (Biskind, 2013). Even though it might have been uttered with a sense of irony, this quote tells us that the president had noticed the similarities between a politician and an actor.

I will return to the comparison of actors and politicians later in the book, and subsequently in this chapter, I will discuss the role of Orson Welles as an experimental force in the contemporary radio industry, but to return to Roosevelt, I will pinpoint that he used the "fireside chats" strategically. Roosevelt sustained his illusions of authenticity by means of radio's key characteristic, its "blindness," which is the medium's most prominent feature compared to other media. For Roosevelt, the "blindness" of radio communication was an advantage in his communication with the public, both because he mastered the medium with his voice, but also because it offered the ability to speak directly to the audience without the complication of visual images. The president and his advisors were always unsure about how the public would react to a disabled president, so it was largely hidden from the American people (Freidel, 1973). In this context, the radio had a high significance for the president, and his main aims with the speeches were to rebuild a sense of national identity, encourage individual participation in society, and forge an intimate bond with the public (Buhite & Levy, 1992). The radio medium

thus required an expanded kind of authenticity, as if to compensate for the distance between sender and receivers.

These compensations included illusions of authenticity, which might have been used intentionally, or unintentionally, but which, either way, contributed to increase the intimacy of the speeches. First, the setting before a fireside was an authenticity illusion, as the President's speech was not recorded before a fireside, but in a White House office. Second, he addressed the listeners personally, and extensively used personal pronouns, such as his use of the greeting "my friends," and his referring to himself as "I" and the American people as "you." A third technique to enhance authenticity was to use informal talk and simple language, in order to be understood by ordinary people: "He looked for words that he would use in an informal conversation with one or two of his friends" (Rosenman, 1952, pp. 92–93). Fourth, he communicated authenticity in spontaneous, or unrehearsed, talk, such as the trope of the "imperfect performance." The best example of this is when the president interrupted one of his speeches to ask for a glass of water. After pausing to drink, Roosevelt confessed to his listeners: "My friends, it's very hot here in Washington tonight" ("The president broadcasts," 1933). This informal, intimate talk and the sharing of information about his thirst with his listeners made the "fireside chats" seem more like personal addresses to the voters than a public speech.

Intimacy was established through these authenticity illusions; evidence comes in the form of the millions of letters, from nearly every social segment, posted to the White House in response to them. People often wrote these letters within days, and even hours, of hearing the president speak directly to them through the radio, and they described how they felt during these addresses, almost as if Roosevelt had entered their homes and engaged them individually. These listeners generally expressed their admiration, appreciation, and confidence regarding their leader and radio "friend" (Ryfe, 1999, 2001). History has judged Roosevelt as one of America's greatest leaders, in part because he maintained public confidence in seeing the nation through the struggles of the Depression and World War II, but studies have also explained his high approval ratings with his public communication activities and in particular his "fireside chats" (Baum & Kernell, 2001). Roosevelt had used them to gain public support, and by tapping into the "radio bonanza" and "zen of listening" as contemporary trends, he also exploited the radio's novelty, which added to his speeches' allure and mystique and contributed to this effect. Contrasting this seemingly flawless communication, I will now turn to investigate a fictional radio program, *The War of the Worlds* (1938),

which also included illusions of authenticity, but that resulted in a communications failure.

Authenticity Scandal: *The War of the Worlds*

The War of the Worlds has become a mythical story about the manipulative power of mass media, and the communication failure has been studied widely in various fields, including psychology (Cantril, 1940), media panic (Pastel, 2002; Orr, 2006), media history (Hughes, Wells, & Geduld, 1993) and critical theory (Adorno, 1964/1973). The following analysis draws on secondary literature, including the above mentioned studies, in addition to a textual analysis of the audio drama and the transcript, with focus on authenticity illusions, but first I will give a short introduction to the play and why it has become an emblematic example of miscommunication in broadcast media.

The radio version directed by Orson Welles is the most infamous among several adaptations of *The War of the Worlds*, a science-fiction novel about a Martian invasion of the Earth written by H. G. Wells in 1898. This particular adaptation has become a legend not so much because of the play itself but because of the audience reactions, and the fascinating stories about how people mistook the play for a news report, and were scared for their lives after listening to the radio. If the actual audience reaction was rather less pronounced than the legend that has arisen around this broadcast, research has nevertheless demonstrated that the play did cause a degree of disruption in the lives of its listeners. Historians have calculated that around 6 million people heard the CBS broadcast, 1.7 million believed it to be true, and 1.2 million became genuinely frightened (Crisell, 1994; Hand, 2006). Other accounts insist that over a quarter of those 6 million listeners believed what they heard, and that a number of people living near the supposed invasion site got into their cars and fled (Crisell, 1994, p. 206).

The miscommunication was not a result of an intention by master manipulators to deceive their audiences (see Bell, 1991b), but rather, the play was scheduled and announced as a fictional play. As if to underline the horror of its science-fiction narrative, *The War of the Worlds* was broadcast as a Halloween episode of a radio drama series, and it was advertised in the newspaper as a fictional play: "Today: 8:00–9:00—Play: H. G. Wells's 'War of the Worlds'—CBS." By the time *The War of the Worlds* (1938) was aired, radio had truly become a mass medium—over 90 percent of urban households and 70 percent of rural households had at least one radio set. Yet broadcast radio

was still in its infancy, and the average listener did not have more than three years of experience as a radio listener, and was thus still figuring out how to interpret and relate to the new medium.

In the specific genre of radio drama it is worth noting that although plays were easily transferred from the theatre stage to the airwaves, the social roles of the radio drama audience are radically different from those of the theatre audience. The radio audience is not only "blind" but also "absent" from the performers and each other: The listeners are not where the play is being performed but situated in their own separate environments (Dayan & Katz, 1992; Crisell, 1994). In the theatre, the spectator initiates the communication process by buying a ticket and thus enters into a contract of sorts with the actors. Moreover, as the spectator joins the other spectators in an audience, they are exposed to and influenced by the reactions of others, such as laughter (Elam, 1980). In contrast, the radio listeners were left to themselves to decide if the play was authentic or not, as they were given no social cues from the performers or the community of listeners. The fact that the listeners were invited to solve the *authenticity puzzle* in solitude, or in dialogue with others in their household, is important in order to understand why *The War of the Worlds* imposed an *authenticity scandal*. However, it is not a coincidence that just this radio play caused a scandal, and in the next section I will investigate the textual authenticity illusions, and how they led the listeners to believe the invasion to be real.

Authenticity Illusions in Radio

Through a textual analysis of *The War of the Worlds*, I identified three main authenticity illusions: *"liveness,"* immediacy, and spontaneity. The most important authenticity illusion was simulated "liveness," which not only created an impression of a real broadcast, but also offered the real sense of access to an event in its moment-to-moment unfolding; "this presencing, this re-presenting of a present occasion to an absent audience, can powerfully produce the effect of being there, of being involved in the here and now of the occasion" (Scannell, 1996, p. 84). Radio's codes are auditory and therefore exist in time, which attenuates the sense of "liveness" that we get from radio (and the visual media) as opposed to print—when we begin a book, for example, we are aware that the last page has already been written. But radio, even when programmes are pre-recorded, seems always to be a "present-tense medium, offering experiences whose outcome lies in an unknown future" (Crisell, 1994, p. 9).

The radio version of *The War of the Worlds* unfolds like an authentic broadcast of breaking news; Welles had smoothly transposed the original novel into radio speech that incorporated a very realistic language and tone (Hand & Traynor, 2011, p. 23). Moreover, the radio version directed by Welles moved the play from the distant past to the present, and from a British town to a real US town called Grovers Mill in New Jersey.[5] This adjustment to a contemporary setting, and detailed accounts of the geographic places involved, indeed increased the illusion of authenticity of the simulated live news.

The radio drama produced a fictional meta-environment to encompass the story about the Martians' invasion. Welles admitted to using the meta-broadcast as a technique for increasing the realism of the source novel, and it worked well, because the simulations of the live broadcast indicated to the audience that they were listening to an unfolding story. Welles himself played the role of the storyteller who establishes the frame for the meta-broadcast and introduces its narrative. His voice was deep and serious, which was one of the abiding strengths of Welles as a radio actor; here, it exacerbated the uneasy atmosphere of this fictional universe, as we can tell from the introduction:

> We know now that in the early years of the twentieth century this world was being watched closely by intelligences greater than man's and yet as mortal as his own ... On this particular evening, October 30, the Crosley service estimated that thirty-two million people were listening in on radios. (Welles, 1938)

This opening can be regarded as a meta-comment on the radio medium, which at that time was an attraction in itself, one associated with technological innovation and social progress. After Welles's short introduction, the simulated broadcast started airing radio content that would have appeared perfectly typical for the time: the weather report, a live dance orchestra, and its news bulletin. The first two content types served the purpose of creating a trustworthy broadcast radio environment, while the news bulletin, in tandem with the subsequent bulletins in the play, represented the narrative machinery. Along the lines of Williams's (1975/1990, p. 89) concept of "flow" in broadcasting, which draws attention to the fact that respective sequences

5 "We are bringing you an eyewitness account of what's happening on the Wilmuth farm, Grovers Mill, New Jersey. (MORE PIANO) We now return you to Carl Phillips at Grovers Mill" (Welles, 1938).

become a flow rather than remain distinct, the dance music played prior to the invasion "news flash" set up a light, frivolous atmosphere, which might have then impacted the listeners' reception mode, causing them to be caught off-guard.

Indeed, the slow pace of this evolving narrative built authenticity as well, because the story became more believable as it stretched out over time. The bulletins, in addition, were presented as "news flashes," meaning that they represented an interruption of regular content for the purposes of an extraordinary news report. The authenticity illusions of the first news flash are introduced through this interruption of regular programming and reinforced through the judicious use of "authorised sources," such as academics from elite universities:

> Ladies and gentlemen, we interrupt our program of dance music to bring you a special bulletin from the Intercontinental Radio News. At twenty minutes before eight, central time, Professor Farrell of the Mount Jennings Observatory, Chicago, Illinois, reports observing several explosions of incandescent gas, occurring at regular intervals on the planet Mars. The spectroscope indicates the gas to be hydrogen and moving towards the earth with enormous velocity. Professor Pierson of the Observatory at Princeton confirms Farrell's observation, and describes the phenomenon as (quote) like a jet of blue flame shot from a gun (unquote). We now return you to the music of Ramón Raquello, playing for you in the Meridian Room of the Park Plaza Hotel, situated in downtown New York. (Welles, 1938)

The second main authenticity illusion was *immediacy*, created by the news-flash genre that suddenly interrupted the program and thus seemed urgent and realistic. The news bulletin in general had only recently been introduced to listeners, and it was employed at length to report on dramatic world events, such as Hitler's conquests in Europe in the late 1930s (Hand & Traynor, 2011, p. 29). The radio play was actually aired just a month after the Munich crisis and Neville Chamberlain's capitulation, and "Americans had been glued to their radio sets" (Douglas, 1999, p. 165). The authenticity scandal is thus inseparable from the historical context of what has been termed the "age of anxiety," because the US was in a post-Depression phase that was further troubled by endemic paranoia, due to the turbulent territorial expansions in Europe.

Immediacy was constructed through the eyewitness accounts of the reporter and his seemingly alarming experiences while reporting on the invasion from Mars. The listeners were given access to the reporter's struggles and travel distances in his attempt to cover the event for the broadcaster;

"Ladies and gentlemen, this is Carl Phillips again, at the Wilmuth farm, Grovers Mill, New Jersey. Professor Pierson and myself made the eleven miles from Princeton in ten minutes" (Welles, 1938). The live reporting appears to provide an unfiltered account, both through its eyewitness interviews and background noise, including startled screaming and a host of "unidentified" sounds. Authenticity in the narrative was likewise enhanced through the use of a first-person storyteller:

> PHILLIPS: Good heavens, something's wriggling out of the shadow like a gray snake. Now it's another one, and another. They look like tentacles to me. There, I can see the thing's body. It's large, large as a bear, and it glistens like wet leather. But that face, it … Ladies and gentlemen, it's indescribable. I can hardly force myself to keep looking at it. The eyes are black and gleam like a serpent. The mouth is V-shaped with saliva dripping from its rimless lips that seem to quiver and pulsate. The monster or whatever it is can hardly move. It seems weighed down by … possibly gravity or something. The thing's raising up. The crowd falls back now. They've seen plenty. This is the most extraordinary experience. I can't find words. (Welles, 1938)

A third authenticity illusion in the play was unpredictability and *spontaneity*, which in radio includes imperfection in the transmission and silence in the broadcast. Early on, an atmosphere of unpredictability arises when "the reporter" informs the listeners that unforeseen events might interrupt his work:

> I ask you to be patient, ladies and gentlemen, during any delay that may arise during our interview. Besides his ceaseless watch of the heavens, Professor Pierson may be interrupted by telephone or other communications. During this period he is in constant touch with the astronomical centres of the world. (Welles, 1938)

In this way, the radio play underlines the urgency of the situation and thereby enhances the illusion of reality in the fictional narrative.

The scripted imperfections in the broadcast are repeated with increased force throughout the radio play, until the entire meta-broadcast breaks down. As the situation develops, "the reporter" increasingly struggles to keep up his live announcements because of the dangers of the unknown object: "I'll pull this microphone with me as I talk. I'll have to stop the description until I can take a new position. Hold on, will you please, I'll be right back in a minute" (Welles, 1938). Subsequently, mellow piano music is faded in before the in-studio announcer reorients the listeners (and anchors the authenticity of the on-the-scene reporter) by again introducing reporter Carl Phillips. Returning to the air, "the reporter," however, is even less in control than before. He is obviously confused and asks "Am I on?" several times before forging

ahead with his journalistic duty in spite of the explosions that are drowning him out and even blurring his vision: "I'll give you every detail as long as I can talk. As long as I can see." The audience is even led to fear for the reporter's life, as he suddenly exclaims: "It's coming this way," before we hear the crash of his microphone and then a forbidding silence (Welles, 1938).

The use of silence as an indicator of authenticity is remarkably effective, in fact, because silence is indexical, indicating that, for the moment, at least, there is a void, or what is sometimes referred to as "dead air." If the silence persists for more than a few seconds it signifies the dysfunction or non-functioning of the medium; either transmitter or receiver has broken down or been switched off (Crisell, 1994, pp. 52–53). The dramatic use of silence in *The War of the Worlds* is what produces the authenticity climax in the play as well, when the in-studio announcer ultimately breaks the silence with a brief message: "Ladies and gentlemen, due to circumstances beyond our control, we are unable to continue the broadcast from Grovers Mill. Evidently there's some difficulty with our field transmission. However, we will return to that point at the earliest opportunity" (Welles, 1938). As the situation becomes more chaotic and the broadcast becomes even more troubled, the announcer "reappears" in a desperate attempt to transmit from the roof of the CBS building in New York:

> ANNOUNCER: I'm speaking from the roof of the Broadcasting Building, New York City. The bells you hear are ringing to warn the people to evacuate the city as the Martians approach. Estimated in last two hours three million people have moved out along the roads to the north, Hutchison River Parkway still kept open for motor traffic. Avoid bridges to Long Island ... hopelessly jammed. All communication with Jersey shore closed ten minutes ago. No more defenses. Our army wiped out ... artillery, air force, everything wiped out. This may be the last broadcast. We'll stay here to the end ... People are holding service below us ... in the cathedral.
>
> (VOICES SINGING HYMN) Now I look down the harbor. All manner of boats, overloaded with fleeing population, pulling out from docks.
>
> (SOUND OF BOAT WHISTLES) Streets are all jammed. Noise in crowds like New Year's Eve in city. Wait a minute ... Enemy now in sight above the Palisades. Five— five great machines. First one is crossing river. I can see it from here, wading the Hudson like a man wading through a brook ... A bulletin's handed me ... Martian cylinders are falling all over the country. One outside Buffalo, one in Chicago, St. Louis ... seem to be timed and spaced ... Now the first machine reaches the shore. He stands watching, looking over the city. His steel, cowlish head is even with the skyscrapers. He waits for the others. They rise like a line of new towers on the city's west side ... Now they're lifting their metal hands. This is the end now. Smoke comes

out ... black smoke, drifting over the city. People in the streets see it now. They're running towards the East River ... thousands of them, dropping in like rats. Now the smoke's spreading faster. It's reached Times Square. People trying to run away from it, but it's no use. They're falling like flies. Now the smoke's crossing Sixth Avenue ... Fifth Avenue ... one hundred yards away ... it's fifty feet ...

(BODY FALLS)

OPERATOR FOUR: 2X2L calling CQ ... 2X2L calling CQ ... 2X2L calling CQ ... New York. Isn't there anyone on the air? Isn't there anyone on the air? Isn't there anyone ... 2X2L—(Welles, 1938)

The meta-broadcast then ended with a broken-off transmission and "dead air." As if the 'end of the world' was signified by the 'end of a broadcast', we might interpret this as an artistic acknowledgment that radio broadcasting had become a social institution that serves to create sociable relations in society but can also fall prey to evil forces. This breakdown, then, can symbolically be understood both as a climax to the failed communications in the broadcast and as an anticipation of the end of the "radio broadcast era."

The authenticity scandal has resulted in a variety of interpretations; in the next section I will explore the most prominent theories, and in the subsequent section I will examine the negotiation of authenticity between the producers and the general public.

Interpreting an Authenticity Scandal

The impact of *The War of The Worlds* authenticity scandal on media research and interpretations of mass communication has been prominent. I will divide between three main perspectives on the scandal, founded on, respectively, critical theory, radio theory, and reception studies.

First, the authenticity scandal brought fuel to the fire for critics of mass communication, such as the Frankfurt School. The authenticity scandal was taken as a prototype of what Adorno (1903–1969) defined as the *inauthenticity of broadcast media*; he diagnosed the hysteria caused by the inauthenticity of this radio drama as a "collective sickness" and lamented the episode as clear evidence of the destructive force of the broadcast media:

> The affair of Orson Welles' broadcast "Invasion from Mars" was a test performed by the positivistic spirit to determine its own zone of influence and one which showed that the elimination of the distinction between image and reality has already advanced to the point of a collective sickness. (Adorno, 1991, p. 56)

Mass mediated communication was seen as a threat to "authentic art" and high culture both because of its lack of original quality, and because of its manipulative power to mislead the masses (Adorno, 1964/1973; Benjamin, 1936/1969). *The War of the Worlds* scandal thus provided contemporary critics of mass communication with seemingly hard-hitting empirical evidence for their theories.

Second, the authenticity scandal has been analysed in radio theory studies, but rather than "inauthenticity," the concept "miscommunication" is used to describe confusion caused by radio programs such as *The War of the Worlds*. In this perspective, miscommunication is regarded as a *communicative process* where both the sender and the receiver are responsible for the authenticity scandal:

> It is possible for hearers to misunderstand something which was clearly and accurately expressed. We can assess whether miscommunication has occurred by comparing the propositional content of a message either with what the communicator declares herself to have meant by it, or with what the hearer declares himself to have understood. (Bell, 1991a, pp. 212–213)

The possibility of miscommunication could be seen as one of the characteristics of mass mediated communication, which communicate with mass audiences and engage in an impersonal communicative contract where misunderstanding is unavoidable. Not least the lack of feedback means that the communicator has no way of knowing whether the message has been misunderstood (Winston, 1986; Bell, 1991a; Bell, 1991b; Crisell, 1994). Moreover, fact and fiction might be especially difficult to separate from each other in radio, the medium of imagination, because in radio, everything is imaginary, whether it exists or not (Crisell, 1994, p. 11). The announcements failed because the dramatic sounds in the play itself were vastly more compelling than the brief announcements. Roland Barthes (1977) argued that visual images are polysemous, meaning that they always support several possible interpretations by themselves typically require textual annotation to anchor their meaning (p. 39). Building on this argument, Crisell (1994) claimed, "The ear will believe what it's let to believe" (p. 48). Sounds require textual underpinning as well—that is, support from a dialogue or narrative—because, Crisell argued, they are equally polysemous. In this regard, studio simulations of sounds in radio dramas often appear more real than the actual sounds themselves (McLeish, 1978, p. 252). Such deliberate "manipulation of the ear" for dramatic purposes was widely applied in the production of

The War of the Worlds, and because those sounds were also accompanied by interpretation by the "reporter" the radio listeners were pointed in the direction of investing their credulity in the narrative, rather than interpreting it as fictional.

A third theoretical approach to *The War of the Worlds* is based on reception and psychology studies, and the investigation of how the listeners in fact reacted to the play and why they reacted as they did. In contrast to theatre audiences' collective interpretations, the radio listeners' interpretations were characteristically individual. As we have seen, radio revolutionized the whole notion of the audience by creating one that encompasses different emotional states of mind and thus different modes of listening to the same thing. *The War of the Worlds* was thus mediated through the technological innovations of radio, which infiltrated the domestic space of millions of listeners with entirely individual frames of mind (Douglas, 1999; Hand & Traynor, 2011). This factor explains the varied interpretations of the radio play, which were among the key findings in Cantril's (1940) study *The Invasion From Mars*, a research project that examined audiences' reactions to the radio broadcast of just months before.[6] Cantril identified a correlation between a listener's level of psychological stability and his or her interpretation of the broadcast's authenticity illusions and subsequent reactions. Listeners who were generally nervous and unstable emotionally, obviously, were also likely to be the most horrified by the invasion narrative. Overall, because radio literacy and decoding skills, as well as psychological stability, were not evenly distributed among the listeners, the effect of an experimental radio play such as *The War of the Worlds* was quite unpredictable.

6 The study was based on interviews with listeners about how they were affected by the broadcast, and it clearly indicated that a considerable number of listeners had decoded it as a factual transmission: At least a million listeners across the country were frightened. New Yorkers fled their homes to nearby parks. Families in northern New Jersey ran into the streets, covering their faces with towels for protection from gas they feared the Martians would soon release. Police phone lines were clogged with calls from people so terrified they never thought to ask whether the 'news' was true, but simply how to escape. Across New England, the Midwest, and South, people prayed, wept, and worried about the fate of their loved ones in New Jersey and New York City. (Cantril, 1940, p. vii)

Negotiating Authenticity

A key reason why the radio play became an authenticity scandal rather than an authenticity puzzle was that this possibility of miscommunication was largely overlooked by Orson Welles and the Mercury Theatre producers. Rather than imagining individuals with different frames of reference and varying levels of skill as radio decoders, Welles imagined a picky audience with advanced tastes—people quite similar to himself. This tendency to picture the audience as a reflection of oneself and one's media colleagues is in fact a common finding in studies of news production (Burns, 1977; Schlesinger, 1987), and according to Stuart Hall (1989), those audiences who share similar backgrounds with the media producers are more likely to decode messages in line with the encoder's intentions.

The intention behind Welles's encoding was to compensate for what he feared listeners would interpret as a highly unlikely storyline about an invasion from Mars, and he wanted to avoid making listeners "bored or annoyed at hearing a tale so improbable" (Welles quoted in *New York Times*, 31.10., 1938). Instead, he sought to "convince them," in a sense—to make listeners imagine that Martians really were invading the earth—and he thus exploited all of the techniques at his disposal to create exactly this illusion of authenticity. In response to the authenticity scandal, however, Welles refused to admit that he had badly overestimated his listeners' media literacy or abused their trust via his illusions of authenticity; instead, he always saw the miscommunication as a result of his underestimation of "the extent of our American lunatic fringe" (Nachman, 1998, p. 447). Welles's arguments defended his rights as a radio producer to experiment with genres and to challenge the investigative skills of the listeners, and thus negotiated the authenticity contract and claimed his artistic freedom to break the rules.

The main stakeholders in this negotiation process were, in addition to the producers and the listeners, the press, the police, and the regulators. *The press* termed the incident a "mass panic," and orchestrated a national scandal, which was partly powered by the print media's distrust of radio, as a new competitor both for news distribution and for advertising income. In total, the US press published roughly 12,500 related newspaper articles during the first three weeks after the broadcast (Crisell, 1994; Douglas, 1999; Chapman, 2005). The press coverage included sensationalistic articles such as *The New York Times* cover story "Radio Listeners in Panic, Taking War Drama as Fact" (1938, October 31):

> A wave of mass hysteria seized thousands of radio listeners throughout the nation between 8:15 and 9:30 o'clock last night when a broadcast of a dramatization of

Radio Listeners in Panic, Taking War Drama as Fact

Many Flee Homes to Escape 'Gas Raid From Mars'—Phone Calls Swamp Police at Broadcast of Wells Fantasy

A wave of mass hysteria seized thousands of radio listeners throughout the nation between 8:15 and 9:30 o'clock last night when a broadcast of a dramatization of H. G. Wells's fantasy, "The War of the Worlds," led thousands to believe that an interplanetary conflict had started with invading Martians spreading wide death and destruction in New Jersey and New York.

The broadcast, which disrupted households, interrupted religious services, created traffic jams and clogged communications systems, was made by Orson Welles, who as the radio character, "The Shadow," used to give "the creeps" to countless child listeners. This time at least a score of adults required medical treatment for shock and hysteria.

In Newark, in a single block at Heddon Terrace and Hawthorne Avenue, more than twenty families rushed out of their houses with wet handkerchiefs and towels over their faces to flee from what they believed was to be a gas raid. Some began moving household furniture.

Throughout New York families left their homes, some to flee to near-by parks. Thousands of persons called the police, newspapers and radio stations here and in other cities of the United States and Canada seeking advice on protective measures against the raids.

The program was produced by Mr. Welles and the Mercury Theatre on the Air over station WABC and the Columbia Broadcasting System's coast-to-coast network, from 8 to 9 o'clock.

The radio play, as presented, was to simulate a regular radio program with a "break-in" for the material of the play. The radio listeners, apparently, missed or did not listen to the introduction, which was: "The Columbia Broadcasting System and its affiliated stations present Orson Welles and the Mercury Theatre on the Air in 'The War of the Worlds' by H. G. Wells."

They also failed to associate the program with the newspaper listing of the program, announced as "Today: 8:00-9:00—Play: H. G. Wells's 'War of the Worlds'— WABC." They ignored three additional announcements made during the broadcast emphasizing its fictional nature.

Mr. Welles opened the program with a description of the series of

Continued on Page Four

Reproduced with permission of the copyright owner. Further reproduction prohibited without permission.

Figure 2.1. Radio Listeners in Panic, Taking War Drama as Fact, Many Flee Homes to Escape "Gas Raid from Mars." From *The New York Times*, October 31, 1938. Permission holder: PARS Intl.

H. G. Wells' fantasy *The War of the Worlds* led thousands to believe that an interplanetary conflict had started with invading Martians, spreading wide death and destruction in New Jersey and New York.

The police engaged with the authenticity scandal as a result of stories in the press about people being seriously wounded during their flight from the "Martians," even attributing miscarriages and deaths to the panic. These incidents made the radio play responsible for accidents, and those involved in the broadcast could, in theory, be indirectly charged with crime. As a result, the police approached the production team the day after the brutal story was published, wanting to confiscate the manuscript to avoid any repeated stunts along those lines, but no official charges were ever brought against the producers. Following these crime accusations, the CBS radio company was also hit with several lawsuits totalling $750,000, all of which were settled out of court (Crook, 1999, p. 108). The producers consequently escaped formal punishment, not least because they could argue that there had been announcements in the first part of the play indicating that it was fiction; "The Columbia Broadcasting System and its affiliated stations present Orson Welles and The Mercury Theatre on the Air in 'The War of the Worlds' by H. G. Wells."[7] The problem was that many listeners did not hear these announcements when they were aired, because at the same time, many people had been listening to another, very popular program on a different radio station. Accordingly, many listeners jumped right into the fictional authenticity of the play when they switched stations. The announcements thus served the purpose to counter the charges of any deliberate manipulation of the audience, but not to avoid the misinterpretations.

The regulators responded to the authenticity scandal by implementing new rules and restrictions for the broadcast industry. The main aim of the new rules was to avoid a repetition of the "mass panic" as described by the press, and to reconstruct the public trust in news media. The Federal Communications Commission (FCC) regulatory body labelled Orson Welles a "radio terrorist" and put pressure on the CBS radio company to promise to never

7 CBS explained in a statement that it was not the intention of either the broadcast company or the Mercury Theatre to "mislead anyone, and when it became evident that a part of the audience had been disturbed by the performance, five announcements were read over the network later in the evening to reassure those listeners" ("Radio Listeners in Panic," 1938).

again use the phrase "we interrupt this program" for dramatic effect. As such, specific new regulations for radio forbade "dramatizations of simulated news bulletins" (Douglas, 1999, p. 165). In sum, the negotiation of authenticity in the aftermath of *The War of the Worlds* produced tighter broadcast regulations but also an increased scepticism among listeners.[8]

Broadcasting thus faced a powerful process of negotiation, and the creators of the controversial drama were even thanked by some for reminding the public at the height of the "radio bonanza" about the dangers of radio when miscommunication takes place.

Relating to the book's overarching question about how authenticity is constructed in the media, this chapter has demonstrated that *the genre system* is the fundament of the authenticity contract in the media and that audiences use their genre knowledge to interpret content. The analysis of the burgeoning social practice of radio listening in the early twentieth century found that the new and unexpected use of genre conventions in the fictional play was difficult to interpret, in particular for those who were less familiar with the medium, and who struggled with psychological insecurity. Mass mediated communication faced its first major crisis with the "errant decoding" of *The War of the Worlds*, and the crisis emphasised that even though the technology made it possible to reach the masses as if they were all equal, the individual listeners and their interpretations were yet innumerable and contradictory.

Throughout the next decades, broadcast media evolved and with the introduction of television, the *authenticity contract* between the producers, the audiences, and the public institutions was again vulnerable and under pressure. This new visual turn in broadcasting and its implications for the notion of authenticity will be explored in the next chapter.

8 Many radio listeners "did not believe the announcement of the attack on Pearl Harbor three years later because of the Martian landing hoax" (Nachman, 1998, p. 445).

· 3 ·

MONEY, FRAUD, AND DECEPTION

The Quiz Show Scandals

The American people don't believe anything until they see it on television.
—Richard Nixon

The introduction of TV changed the notion of mediated authenticity. Audio-visual communication was not a completely new phenomenon, as moving pictures had been introduced through the cinema, and the radio had been a forerunner for visual broadcast media. I will thus assume that the authenticity illusions in TV partly built on the pre-existing illusions in radio and film, but also established its own medium-specific authenticity illusions and a unique contract with the viewers.

This chapter will use literature on audio-visual media and theories of broadcasting to investigate how television addressed its audiences and established an *authenticity contract*. As with radio, TV soon became a prominent social institution and key source of information and entertainment, and the viewers developed an intimate relation with the TV personality. In this chapter, I will explore the *authenticity illusions* in television and how reality was constructed in early audio-visual mass media. As in the previous chapter, I will explore an *authenticity scandal* to demonstrate the balance between authenticity illusions and deception.

Structurally, this chapter is divided into two main parts. In the first part, I will discuss the introduction of TV and its audio-visual authenticity. Here I will also engage with the larger societal shift towards a visual culture. In the second part, I will analyse the so-called American quiz show scandals of the late 1950s, when the TV industry was shaken by the news that quiz shows had been rigged. Here I will investigate the negotiations of the authenticity contract between the TV industry and its publics, including public institutions such as the court, the press, and the regulatory bodies.

The Rise of the TV Industry

Television had been shaped by pre-existing media, such as the telephone, the radio, and the cinema, but audio-visual broadcasting was a genuinely new communication form (Barnouw, 1990; Spigel, 1992). By the time TV was launched in the US, broadcasting had earned an "almost irrational loyalty among listeners" (Barnouw, 1990, p. 72), and by 1958, when the quiz show scandals occurred, broadcasting had in fact become quite explicitly commercial; in this context, TV was regarded as a visual wonder for the business of advertising and sponsorship. On the basis of the commercial structure of American radio, the broadcasting industry expected TV to fit in an income model based on sponsorship and the advertisement of consumer products. Still, prior to the launch of TV, there was a congressional debate about the status quo, formed mainly by educators, clergy, and labour leaders, who joined forces in a protest against the growing commercialisation of the airwaves. Among the broadcasters' critics was the copy-writer and journalist James Rorty, who thought of commercial broadcasting as at once a deceiving and powerful stimulus:

> The American apparatus of advertising is something unique in history ... It has taught them how to live, what to be afraid of, what to be proud of, how to be beautiful, how to be loved, how to be envied, how to be successful. (Barnouw, 1990, pp. 74–75)

The commercial broadcasters defended their cultural impact by referring to the existing networks' practise of offering unsold airtime to unsponsored programming, including the news. Echoing these arguments, the Communications Act of 1934 became law without any restrictions on advertising for the purpose of profit, though it continued to generate discussion about how to balance entertainment with enlightenment and education.

The expectations towards television[1] as a new media technology of transmitting live pictures across wide geographical distances included visions of a new world order, and of television as a tool to improve the conditions for the working class. The Russian film director Dziga Vertov (1925/1984) argued that the new medium should be used to implement the ideology of communism rather than providing elitist high-culture:

> In the near future man will be able to broadcast to the entire world the visual and auditory phenomena recorded by the radio-movie-camera ... We will not prepare for the broadcast of operas and dramas. We will prepare wholeheartedly to give the workers of every land the opportunity to see and hear the world in an organized form; to see, hear, and understand each other. (p. 56)

The invention of TV was a result of the work of individual experiments, starting off as hobbies and curiosities; but the technological innovation enabling broadcast TV soon became corporative assets and conflicts over standards. The visions for broadcasting in the USA were as a force in virtually all aspects of society, and it was hoped that it would become a new concert hall, a theatre, a classroom, a podium, and a political arena. These visions propelled the experiments forward, and particularly from the mid 1920s, the experiments began to achieve results; in 1925, John Logie Baird in England and Charles Francis Jenkins in America were able to hold public demonstrations of television. They both built on the innovation by German Paul Nipkow, who, in 1884, devised the "Nipkow-disk." This was a rotating disk with perforations arranged in a spiral pattern, with a beam of light shining through to preform a rapid scanning movement, like the movements of eye back and forth across a printed page. The device was seen as a way of transmitting pictures by wire, in the form of a series of dots of varying intensity. For decades the Nipkow-disk remained the basis for experiments of images (Barnouw, 1990; Herbert, 2004; Briggs & Burke, 2002). These technological innovations led to the official opening of US

[1] A suggested definition of television is the "transmission of a moving picture"—this transmission can happen in several ways, however, including broadcasting, metal wire or laser technology. The main idea behind the TV set arose from the photoconductivity of the element selenium, which was discovered by Willoughby Smith in 1873, but the term television was not used until 1900, in a paper by Constantin Perskyi, read at the 1900 International Electricity Congress (Dienst, 1994, p. 17; Herbert, 2004, p. 4).

television on April 30, 1939, when Franklin D. Roosevelt became the first president to appear on television. As the studio productions included plays, opera excerpts, comedians, and puppets, there were few signs of the idealists' expectations for broadcast media to serve as a tool to democratize the means of media communication, and thus change society. Rather, after the Second World War ended in 1945, and the pace in TV-related activity increased, it became increasingly clear that TV took form as a commercial and highly competitive industry.

In spite of television's visual orientation, radio has, more so than film, been most convincingly described as the "mother of television" (Baughman, 2007, p. 8). Early TV productions were parasitic and generally derived from previous cultural and media forms, and of these, radio was the initial inspiration for TV productions. The technology of television broadcasting was largely interpreted as an audio-visual version of the radio, as demonstrated in the early descriptions of TV as a "radio eye" (Vertov, 1925/1984) or the "broadcast of sight" (Sarnoff, 1936).

Towards the mid-1950s, television programming began to distance itself gradually from radio. In addition to programming, the influence of radio is particularly evident in the institutionalisation and financing of TV in the US; the two dominant television networks in the 1950s, CBS and NBC, were also America's major radio chains, and they brought to television the industrial structure they had first established while operating radio networks and stations since the late 1920s. Radio institutions such as NBC had also been key lobbyists for the introduction of commercial television broadcasting in the US, as the company viewed TV as a new market for advertising sales (Vianello, 1994). In Europe, TV was institutionalized as a part of existing public service broadcasters such as the British BBC, which had a monopoly in radio broadcasting. The idea behind PSB had been to "inform, educate and entertain," and this threefold aim was transferred to television. A key aim in European public service television was to counterweight the entertainment-oriented commercialism that promptly came to characterise US television, and a financial structure based on public funding through state support or a licensing fee was implemented.

In the US, however, the government did not construct a similar system of public financing; instead, the Federal Radio Commission (FRC), which later became the Federal Communications Commission (FCC), decided to launch "super stations," which were legally protected from local interference and which served audiences that were large enough to be attractive to national

advertisers (Vianello, 1994, p. 6). This was rooted in US public officials' intentions to maintain the airwaves "in the public interest," but soon resulted in a situation in which the networks became extremely powerful commercial players. The commercial income model from radio was transferred to television, and in the beginning, advertising through the sponsorship of a particular program was the main source of financial support for US television productions (Barnouw, 1978/2004). Reluctance about investing in the new medium was nevertheless evident, as many advertisers of mass-produced items doubted that television had yet become a mass medium. Instead, they believed that TV ownership had an upper-class association and that television was only a "glamour medium" (Baughman, 2007, p. 195). Around the mid 1950s, however, this class stigma would change, and most national advertisers regarded TV as an irresistible medium for promoting their products.

As television proved to be more and more attractive, advertisers were forced to revisit their exclusive influence over individual programs, because the cost of this exclusivity soon proved too steep for most. Moreover, the sponsors began to involve themselves more directly in the programs in the hopes of guaranteeing their investment, and advertising agencies began to send their own people to supervise television production work and even began interfering with the scripts and with the casting. Agencies were intimately involved with approximately one-third of all network TV shows in the mid-1950s (Baughman, 2007, pp. 185, 202), and they retained the power to influence the storyline and character development in both sitcoms and drama series. For example, the most popular series in the 1950s, *I Love Lucy*, was angled to promote the products of the sponsor, tobacco company Philip Morris, and the lead actors promoted the product as chain smokers (Murray, 2005). The sponsors closely monitored the ratings, as well as the demographics and the habits of the viewers, and adjusted their investments accordingly.

The Birth of a TV Nation

In tandem with the development of television as an industry, which took place as a duel between various economic, political, and democratic interests, a TV audience gradually emerged (Barnouw, 1990; Browne, 1994; Doyle, 2002). As a parallel to the TV industry, the TV audience's reception mode and decoding was based on experiences from listening to radio and watching movies. The radio had become the centre of public communication by the time TV was launched, and had also gained a key hold of the audience as their preferred

source of entertainment, and reduced the attraction of movies and theatres (Douglas, 1999). The attractive novelty of the TV, combined with the new home entertainment culture, thus replaced the role of the movies as the most popular mass medium. Culturally and historically, the replacement of film by television in the 1950s as the dominant form of American mass entertainment signified an important shift in American life.

Early on with movies (as with television), there was a novelty to moving images, although the content of films was simple at first. Early cinema audiences liked themes that had never been shown before inside a theatre, such as the wonders of nature and remote places, rare sights, even machines and fast locomotives (Chapman, 2005, p. 126).

The audiences' first experience with a new medium is of key interest in a study of the negotiated authenticity that takes place particularly in the first phase of a new media phenomenon. In relation to cinema audiences and their early decoding of authenticity, the crown example is the French filmmaker Louis Lumière's *Arrival of a Train* (1896), which displayed a single shot of an approaching train. The audiences mistook the image for a real train, and thus reared back in their seats, and were shocked to a degree that they screamed and fled the auditorium.

This decoding resembles the miscommunication in *The War of the Worlds*, as the audiences were unprepared for the movie's contradiction of the theatre's conventional distance between actor and audience. Also, the miscommunication might be explained by the audiences' familiarity with a real crash at a Paris station that had happened only a few months earlier (Chapman, 2005, p. 126). As such, both of these authenticity scandals might have turned into unfortunate myths of the naïve audiences, and the myths often overlook the historic context of the decoding (Gunning, 1989, p. 5). The myths in turn contribute to keeping alive a mystification of early mass media's power to manipulate minds and emotions.

The TV audience was initially constituted as a group of people in a public place with one thing in common: they were curious to watch television, but did not have access to a private TV set. As a result, crowds of people could be observed in the streets, outside appliance dealerships, aiming to get a glimpse of the moving images through the store window (Marc & Thompson, 2005, p. 52). The first TV sets were very expensive and therefore reserved for the generally well off; thus, the set signalled economic success and the very latest in lifestyle trends, and televisions proved to be a great source of envy. In many countries, such as Norway, the TV signals were gradually

built throughout the country, starting with the cities, and moving on to the more rural areas, as the income from the more populated areas allowed it. This created a geographical envy, and great suspense was expressed in the local newspaper during the waiting phase to be included in the "TV age" (Enli, 2001).

TV was thus interpreted as more than a medium, as it symbolized a cultural shift, which also embodied the larger modernist turn towards consumerism and visual glamour. In the context of post-war optimism, and economic growth, the introduction of television collided with a burgeoning private consumerism. The enormous appeal of television among consumers is evident from the variety of TV-related products, which were branded to be associated with the new habit of watching television, of which the most common were TV dresses, TV slippers, TV coffeepots, and TV dinners, and even a "TV stove," which was advertised for its combined capacity for cooking with a screen for watching television (Spigel, 1992; Enli, 2001). Obviously, the existing media, such as the press, benefitted from the advertisements for TV-related products, but also offered their readers consumer advice on how to enhance the viewing experience, such as how to choose the right TV, where to place the set, and how to adjust the antenna.

The dominating dramaturgy of the constitution of a TV audience was the development from technological fascination, where the capacity to transmit moving images was in itself viewed as spectacular, to a more critical phase where viewers expressed disappointment about the programming (Enli, 2001). As a result, the initial fascination with a new media technology is fairly soon replaced by a more distanced evaluation of the quality and what programming is really worth watching.

Audio-Visual Authenticity

Television's claim to audio-visual authenticity contrasted the "blindness" of the radio, where listeners create pictures in their minds by appealing to their visual imaginations. Television presented the viewers with the pictures as well as the sound, and thus more information was provided to the audiences and there were fewer open spots to be filled by the imagination. TV is supported by visual evidence, and regarded as a more complete representation of reality, compared to radio. Primarily factual genres, such as news, gained increased trust when they were proven by footage, and news anchors authorized the stories with a trustworthy face (Ellis, 2000; Bennett, 2011).

Among the classic concepts in studies of broadcast communication is the metaphor of a "friendship," or even an intimate relationship, between the TV personality and the viewer. The notion of a para-social interaction or relationship arose in the mid-1950s to label a process in which viewers perceive those people who frequently appear on TV in personal terms (Horton & Wohl, 1956). The illusion of face-to-face interaction that is created when people on the screen directly address viewers through eye contact and informal language also perpetuates, more broadly speaking, an illusion of authenticity. Television's claim to authenticity is thus closely related to the TV personality and the "para-social relationships" that the viewers might experience while watching TV. This "para-social relationship" is a result of media-specific characteristics of broadcast media, which also explains how TV builds its authenticity: *ordinariness*, *repetitiveness*, and *liveness*.

Ordinariness

First, TV is a medium recognized by *ordinariness*, in the sense that it's watched in the home and blends into the everyday routines of the viewers without any extraordinary efforts such as going to the theatre or booking tickets. This mundane character is, for example, reflected in a different "gallery of personas"; the cinema is recognized by its extraordinary and glamorous "movie stars," while television has its more girl-next-door "TV-personalities" (Van den Bulck & Enli, 2013). The ordinariness of the TV personalities made many viewers feel attached to the characters, and sometimes they acted as if they mistook the fictional characters for real people.[2] In these early days, people also addressed television actors in public using their show names and/or catchphrases. Although such approaches happen even today, as viewers have became more familiar with the medium, of course, they have probably adopted a more ironic-critical distance, becoming more conscious about the distinction between the TV personality and the real person.

2 When the actress Peggy Wood of the popular show *Mama* appeared on the *Gary Moore Show* and invited questions from the audience, women asked her for advice about raising their families as if she were actually her character rather than an actress playing a role (Lipsitz, 1990, p. 53).

Repetitiveness

A second characteristic of TV's authenticity illusions is *repetitiveness*, in the sense that programming and their fictional characters become more real because their fictional universe is repeatedly established and sustained. Among the emblematic TV genres in the 1950s were "formats borrowed from radio, such as serial formats, sitcoms, variety and game shows" (Browne, 1994, p. 73). In common, these genres have a repetitiveness, which in some formats is created through seriality, in the sense that one episode builds on the former, and prepares for the next, and which in other formats is created through a predictable formula that provides the viewer with the pleasure of recognizing narrative structures and aesthetic elements. As a rule, TV programs are decoded by the viewers not solely as isolated units but also as a part of a "flow" of programming (Williams, 1975/1990), which related to each other as a cumulative text characterised by a high degree of repetitiveness (Hoerschelmann, 2006, p. 35). Weekly episodes of a drama or comedy offered a comforting predictability and in this way strengthened the audience's emotional engagement with the characters. Compared to film spectators, TV viewers have a different "psychic investment in the image," because of its "different definitions of the shot or the sequence, different forms of structure and textual closure" (Elsaesser, 1994, p. 100). As shown in a study of the audience's engagement with the characters in the drama series *Mad Men*, the long-term engagement required of TV viewers might make them more emotionally engaged than filmgoers (Blanchet & Vaage, 2012). As a result, authenticity illusions in television are typically built up and strengthened through repetitiveness, and over a longer time stretch than, for example, movies.

Liveness

As in broadcast radio, the illusion of authenticity in television derives from the phenomenon of its *liveness*, including both the perceived immediacy of its broadcasting and its simulation of a "live transmission" (Scannell, 1996). In the first years of television, this "liveness" was *not* simulated but real; well into the 1950s, television programming consisted mostly of shows that were not taped but aired live, because broadcasting was launched before the technical capacity to produce and transmit recorded material was introduced (Dienst, 1994, p. 22). Of course, these live airings represented a huge challenge for

those actors and actresses who came from the movies and were suddenly asked to perform in "real time"—Fred Astaire, for example, once insisted on 47 takes of a single routine for a movie, so that he could fine-tune his performance. This degree of control was simply not possible in TV, and accidents did happen—actors would fall over, or their clothing would be ripped during an act (Baughman, 2007, p. 155). For audiences, live television offered unfolding and unpredictable audio-visual content and accordingly further increased their sense of immediacy and authenticity.

The authenticity illusions of ordinariness, repetitiveness, and "liveness" made TV a strong force for persuasion of the audience, and, as it turned out, advertisers did get value for their money when investing in TV programming. According to several studies of the 1950s TV industry in the US, advertising generally produced instant sales and enhanced product demand, and people asked for things they had seen on TV. The influence of TV on sales was also proven by the fact that products that were not promoted on TV saw their sales decrease (Barnouw, 1978/2004, p. 46). As a result, TV represented a cultural shift that was characterised not only by its visual alignment but also by its intense devotion to private consumerism.

Among the most profound illustrations of television's new cultural shift was the growth of the TV quiz shows in the 1950s. The quiz shows indeed fuelled the popularity of TV and contributed significantly to the building-up of the audience for commercial TV in the US and Britain in the earliest phase of audio-visual broadcasting. In what follows, I will examine the development of the most popular quiz shows in the 1950s, first by discussing key genre features and its dominant *authenticity illusions*. Second, I will look at the ensuing *authenticity scandal* caused by the revelation of frequently rigged competitions, before I explore the negotiation of the *authenticity contract* that was the final result of the trust crisis involving the 1958 quiz show scandals.

Authenticity Scandal: The Quiz Shows

The following analysis draws on textual analysis of key episodes of *Twenty-One* and *The $64,000 Question*, analysis of legal documents including the transcript of the 'investigation of television quiz shows' hearings, and secondary literature about the quiz show genre and the scandals. The development of quiz shows coincided with the fundamental solidification of commercial broadcasting, as the shows were primarily vehicles for commercial messages. The earliest example of the genre is often identified as *Major Bowes' Original*

Amateur Hour (1935–1945, 1948–1952), a program that originated as a local broadcast in 1935 on NBC. The show spotlighted amateurs coming to New York to present their musical, dramatic, or other talents and embark on a career in show business. Another relevant forerunner of the genre is *Uncle Jim's Question Bee* (1936–1941), which involved a competition for money between contestants, questions on a variety of subjects, the presence of a master of ceremonies, and the integration of the studio audience into the program. Still, genre history can seldom truly confirm or authenticate the pioneering status of a given film, radio program, or TV show. The act of pointing to one radio program as the originator of all quiz shows would reinforce otherwise unfortunate traditional notions of a linear unfolding of history. And, in fact, quiz shows are not necessarily rooted in broadcasting alone but evoke everyday practises outside the media industry as well. Nevertheless, the exertion of institutional power within the industry has motivated many attempts to define and stabilize genre categories, and we do indeed find that genre quiz shows played a key role in the later development of commercial broadcasting.

TV producers embraced the quiz show genre partly because of its ordinariness, repetitiveness, and "liveness." First of all, the quiz show had an ordinariness and everyday appeal that resonated with other aspects of American social life, dealing as it did with issues of central concern to the contemporary culture, such as competitions, success, and general trivia knowledge. The use of studio audiences and ordinary people as contestants supported the illusion of authenticity, and served as a strategy for connecting with the viewers, who could then better identify with the contestants.

Returning contestants in quiz shows was a second factor that increased authenticity, because the repetitiveness gave the programs a serial quality and created a narrative in which the viewers could engage over several weeks. Moreover, the quiz show created repetitive, ritual performances that acted to consolidate television as a regular and predictable part of viewers' daily or weekly routines. For the producers, seriality meant predictability and standardisation, which in turn made series production less costly than stand-alone productions; for the viewers, seriality enabled the establishment of a relationship with these TV personalities, as hosts, actors, or contestants. The cumulative effect of what has been termed "para-social relationship" (Horton & Wohl, 1956), referring to a simulated mutual relation between two people, because of the "intimacy at a distance" created by TV, was that viewers felt they "knew" the contestants and engaged personally with their winning and losing on the TV screen. This effect depended to a degree upon the presence

of a human face and body, which simulated face-to-face interactions and was thus comparatively stronger in the TV versions of the quiz shows than in the radio versions.

Third, "liveness" contributed to the quiz show's attraction and even suspense, because no one knew what would happen. The live transmission did not imply a totally unpredictable programme, because the production team scripted these shows in advance in order to make them entertaining and as flawless as possible. The only elements in quiz shows that are not preordained are the actual winners of a given individual program and their success at securing the available prize. In the next section, I will investigate how the quiz show genre used *authenticity illusions* to increase its audience appeal by highlighting the features of ordinariness, repetitiveness, and liveness through particular visual effects.

The Big Money Quiz Shows

The production of the big money quiz shows was influenced by political and legal factors such as the US Supreme Court, which in a 1954 ruling gave the impetus for the development of a new type of quiz show by settling a dispute over the legality of jackpot quizzes—the judges decided that they were not a form of gambling and were therefore legal. Producer Louis G. Cowan, in cooperation with the Revlon Corporation, developed the idea for a new quiz show based on the radio quiz show *Take It or Leave It* (1940–1947). The result was *The $64,000 Question* (1955–1958), which premiered on June 7, 1955. Analysing the format's migration from radio to TV makes it possible to identify the implementation of visual authenticity illusions.

The TV version was considerably more spectacular, commercial, and dramatic. TV quiz shows, first of all, raised the genre's prizes to a spectacular new level and changed the style and format of quiz shows dramatically. In adapting the quiz show genre to TV, the producers were concerned with the risk of its fundamental question-and-answer sequences being better suited to verbal rather than visual mediation, and thus sought ways to enhance the visual appeal of the genre (Holmes, 2008, p. 40). An example of how the TV version was made more spectacular was the increased scale of winnings. Instead of $64 or $100, as in the radio version, contestants could win up to $64,000. To keep big-money shows attractive, the prize money was constantly increased, and it even became unlimited on several shows (Barnouw, 1978/2004, p. 42). The aesthetic technique here involved the

visualization of prizes, which increased the genre's function as a vehicle for commercial messages.

Dramatic visual effects were created by neon lights, isolation booths, and bank guards, as if to underline the seriousness of the competition. There were moreover no multiple answers to the questions on television, and scholars were hired as judges to demonstrate the significance of the competition. A ceremonial atmosphere was created during the high-stakes questions; the studio was darkened and a spot was directed at the contestant. These dramatic effects were intended to inspire audiences' emotional investments through identification with the contestants as they struggled to find the right answers, and they made close-up shots of the contestants' bodily reactions—such as sweat, blinking, and lip biting—into a primary attraction of the show (Lury, 2005, pp. 16–17). This close-up aesthetic made the quiz show more spectacular through personalization and intimacy. Consequently, the big-money quiz show made ordinary people into celebrities and was thus a forerunner for the reality TV trend in current television.

Authenticity Illusions in the Quiz Shows

In spite of its enormous popularity, however, the TV quiz show genre was only a short-lived success. Both *The $64,000 Question* and *Twenty-One* (1956–1958) were taken off the air by the end of 1958, following revelations of rigged quizzes that became known as the "quiz show scandals." The scandals were also forerunners for more recent revelations of manipulated audience participation and staged performances. For the first time in the history of TV, it was revealed to the public that the seemingly authentic performances of ordinary people had been seriously manipulated.

The commercial logic of the current TV industry is thus neither particularly novel nor a result of digitalization or new market structures. Already in the 1950s, the TV industry in the US was profoundly profit-oriented, and the aim to produce programs that attracted mass audiences, and in turn sponsors and advertisers, was a result of an overarching search for profit. For example, the president of NBC at the time, Robert E. Kintner, was quick to surrender to sponsors and independent producers the initiative in creating and producing his network's programs, as a strategy to increase the company's profits. The interests of the sponsors came to supersede the interests of NBC as a responsible and trustworthy institution. In the production of the quiz shows, the sponsors' influence resulted in manipulated competitions, because only

that made it possible to ensure that the most popular contestants would stay in the show and continue to generate profits. In practise, the producers met with the favoured contestants before the live show, and gave them the questions, as well as the correct answers, in advance. That way, they could manipulate the outcome of the seemingly fair and honest competition.

Even though manipulated competition was the rule rather than the exception at this time, the lasting symbol of the quiz show scandals was the rise and fall of the successful contestant in *Twenty-One*, Charles Van Doren (Holmes, 2008; Hoerschelmann, 2006; Baughman, 2007). The story of Van Doren is fascinating because he was cast as the intelligent "boy next door" and was embraced by the audience as a contestant they identified with and whom they wanted to win. The story has become one of the most memorable episodes in US television history, not least thanks to the movie *Quiz Show* (1994), a fictional film based on the true story of a loved and admired quiz show contestant who turned out to be a fraud and disappointed an entire nation. The most famous episode of the format *Twenty-One* was aired November 28, 1956 and is popularly referred to as 'the Herb Stempel episode'. In this episode, the new contestant, Charles Van Doren, challenged the incumbent champion Herbert Stempel and it turned out to be a highly dramatic and very tight race for the biggest prize ever won in the quiz show. The outcome of the episode was that Stempel was in the end defeated by the challenger, Van Doren. Stempel, the incumbent champion, had an image as a "working-class nerd" because of his eccentric appearance and his impressive knowledge, and initially, the producers had believed this image to be a successful formula. However, the ratings declined, and the producers were under pressure from the sponsors to improve them, so the necessity to replace Stempel with a more appealing winner seemed unavoidable. The replacement of the "working-class nerd" with the more telegenic intellectual came as a consequence of declining ratings, and pressure from *Twenty-One's* sponsor Geritol to "take any measures" to make the show popular and successful (Anderson, 1978; Venanzi, 1997).

The casting of Charles Van Doren as the new quiz show champion resembles the casting practices in fictional TV series or movies. Fairness in the competition was subordinated to the profit-oriented search for the most popular TV personality, and both the new and the former champion were cast in stereotyped roles. Stempel was cast as the ordinary working-class man, with limited education but a phenomenal recall, but he lacked telegenic charm and seemed odd, with ill-fitting clothes and an unflattering haircut. A completely opposite stereotype, Van Doren performed the role of an intellectual hero, educated at prestigious schools and working at Columbia University, but also a charming

and handsome young man (Real, 1996; Baughman, 2007). These roles were, of course, not entirely invented by the TV producers, but were enhanced versions of their actual life stories and personalities. Stempel was, for example, instructed to wear unsophisticated cheap-looking clothes, as if to underline that he was an ordinary working-class man with an extraordinarily good memory.

In retrospect, neither the extraordinary qualities of the "working-class nerd" nor those of the "boy next door" were genuine, as they were given the correct answers in advance and also coached to appear insecure, for example by letting their hands shake, and to "explicitly pause before some answers, skip parts and return to them, hesitate, build up suspense" (Barnouw, 1990, p. 245). As shown in Figure 3.1., Charles Van Doren used body language and facial expressions as a strategy to underline his insecurity when answering the questions. This way his performance produced authenticity illusions. Likewise, the host had introduced the contestants and the rules of the game with

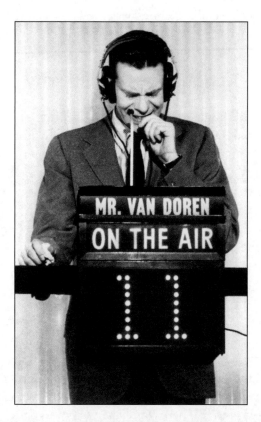

Figure 3.1. Charles Van Doren on the air. The quiz show contestant Van Doren was later found guilty of fraud in the so-called "quiz show scandal." Permission holder: All Over Press.

an authority intended to convince the audience about the fairness of the quiz show: "Neither player inside the studios can hear anything before I turn their studios on with switches I have right here in front of me (pointing to the switches). Nor can they see anyone in the television studio audience because of the way the lights are constructed" (*Twenty-One*, 28.11.1956). What the host did not communicate to the audience, was that the quiz show was rigged, and that Stempel was instructed by the producers to deliberately give the wrong answer to a high-stake question, and in turn, lose to Van Doren.

Although highly manipulative, the introduction of a new, impressive game show champion turned out to serve its purpose by increasing the show's popularity, and thus an intensified demand for TV sets across the US. Consequently, Charles Van Doren became a national celebrity and a symbol of the quiz show success. His popularity became so great, in fact, that NBC signed him to a contract to appear regularly on *The Today Show*, and he was well on his way to becoming an emblematic TV personality. Moreover, Charles Van Doren's celebrity status was crowned with his appearance on the cover of *Time* magazine on 11 February 1957.

Negotiating Authenticity

The authenticity illusions extended beyond scripting of performances and production techniques to enhance dramaturgy, and included actions of fraud and even crime. The inauthenticity of the game shows was revealed gradually, and it took a time-consuming process to uncover the fraudulent TV production. The revelations started as sporadic rumours among the viewers who wondered whether the game shows were rigged and thought that Van Doren's repeated victories seemed unlikely at best. The rumours were made public in 1957 when *Time* magazine, in the article "Are TV Quizzes Fixed?" speculated about show manipulation and claimed that contestants were only asked questions that the producers knew they could answer correctly (Anderson, 1978, p. 88).

A key source in the revelations was the former quiz show champion, Stempel, not without bitterness after his summary replacement by Van Doren, who approached several newspapers with his personal testimony about the rigged shows. However, the public trust in broadcasting remained high at this time and the show was highly popular among readers, so every newspaper refused to publish the story. The TV hero Van Doren was thus partly protected by his popularity and media exposure.

Yet once the rumours had started, people in the justice system started a legal enquiry; the New York District Attorney initiated an investigation, which included interviews with 150 witnesses over a period of nearly a year, and produced a trial before the New York grand jury in 1958 (Barnouw, 1990). In October and November 1959, the House Commerce Committee also held hearings on the big money quiz shows. A key witness here was former contestant Herbert Stempel, who stated that the producers were given private bonuses from the sponsors if they manipulated the show to secure ratings. Accordingly, it took a congressional investigation to convince the public that they were being lied to by TV (Marc & Thompson, 2005; Holmes, 2008). In turn, the authenticity scandal changed the relationship between the public and television as a new social institution.

First of all, the scandal removed Charles Van Doren from his pedestal, as he was forced to admit to fraud, and thus destroyed the largest and most influential celebrity created by TV. The darker side of the parasocial relationship between the TV personality and the audience thus came into play, as the viewers were disappointed to know their hero was a fake. For Van Doren personally, the cost of the trial was tremendous, as he lost all his engagements at the TV company and was fired from his job as a lecturer at Columbia University on the very day he testified before Congress. The story thus encompassed the rise and fall of the first "TV-made personality" in the US.

The many letters that NBC and especially Charles Van Doren received after the scandal expressed a deep disappointment in television's dishonesty. Many were written by ordinary people, among them schoolchildren who had identified with Van Doren and been inspired to study by watching his triumphs in the show. After all, the quiz show trial had attracted enormous attention—about 90 percent of the American people followed the congressional hearings, which culminated in the quiz hero's confession (Boddy, 1990; Baughman, 2007).

In his testimony, Charles Van Doren apologized to the viewers in a personal and emotional statement, in which he defined the viewers as his friends and expressed a deep affection for the people who had believed in him, written him letters, and supported him. Although humble, Van Doren explained the fraud by "the trappings of modern publicity," which referred to the novelty of TV and that he had been misled by the privileged celebrity status:

> I would give almost everything I have to reverse the course of my life the last three years ... I was involved, deeply involved in a deception ... I have deceived my friends, and I had millions of them. Whatever their feelings for me now, my affection

> for them is stronger today than ever before. I am making this statement because of them. I hope that my being here will serve them well and lastingly …
>
> But from an unknown college instructor I became a celebrity. I received thousands of letters and dozens of requests to make speeches, appear in movies, and so forth—in short, all the trappings of modern publicity … These letters and all they stood for were like a vast weight. I could not bear to betray that faith and hope. ("Testimony of Charles Van Doren," 1959)

The novelty of the medium was also a factor when Charles Van Doren, in his testimony, blamed the producers for misleading him to believe that the fraud they asked him to partake in was an accepted practise in TV:

> Producer Albert Freedman told me that I would not have a chance to defeat Herbert Stempel because he was too knowledgeable. He also told me that the show was merely entertainment and that giving help to quiz contestants was common practise and merely a part of show business. ("Testimony of Charles Van Doren," 1959)

This quote demonstrates that the definition of game shows as "merely entertainment" and "show business" was used to justify the deceptive TV productions. Yet, as the trial showed, TV entertainment was not an unregulated arena where producers could manipulate productions in order to maximize profit.

The trial demonstrated that television entertainment was indeed a serious matter, and reactions to quiz show scandals came from the White House and elite intellectuals, as well as ordinary viewers. President Eisenhower characterised the scandals as a deceptive misuse of public trust, and called the incident "a terrible thing to do to the American people"—a remarkable indictment of TV's betrayal of the public trust that it had gained as a popular mass medium (Barnouw, 1990, p. 247). Similar reactions came from elite intellectuals such as the prominent newspaper columnist Walter Lippmann, who, on the basis of the scandal, argued that the US commercial TV industry had proven itself unworthy of the huge responsibility related to running an institution as influential and powerful as television broadcasting. Lippmann even went so far as to advocate for the commercial networks' replacement with some American equivalent of the British public service broadcaster BBC (Baughman, 2007, p. 298).

In line with this, European countries used the quiz show scandal as evidence in a rhetorical defence of the regulation of TV in public broadcasting, and the reluctance to import commercial formats without adjusting to the ethos of PSB (Bastiansen & Dahl, 2008; Enli, Moe, Sundet, & Syvertsen, 2013). The big-money quiz shows were particularly held up to

be an abhorrent image of what was undesirable on TV, and in Norway, for example, the genre was even used in arguments against introducing television at all—it was seen as a symbol of "Americanization," which referred to an ignorance of public service values.

At a regulatory level, the quiz show scandals resulted in a new critical review of television and its role in society. At the 1961 convention of the National Association of Broadcasters, the chairman of the Federal Communication Commission (FCC) characterized TV programs as a "vast wasteland," while advocating for more programming that was influenced by public interest and less by the demands of commercial entertainment. In this so-called "Wasteland Speech," Newton N. Minow argued that TV manipulates viewers, and offers disruptive content:

> I invite you to sit down in front of your television set when your station goes on the air and stay there without a book, magazine, newspaper, profit and loss sheet or rating book to distract you—and keep your eyes glued to that set until your station signs off. I can assure you that you will observe a vast wasteland. You will see a procession of game shows, violence, audience participation shows, formula comedies about totally unbelievable families, blood and thunder, mayhem, violence, sadism, murder, western badmen [sic], western good men, private eyes, gangsters, more violence, and cartoons. (Barnouw, 1970, pp. 197–198)

This critique against television damaged first and foremost the reputation of the TV medium and the quiz show genre (Mittell, 2004; Marc & Thompson, 2005; Boddy, 1990; Hoerschelmann, 2006). In spite of a few symbolic dismissals of TV executives,[3] most of the producers and executives in the TV industry immediately divorced themselves from all responsibility, and many of the producers and executives responsible avoided jail or financial penalty. Instead, the scandals "nearly killed the entire genre"; the major TV networks all cancelled their scheduled big-money quiz shows and were, in general, hesitant to re-launch the genre for decades, except in cheap daytime versions. When the American TV industry finally sought to reshape the genre, it was empowered by a strategy of rebranding "quiz" shows as "game" shows.[4]

3 For example, the creator of *The $64,000 Question*, Louis G. Cowan, who had been promoted to the president of CBS television solely on the basis of the game show's success, was fired as a result of the quiz show scandals.

4 After 40 years in exile from primetime, ABC finally deemed the prisoner to have been rehabilitated in the cable era with its evening placement of *Who Wants to Be a Millionaire* in 1999 (Marc & Thompson, 2005, p. 71).

The criticism was implemented in regulatory change and re-examination of cultural values in the US. Rigging of quiz shows was actually not forbidden at the time, and it also lacked a clear victim, so the TV producers and executives prosecuted were not convicted of television fraud but of lying to a grand jury. After the scandal, however, Congress passed a law prohibiting the fixing of quiz shows, and the regulators imposed restrictions on the prizes as well. The US bill that was finally passed in 1969, declaring it illegal to run a game or contest on television with intent to deceive, was also an indirect result of the scandals (Anderson, 1978; DeLong, 1991). This sudden necessity to regulate demonstrates that the rapid growth of television had outpaced the development of a regulatory framework for it.

The networks' counter-strategy to the failure of the quiz show genre was, first of all, to move towards full control over schedules; instead of letting the sponsors decide what to produce, the networks would do the scheduling and let sponsors know what was available (Barnouw, 1978/2004, p. 57). Second, the TV-industry took self-regulatory actions, such as when the CBC chief executive in 1959 decreed that everything on CBS must be "what it portrays to be," even ordering that canned laughter and applause should be identified as such.

A third strategy to restore the TV's reputation was to cancel all big-prize quiz shows and replace them with episodic films from Hollywood, documentaries, and news programming, including the political debates; in 1960, for example, the networks dedicated much of their airing time to the presidential campaign, and even agreed to televise four one-hour debates between the major party candidates for president. These debates netted generally positive reviews, and only a year after the quiz show hearings, the networks had partly rebuilt their image and countered the worst criticism (Baughman, 2007, p. 299). Rather than being associated mainly with game show scandals, TV became increasingly associated with the debates between Kennedy and Nixon, and to what degree these influenced the election outcome because Kennedy appeared more attractive and trustworthy on-screen than his opponent. The power of TV was again debated, but in another light, and within the frames of a "public service image" rather than a "pure entertainment" image.

The next chapter will further examine how performances of ordinary people as authenticity illusions have developed in TV, by taking the more recent phenomenon of reality TV as an example, and also exploring the transition from ordinariness and celebrity.

· 4 ·

ORDINARINESS AS AUTHENTICITY

The Reality TV Genre

In the future, everyone will be world-famous for 15 minutes.
—Andy Warhol, 1968

The reality TV genre claims authenticity and is often used as a point of reference in critical debates about manipulated reality in contemporary media. Compared to the 1950s, when Charles Van Doren became a celebrity through his participation in game shows, TV from the 2000s has become a celebrity factory and an arena when Andy Warhol's cliché phrase about everyone's "15 minutes of fame" has become a key business formula.

This "participatory turn" in broadcast television is partly a response to the interactivity offered by the web, but also to an increasingly exhibitionist culture, and accordingly, broadcast media increasingly serve their publics as players and participants as well as citizens and consumers (Syvertsen, 2004; Enli, 2008). As reality TV has grown into one of the most dominating trends in contemporary TV, ordinary people have to a degree replaced actors and scripted reality has to a degree replaced fiction. This chapter explores the authenticity illusions in reality TV, and how authenticity puzzles are an essential part of the hybrid genre.

This chapter has three main parts. The first investigates the genre of reality TV, its origins, and its implications for the TV industry and celebrity

culture. The second part presents the case study, in which I explore the reality-TV participant Susan Boyle, and the construction of an authenticity icon. Lastly, the chapter will discuss how authenticity is negotiated between producers and audiences in reality TV, and in mediations of ordinariness as authentic.

The Rise of Reality TV

The origins of reality TV are manifold and complex, and its claim to authenticity is contradictory. On the one hand, reality TV promises a direct access to "the real" by using surveillance cameras and cultivating a "fly-on-the-wall" style as if representing reality without any kind of intervention. On the other hand, the genre is scripted and crafted to have a dramaturgical appeal in line with soap operas and drama series, with storylines and main action planned in advance, and the participants cast as if they were actors. Reality TV is a hybrid genre, and this genre-mixing and innovative combinations of existing conventions constitute its most successful production strategy (Mittell, 2004, p. 197). The combination of genre conventions known in documentary as well as fictional genres such as drama and soap opera makes reality TV a genre of *authenticity puzzles* among its main attraction, because the viewers are constantly intrigued by the duality between reality and fiction in the production.

To further explore the distinction between factual and fictional authenticity, I will in the following discuss the main genre features of the documentary, and explore the historic development of the genre as a forerunner for contemporary reality TV. First of all, each cultural era in the past century of moving images has its own privileged style for the delivery of visual content, which reflects the era's cultural, economical, and political contexts. It is common to see the manipulation of reality for the purpose of TV as a fairly new phenomenon, and to believe that the documentary tradition reported more objectively on reality. To a degree this is correct, but studies of the first phase of the documentary found that made-up scenes, faked natural settings, and various other reconstructions to imply authenticity were common practises. This is related to the fact that the documentarist makes endless choices, such as selecting "topics, people, vistas, angles, lenses, juxtapositions, sounds, words." The film is thus an expression of "his point of view, whether he is aware of it or not, whether he acknowledges it or not" (Barnouw, 1983, p. 313). Some of these choices were pragmatic, such as the filming of volcanic eruptions or lions in jungles in simulated environments in order to reduce

the travelling costs and to avoid the dangers of acquiring this footage. Instead, such scenes were created from whatever was available, so while the film *Hunting Big Game* was meant to represent Theodore Roosevelt on an actual African hunting trip in 1907, it was in fact filmed in a Chicago studio jungle and performed by a Roosevelt look-alike and local black men dressed up as native porters (Barnouw, 1983, p. 26). These authenticity illusions were used to reduce costs and to attract audiences, which is fairly compatible with the reasons why reality TV became a popular genre from the mid-1990s. In 2008, a century later, for example, it was revealed that a reality TV show had used faked scenic elements, such as a pond or small waterfall, to make it seem like the participants were in the wilderness while they were in a highly controlled production environment.[1]

Ordinariness and Authenticity

A second heritage from the history of the documentary film is the preference for *ordinariness*, and for people in their everyday life settings. In the 1930s, film director John Grierson (1898–1972) led a movement that politicized the documentary genre by changing its narrative style in favour of formal, constructed, and poetic portrayals of everyday life. Grierson's documentaries were generally characterised by their use of a commentator or narrator, but the film *Housing Problems* (1935), sponsored by the Gas Light and Coke Company, used a particularly novel technique: the direct testimony. Here, slum-dwellers appeared as spokespeople and addressed the camera directly as they provided a guided tour of their neighbourhood. This use of real-life representatives clearly influenced television's later portrayals of reality.

The filming of ordinary people in their everyday life required small and transportable equipment. The ability to move the television camera out into the streets and to film people outside the studio, for example, paved the way for the candid camera formats, a new development in reality-based programming. The most influential format in this genre is *Candid Camera*[2] (1948–2004), the practical joke entertainment show based on stunts in which the production team confronted people with bizarre situations that were filmed by unseen

1 The show *I'm a Celebrity…Get Me Out of Here!* has been accused of manipulating the show to seem more dangerous for the contestants than it in fact was (snatcher 73, 2008).
2 The format was an adaptation of *Candid Microphone* (ABC Radio, 1947–48).

cameras. This documentary method was also used by academics such as anthropologist Jean Rouch to study people's responses to unexpected situations (Barnouw, 1983, p. 312). The TV series was an instant success, as audiences enjoyed the way people were caught on camera while they expressed spontaneous reactions to unexpected and partly bizarre incidents.[3] The fact that no one seemed to expect it increased the comic effect; today, of course, it is much harder to trick people into investing themselves in comic situations without any suspicions being raised about a camera hidden somewhere. For this reason, the genre has become increasingly staged; producers of *Totally Hidden Video* (Fox, 1989–1996) have, for example, admitted to using paid actors, while *Punk'd* (MTV, 2002–) uses celebrities in the pranks, and requires extensive pre-planning to manoeuvre "the victims" into settings where cameras can capture their genuine reactions. A parallel development is seen in contemporary reality TV production; for example, while the participants in the first seasons of *Big Brother* or *Survivor* were fairly unprepared for what to expect in the house or on the island, participants in the subsequent seasons were more aware of the producers' preferred scenes and how to behave to gain "camera time." Ordinariness is thus increasingly crafted, both by the producers and the participants.

In addition to light equipment, early portrayals of ordinariness in reality TV production required people who were willing to share intimate stories and to confess before a national audience. Studies have shown that audience participation in contemporary TV is primarily motivated by excitement and public attention, and that being on TV is no longer exclusive, but has become a familiar activity; in many Western countries it is more common for people to have been on TV than not (Priest, 1994; Bonner, 2003; Turner, 2004).

Early confessional formats typically offered the participants more instant rewards in return for the confessions, such as the refrigerators, bedroom sets, bicycles, and washing machines that winners were provided in the show *Queen for a Day* (NBC/ABC, 1956–1964). This highly popular show's formula was that producers would choose four or five women from a studio audience of up to 800 to be contestants; they would then get a chance to tell their often sad or even tragic life stories and describe the one product that would ameliorate things for them. The studio audience would determine the winner of the given product via an "applause meter"; the main criterion for winning was the most

3 It was quite an achievement to capture unsuspecting people in somewhat awkward situations, especially in early television, with cumbersome equipment, prominent lighting, and hidden microphones (Roman, 2005, p. 173).

compelling story of woe. That *Queen for a Day* described itself as the "Cinderella show" highlights the cultural role of the American Dream and its attendant fantasy about a more glamorous life. However, for the contestants, the long-term makeover effect of *Queen for a Day* did not exist, as the producers' interests in these stories of need vanished when the camera was turned off (Roman, 2005; Watts, 2006). The show's emphasis on consumption as an instant remedy for life challenges, and thus commercialisation of confessions, demonstrates that ethical dilemmas related to the exploitation of the contestants have been a central element in television's portrayals of ordinariness from the very beginning.

Cinéma vérité—Truthful Cinema

Cinéma vérité is translated from the Russian *kino-pravda*, meaning "film-truth" or "truthful cinema," and is related to, but different from, direct cinema:[4] "The direct cinema artist played the role of uninvolved bystander; the *cinéma vérité* artist espoused that of provocateur" (Barnouw, 1983, p. 255). The role as the provocateur means that the aim to film "the truth" requires not only a fly-on-the-wall perspective but also a more active provocation of certain scenes. The cinéma vérité movement aimed to capture reality as raw, brutal, and unpleasant as it sometimes is, without the glossy effects of commercial mass media. As such, the movement was a mismatch with commercial TV because the unflattering and unappealing scenes could prove to be too repulsive for the mass audience. Public television was more tolerant of the documentary genre than commercial television, and what is now understood to be a prominent forerunner of reality TV was the documentary *An American Family*, which debuted on US public television in 1973. The series emphasised unscripted action captured with portable equipment and was intended to be a different, but related television version of cinéma vérité. *An American Family* was produced by a camera crew who followed the lives of the Loud family of Santa Barbara, California—Bill, Pat, and their five children—for seven months (Roman, 2005, p. 173). The camera captured many intimate scenes, including conflicts between family members and confessions about controversial subjects of the time such as homosexuality and divorce. The series became widely popular, thanks to its exposure of previously hidden subjects and taboos, but it was also soon criticised

4 Towards the end of the 1960s, a new wave of "direct cinema" arose around documentaries such as *Salesmen* (1969).

for its manipulation of the family members. The directors did not simply observe but interacted with the family and influenced their actions in front of the camera, highlighting a dilemma related to the documentary that remains true of current reality TV as well: its producers influence the "reality" they capture on camera. *An American Family* changed the definition of documentary by moving the camera into the private zone of the family, and it pioneered the contemporary phenomenon of docusoaps. Indeed, the 1970s debate about how the personal life of the Loud family was affected by the TV cameras in their homes and the exposure of their personal problems foreshadowed current reality TV where the participants are highly manipulated to perform specific roles.

More so than reality TV perhaps, the contemporary equivalent to cinéma vérité are media productions using, for example, grainy footage, under-lit settings, and unsteady filming to create authenticity illusions. For example, the Danish dogme films and the low-budget US movie *The Blair Witch Project* (1999)[5] were filmed with these seemingly documentary methods, and thereby claimed authenticity as more truthful mediation of reality than, for example, Hollywood movies. Reality TV, however, differs from cinéma vérité, for example, in its lack of political or ideological motives for exposing the truth underneath the surface, as reality TV is a genre that is highly compatible with the logics of commercial TV. The greatest contribution to the contemporary focus on real-life material is nevertheless to be found in television, and this trend's main representative is reality TV.

Reality TV as a Cultural Shift

Since the late 1990s reality TV has dominated television programming and has affected almost every TV genre in one way or another (Dovey, 2001; Jenkins, 2006a).[6] The current popularized hybrid reality TV genre originated

[5] The dogme concept originated in Denmark in the mid-1990s, and was fronted by the film makers Lars von Trier and Thomas Vinterberg. The first and most renowned dogme films are *The Celebration* [Festen] (Vinterberg, 1998); *The Idiots* [Idiotene] (Von Trier, 1998); and *Mifune's Last Song* [Mifunes Siste Sang] (Kragh-Jacobsen, 1999). In the "Dogme 95 Manifesto" and the accompanying "Vow of Chastity," the Dogme 95 Collective stated that shooting must be done on location, that extra-diegetic sound and artificial lighting were prohibited, and that one should use a handheld camera only, as well as a number of other rules ("Aspects of Dogma," 2000, December).

[6] It has also borrowed from all of those genres as well—reality TV draws upon features from game shows, soap operas, dating shows, crime drama, talent shows, travel programs, and sports broadcasts.

with *The Real World* (1992–), a series that established a number of editing and shooting conventions that mingled serial narrative, cinéma vérité style, and first-person confessional segments. An overall aim was to downplay the constructed nature of the program and to claim an uncensored access to "the real," not least by making the apparatus of production as invisible as possible. Reality TV became an instantly popular genre and soon came to dominate TV schedules around the world as it connected with *technological changes* such as digitalisation and convergence, a *cultural change* towards participation and interactivity, and an *economic change* in the TV industry, where low-cost productions were sought after by the increasing number of commercial TV stations. The widespread popularity of reality TV might be interpreted as a result of an appeal to authenticity that arose alongside the widely acknowledged triumph of simulation and spectacle, as if the media-saturated culture has produced a greater need than ever before for authentic images.

Reality TV represented a cultural shift in many ways, and has influenced society in multiple ways. One of the most eye-catching is the way confessional culture and ordinariness has become an increasingly important element in political communication. The term confessional culture refers to how intimate talk about private affairs is regularly witnessed by TV viewers. Key forerunners of reality TV are the confessional talk shows, and their focus on exposure of emotional reactions and confrontations. Bill Clinton is commonly referred to as the first US president who participated in a talk show when in 1992 he played the saxophone on the late-night talk show *Arsenio Hall*, but it was his confession on *The Oprah Winfrey Show* that gave him the handle "The Therapeutic President" (Peck, 2008).[7] Clinton spent much of their interview explaining his affair with Monica Lewinsky[8] through the narrative of a

7 Clinton's association with Oprah Winfrey dated back to his first inauguration, and she had even initiated legislation during his presidency, which came to be known as the "Oprah Bill" (the National Child Protection Act, signed in 1993). And during Bill Clinton's appearance on the show in 2004, Oprah's first question to him was why she had not been mentioned in his autobiography *My Life* (2004).
8 President Bill Clinton made what is perhaps the most infamous confession of sexual impropriety by a US politician in history. In January 1998, soon after reports surfaced that he had pursued an affair with White House intern Monica Lewinsky, he emphatically said, "I did not have sexual relations with that woman." By August, as a congressional investigation was grilling Lewinsky and she turned over a DNA-stained dress, Clinton made a televised address to the nation and admitted to an "improper physical relationship" with her. The House of Representatives voted to impeach the president for perjury, but he was subsequently acquitted (see Goldman, 2013).

childhood trauma, its negative effects on his sense of self-worth, and his marriage—and the liberation he had found through therapy (*The Oprah Winfrey Show*, 2004, June 22). Midway through the show, Oprah asked whether his wife had forgiven him. Clinton replied: "She forgave me long before I forgave myself." Apparently fighting back tears, he fell silent—as did the studio audience—before Winfrey cut to commercial. Such moments, which make visible the precise moment when a person is letting go of something, of surrendering the body and its "animal" emotions, constitute the "money shots" of talk shows (Grindstaff, 2002, p. 20). The talk show confession is believed to have had a positive effect on the politician's image because it was undertaken through free will, and not forced upon him; the televised confession is valued because it demonstrates an idealised view of the human self as independent, and with a defined autonomous integrity (Bauer, 2008, p. 174). Thus, the scene demonstrated how authenticity illusions create a powerful alliance between the TV show and the participants, which empowers them both. In the next section, I will investigate this alliance in more detail, by focusing on the performances of celebrities who struggle with instability, addiction, and illness in the context of reality TV.

Celebrity and Ordinariness

Critique of the mass media and popular culture's inauthenticity or constructedness largely refers to celebrity as a key example, and argues that celebrities are fabricated for the media and evaluated in terms of the scale and effectiveness of their visibility (Boorstin, 1961; Franklin, 1999). In the age of reality TV this fabrication of celebrities by and for the media is particularly evident, and the shared interest between celebrities and the media perhaps most evident in the subgenre docusoap. The celebrity docusoap started off with *The Simple Life*, which featured Paris Hilton and Nicole Ritchie (Fox, 2003–2005); *The Osbournes*, with the family of decrepit rock star Ozzy Osbourne (MTV, 2003–2005); and *The Newlyweds*, with pop singer Jessica Simpson and her then-husband Nick Lachey (MTV, 2003–2005). The exchange logic that enables these formats is that celebrities offer the media access to their everyday life in exchange for visibility, exposure, and in some cases, renewed popularity.

The ethical dilemma of this logic is, however, also apparent, and can be illustrated by three celebrity docusoaps and how they exploit human weakness and despair to create illusions of authenticity. The first example is *The Anna Nicole Show* (2002–2003), which featured former model and *Playboy*

playmate Anna Nicole Smith, who exposed her problems with weight gain, her declining career, and her problematic family relations. Smith died mysteriously four years after the show was aired in the US, in 2007. The second show featured Whitney Houston (*Being Bobby Brown*, 2005),[9] and it exposed her private life via apparently unscripted footage that featured her known drug and alcohol abuse. The authenticity of the footage became painfully clear upon her drug-related death less than seven years later. The third troubled-celebrity docusoap, *Chasing Farrah* (TV Land, 2005), starred the actor and beauty icon Farrah Fawcett, who, in 1997, had famously appeared on the *David Letterman Show* seemingly under the influence of drugs and unable to engage in a meaningful conversation. Rather than being excluded from TV after this public disgrace, industry bottom-feeders only wanted more of the uncontrolled and troubled Fawcett. Four years after the show, Fawcett died of cancer, but she was kept around by TV nevertheless, as her long-term partner Ryan O'Neal, who had co-starred in *Chasing Farrah*, then participated in the docusoap *Ryan and Tatum: The O'Neals* (2011, OWN), which exposed his highly dysfunctional relationship with daughter Tatum O'Neal after Fawcett's death and the end of the love affair with Fawcett that had damaged the father-daughter relationship.[10] These three troubled-celebrities—Smith, Houston, and Fawcett—had in common that they, more or less desperately, traded their former celebrity status with media exposure, as an opportunity to increase their value in the celebrity marketplace.

According to the celebrity hierarchy, the less famous you are, the more you have to expose tragedy, unpredictability, and spontaneity to gain publicity; and the more famous you are, the more distanced, controlled, and strategic you can be, and still gain publicity. Consequently, when ordinary people are transformed into celebrities, even if only for a short period, they have to agree to high-risk media exposure that could change their lives positively, but could also seriously harm their public image. In the next part, I will draw on this discussion about the authenticity illusions in reality TV and the ethical dilemmas of celebrity culture in the case study of the British reality-TV star Susan Boyle.

9 The show was about her then-husband Bobby Brown, but she appeared in a central role.
10 In the series, the therapy was portrayed as successful, as the two were seemingly helped by the Oprah Winfrey Network production team to sort out all of their problems. A month later, however, Ryan O'Neal admitted that the TV show told a bogus story: "We only reconciled on the show. Not in life. In fact, we're further apart now than we were when we started the show. So thanks, Oprah, for all your help" (Kindelan, 2011).

Authenticity Puzzle: Susan Boyle in *Britain's Got Talent* (2009)

The reality-TV star Susan Boyle is an illustrative example of the transformation of ordinary people into celebrities and the role of authenticity illusions in this transformation process. Susan Boyle also illustrates a turning point in celebrity culture, as the dynamic between TV and the Internet made her a global celebrity almost instantly after her first TV performance.[11] She was introduced to the British public through the reality-TV show *Britain's Got Talent* (ITV) in April 2009, and later became a YouTube star with a fan base in the US and across the world.[12] Two weeks after the TV show aired, the video clip of her performance had been viewed more than 186 million times on YouTube and was among the most watched viral hits of all time. Simultaneously, her performance was among the most debated topics on Twitter and Facebook (Enli, 2009). Broadcast television had seen its audience ratings decline since the mid-2000s, and the future of TV in the age of the Internet was discussed in a body of research (e.g., Olsson & Spigel, 2004; Lotz, 2007; Katz & Scannell, 2009). Yet, the *Britain's Got Talent* 2009 finals became the most-watched programme on British television in five years, with more than 19 million viewers. The Internet had increased the show's popularity and boosted the interest in Susan Boyle's next performance in the talent competition.

The case study draws on a textual analysis of Susan Boyle's performance in *Britain's Got Talent* (ITV), in addition to a discourse analysis of the media coverage with emphasis on debates about authenticity illusions in the TV production. Because of the mixed reception, the reality TV performance of Susan Boyle is investigated as an authenticity puzzle. Next, I will present the main findings in the textual analysis, by describing chronologically the scenes in which she is construed as an ordinary person who is about to be transformed into a celebrity.

11 American journalist and professor Jeff Jarvis interpreted Boyle's instant stardom as "old media meeting new media and creating something we'd never seen before and couldn't even imagine. It was a crossover moment. And she's the edge case" (Cadwalladr, 2010). The powerful combination of broadcast TV and the Internet made Boyle an instant global celebrity, a status that in the pre-Internet age would often take a decade or two to achieve.

12 The Internet's ability to almost instantly spread cultural phenomena internationally resulted in sweeping coverage of the UK talent show performance in the US mainstream media, where Boyle was interviewed on television shows such as *Good Morning America*, *The Today Show*, and *Larry King Live*.

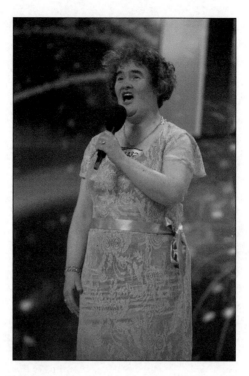

Figure 4.1. Susan Boyle performing at *Britain's Got Talent* (ITV) in 2009. Photographer: Ken McKay. Permission holder: Rex Features.

The "Ugly Duckling" Story

Susan Boyle is, initially, introduced as ordinary by *contrasting the formula*. Rather than being a young, extroverted, and popular girl, she is presented as middle-aged, introverted, and lonely. The first scene shows Boyle from a distance as she sits in the waiting room backstage, alone in the crowd of young people that will compete with her, eating a big sandwich as if to underline that she is not a slim teenager. The next scene shows her as she walks across the floor and introduces herself to the TV viewers: "I am Susan Boyle. I am nearly 48. I am unemployed, but still looking, and I am going to sing for you on *Britain's Got Talent* today." This introduction is clearly rehearsed, and the mention of her age is an intentional statement that contrasts her to the younger contestants, as if that made her a more authentic participant. The presenter puts his arm on her shoulder and asks if she is nervous; she promptly admits: "Yes, sure I am." (episode 1, 11.04.09) This spontaneous openness, and lack of self-protecting facade, was an authenticity marker,

and confirmed the impression of Susan Boyle as an everyday person, without experience of being in the media's spotlight. In the next clip, Boyle appears on stage in front of the judges and is asked to introduce herself; she repeats her age and receives a sceptical response from the judges. This continuous focus on her age demonstrates the fact that the producers' preferred narrative was to tell a story about a middle-aged woman as an outsider in the competition, as a fish out of water.

The construction of Boyle as an ordinariness icon was, secondly, based on *a tragic life story*, which she shares with the viewers before she demonstrates her singing talent on stage: "At the moment I live alone with my cat Pebbles. I have never been bothered. I have never been kissed." She makes a sad face and adds "What a shame!" and starts laughing; then she suddenly pretends to whisper a secret about her dreams (episode 1, 11.04.09). Through this brief and loaded passage, and her highly expressive body language, producers efficiently construct a seemingly authentic character for the show's viewers—an innocent, modest, and lonely woman with little life experience who is at this moment entering the celebrity marketplace for the first time. The fact that she later denied the accuracy of the statement "I have never been kissed"—claiming it was "meant as a joke" (episode 1, 11.04.09)[13]—signals the constructedness of this narrative. Nevertheless, her seemingly spontaneous and uninhibited way of sharing intimate details from her private life enabled her to be cast as an unsavvy, media naïve, ordinary woman. Obviously, Susan Boyle had not been coached by professional media advisors about how to behave on the show, but rather instructed to provide quotes that made her seem genuine and original.

A third element in the construction of Susan Boyle as an authentic ordinary person was that she had *an undiscovered talent,* and thus connected with the ideal that every individual has a hidden talent that just needs to be discovered and nurtured in order to blossom. Immediately after Susan Boyle starts singing, the studio audience explodes in screams, the judges look surprised, and the backstage presenter directly addresses the TV viewers: "You did not expect that, did you?" Even though pre-planned, the judges and reporters appeared to be really surprised and overwhelmed by her talent. Their performances as people stunned and almost silenced by surprise, indeed affected the studio audiences' reactions, and in turn, the close-up shots of their surprised faces affected the home audiences. The first judge is simply ecstatic and, supported

13 According to the ABC news story, "Is Susan Boyle the Real Deal?" (Fisher, 2009).

by the sound of the screaming studio audience, describes the performance as historic: "Without a doubt, this was the biggest surprise I have had in three years of the show." The second judge admits to having been very cynical about Susan Boyle's prospects before hearing her sing, then describes the experience as "the biggest wake-up call ever." (episode 1, 11.04.09) Every comment refers to how unlikely it would appear to be that someone so plain and unglamorous would be able to impress judges in the popular TV talent show. However, the judges knew that she could sing before she started, and they also knew this was not her first appearance on a talent show, but those facts were actively undercommunicated to support the undiscovered talent narrative.

Lastly, a prominent authenticity illusion in the crafting of Susan Boyle as an authentic participant was her *spontaneous reactions* and untamed emotionalism.[14] After completing her song, Susan Boyle promptly walked off the stage, as if she was confused and unable to follow the instructions from the production team—the standard formula was for contestants to stay on stage until they received feedback on their performance. The judges were very touched by Boyle's singing and rose from their seats to give her a standing ovation; they then seemed surprised and a bit charmed by her unexpected exit and call her back to them. The chaotic exit strengthened the authenticity of the scene and made everything seem more unscripted than if she had stayed as she was supposed to. Moreover, after being acclaimed by the judges and advanced to the finals, she expresses a kind of spontaneous and overwhelming happiness that would naturally accompany a totally unexpected result. Boyle uses unrestrained body language and generally seems to enjoy herself wildly; she raises her hands to celebrate her victory, then she starts a little dance with stamping feet, then she again raises her hand and shouts. Her happiness seemed too uncontrolled and too free of vanity to be scripted and is thus in line with the criteria for authenticity in reality TV. Backstage, the presenters encourage Susan Boyle to reflect on her stage performance and remind her of the judges' compliments. During the debriefing she seems out of control emotionally, breaking into relieved laughter while repeating three times, with increasing intensity, "Oh my God!" In the next clip, her laughter has turned into crying, and she whispers: "I am so emotional. Unbelievable. Fantastic." (episode 1, 11.04.09) In such scenes, Boyle

14 Four years after her appearance in the show, it became publicly known that Susan Boyle was diagnosed with Asperger's syndrome (Deveney, 2013).

demonstrates that she is authentic in the sense that she is not performing in line with either the norm for how participants reacts to positive feedback, or the social norms for how we express happiness in front of other people. Her unorthodox reactions functioned as evidence of her authenticity as an ordinary woman who had an extraordinary talent but never had performed before a crowd before.

The Ethics of Constructed Ordinariness

The performance of Susan Boyle raises questions about the ethics of reality TV and its exposure of ordinary people. In line with the troubled celebrities discussed above, the inexperienced celebrity Boyle was emotionally unstable, and at times so troubled that she lost her temper in public, behaved rudely towards journalists, and was even admitted to a private psychiatric clinic in London. The latter incident occurred the day after the finals, when Boyle had unexpectedly ended up second, and in spite of speculation in the British press about fixed voting and manipulated results, the producers claimed that she simply did not get enough call-in votes to win (Jamieson, 2009; Enli & Ihlebæck, 2011).

The production company's official statement on Boyle's hospitalisation said that "Following Saturday night's show, Susan is exhausted and emotionally drained" ("Talent star Boyle taken to clinic," 2009). Through using the participant's first name, the producers aim to create a sense of intimacy and caring, as if "Susan" was their friend, rather than a business partner. Although there might have been aspects of friendship involved, the relationship between the participant and the producers was first and foremost a business alliance. The partnership was meant to benefit both parties, and they had common interests in the construction of Susan Boyle as an authentic ordinary woman with an extraordinary talent. This narrative attracted viewers, and thus also advertisers, to the show, and it enabled Susan Boyle to start a career as a professional singer.

On the background of press reports about Susan Boyle's mental breakdown, the British Press Complaints Commission (PCC) wrote a reminder to the producers about the privacy clause in their code of press conduct (Brook, 2009, June 3). The concerns for Boyle had reached the political arena, and even the British Prime Minister, at the time, Gordon Browne, sent his regards and said to the BBC that he was concerned about her welfare ("Talent star Boyle taken to clinic," 2009). In sum, this demonstrates that, even though a partnership with mutual interests, there were ethical dilemmas related to

the fact that one part of the deal was considerably stronger than the other, and that there were aspects in the deal that were under-communicated by the producers.

The key ethical dilemma related to this under-communication was that Boyle's audience appeal was not merely a result of her extraordinary singing talent, but also of personal traits such as her working-class background, her unpolished looks, and her untamed emotionalism. Reality TV has a tradition of using class conventions to signal authenticity (Skeggs and Wood, 2011), and in line with this, Boyle was crafted as an emblematic British working-class woman. Her plain looks were central as an attraction of the show, and the producers did nothing to make her seem more attractive, such as offering her advice on hair, clothes, and make-up. Rather, the production highlighted her lack of glamorous beauty to create an "ugly duckling" moment and surprise the viewers when she turned out to sing beautifully.

Moreover, Boyle's untamed emotionalism and psychic vulnerability were used by the producers as authenticity illusions, and the crafting of the reality TV participant as authentic was done on the basis of highlighting her oddities, rather than downplaying them, to make her seem more authentic in the role of a naïve working-class woman. An ethically troublesome aspect of this is related to the question of "informed consent," and to what degree the contestant was completely informed and comfortable with the way she was exposed on national TV.

The next section will explore to what degree Susan Boyle's performance was interpreted as authentic in the press and among users, and what arguments were used to support their interpretations. And lastly, I will return to the ethical dilemma of authentic media participants.

The Negotiation of Authenticity

Susan Boyle became a global celebrity as a result of her performance on *Britain's Got Talent*, but once the initial phase of fascination was over, the authenticity puzzle began. In this phase, the authenticity of Susan Boyle and her reality TV performance was thoroughly scrutinized in the popular press and in social media. There were polarized opinions about the authenticity of the performance, and she was on the one hand perceived as constructed, and on the other hand evaluated as exceptionally genuine TV personality. In this part, I will discuss the main arguments in the debate about Susan Boyle as an authenticity puzzle, drawing in articles in mainstream media and online user comments.

Demolishing Authenticity Illusions

A primary argument in the debate about the authenticity of the reality TV show was the *inconsistency* in Susan Boyle's performance over a period of time. According to critical commentaries, she simply did not seem authentic as an ordinariness icon because she was so quickly absorbed into a superficial glamour-seeking lifestyle made possible by her instant fame. The press frequently reported that she changed her clothes, her hair, and her looks to be more in line with the mainstream idea of beauty, or so it seemed, thus trading her authenticity for the standards of the cultural industry to which she initially represented a welcome contrast. British tabloids, for example, scrutinized Boyle's authenticity by investigating her money-spending following the TV show, and lingered over the paradox that a working-class heroine had spent money to improve her looks. The *Daily Mail* article "Hairy Angel *Britain's Got Talent* Star Susan Boyle Gets a £100 Makeover," for example, detailed how much money she spent on each beauty treatment, such as: "Her frizzy grey hair has been cut and coloured for £35 while her famously bushy eyebrows have been reshaped for £5." The press was generally rather sarcastic in its reports on her new look, criticising her for trying to "raise her game in the style stakes with a pair of high heels and a rather enthusiastic smothering of make-up" (Smith, 2009).

Along these lines, she was also confronted with earlier statement such as "stardom would not change me" to raise doubts about the consistency between her self-presentation and her actions. This definition of authenticity as a demand for consistency was also subscribed to by the judges, such as the actor Amanda Holden, who said to the press that Susan Boyle's image would benefit from staying true to her 'extraordinary ordinariness': "She needs to stay exactly as she is because that's the reason we love her. She just looks like anybody who could live on your street. The minute we turn her into a glamourpuss is when it's spoilt. (…) I think it's the underdog thing" (Smith, 2009, August 5). This quote confirms that the underdog narrative was regarded as Susan Boyle's perhaps greatest asset, by the production team.

The *recycled "ugly duckling" story* was a second prominent argument in the debate about the authenticity of Susan Boyle. This argument claimed that the talent show narrative was recycled across various TV shows, and also within the *Britain's Got Talent* formula. For example, the *Time* article "Susan Boyle: Not Quite Out of Nowhere" (Luscombe, 2009) pinpointed a series of parallels between the life stories of participants in the TV shows, and how the stories seem to emphasize the contestants' underprivileged childhoods and

working-class backgrounds. Furthermore, the article argued that this narrative angle is chosen as an illusion to make the talent show more authentic, as the place where ordinary people who struggle in their everyday life get an opportunity to shine. More specifically, similarities were drawn between the life stories of two successful British reality-TV participants: Paul Potts, who won the first season of *Britain's Got Talent* in 2007 with a performance of the aria "Nessun Dorma" from the classic opera *Turandot* by Puccini, and Susan Boyle, who finished second with a performance of the classic song "I Dreamed a Dream," from the famous musical *Les Miserables*:

> Their life stories, as told in countless profiles, are oddly similar. Potts, 39, was raised in a scuzzy part of Bristol, England, we're told, by a bus-driver dad and supermarket-cashier mom. Boyle, 48, was one of nine children whose father worked in a car factory and a mother in a typing pool. At school they were both bullied. (Luscombe, 2009)

These observations of an "ugly duckling formula" in the reality TV talent show genre and evaluations of the contestants as less genuine and unique than the shows that are framing them are also dominant in many of the user commentaries about the performance of Susan Boyle. Yet, the user comments bear the mark of the "gut feeling" response of an offended viewer rather than of the more distanced and analytical journalist. The following examples are from user comments to the article "Is Susan Boyle the Real Thing?" (19.04.2009), by Dan Collarusso in *Business Insider*:

> Dude, that was such marketing horseshit. (Damn well done, but horseshit nonetheless.) This did the *exact* same thing a coupla seasons back with the Paul whatshisface mentioned above: Goat-faced fat man gets up, everyone guffaws … and then OHMIGOSH! Turns out (golly gee), you can't judge a book by its cover. I dunno about you, but I sure learned an important lesson. Seriously, how is it that everyone doesn't smell this from a mile away?!? (Colarusso, 2009)

This user comment is riddled with syntax errors, grammatical mistakes, and unsupported arguments, but nevertheless comes across as a trustworthy account of one viewer's response to the performance of Susan Boyle. The viewer seems insulted by the recycled "ugly duckling" narrative, and the implicit expectations of the audience to be surprised and amazed by the stories, rather than noticing the formula. The repeated formula is, in turn, regarded as a dumbing-down of the audiences, and an ignorance of their media skills and genre knowledge.

The third main argument against Susan Boyle as an authentic talent show contestant was that her stage performance contradicted her amateur image so

blatantly that it raised suspicions about *faked amateurism*. In the online debate, for example, a viewer expressed suspicion that Susan Boyle is "a plant," meaning that the TV persona is artificially constructed. In this view, the professionalism of her singing is seen as proof that she must have had a previous career, but that the producers hid that information from the viewers. The viewer builds the suspicion on the basis of his or her genre knowledge and experience of watching *American Idol* and realising that several contestants who had been framed as unknown talents had in fact had previous careers in the music industry:

> I wonder if she's a plant—maybe a musical actress in her 20s who retired to have a family, then 20 years later was recruited and given a new identity for the show. The last couple of seasons of AI [*American Idol*] have had more plants than a nursery. (Colarusso, 2009)

Faked amateurism is furthermore a key argument in the below user comment about Susan Boyle as inauthentic in the role of a middle-aged woman who had never before in her life sung before an audience, and did not know she had an extraordinary talent. The user acts as a TV critic and suggests that people should watch the video again to detect the professionalism of Susan Boyle's voice and stage appearance:

> This was also staged, and her bio—the whole angle of her taking care of her sick mum and having a cat is really too obvious an angle. Watch the video again, and how calmly she returns to the stage and how the announcers are into it. As a singer, Ms. Boyle has incredible poise and control for someone who claims she has never been given the chance to sing. She has, it's obvious. (Colarusso, 2009)[15]

To a degree, these objections were supported by the fact that Susan Boyle was not a complete novice as a singer when she entered the stage at the show *Britain's Got Talent*; she had taken singing lessons, recorded a few CDs, and attended a couple of auditions. Yet, her main experience with singing was from her local choir, the church, and some karaoke down at the pub; she was a newcomer in the context of mass media and had not previously performed on national TV. Boyle's experience as a singer was, however, not commented on in the show, as it was a dramaturgic advantage to introduce her as if she had never had an audience, that way the viewers were invited to discover a talent and to be amazed.

15 Originally posted on the debate forum *The Velvet Rope* and quoted in Colarusso, 2009.

Defending Authenticity Illusions

Contrasting the above arguments that Susan Boyle is inauthentic, there were also users who thought of Susan Boyle as an authentic participant, meaning that the real-life person is correctly represented in the mediated version. These arguments were primarily voiced as response to the manifold accusations of manipulation of the media persona Susan Boyle. Claims that Susan Boyle was the "real thing" build particularly on three kinds of arguments: the eyewitness accounts, the psychological analysis, and the ideological evidence. The first evidence was from users who claimed that they had real-life knowledge, or could testify of her authenticity on behalf of friends who had first-hand knowledge about the reality-TV contestant in question. For example, these two comments argued that they could prove that Susan Boyle was genuine and not staged by the producers:

> Susan is 100% genuine. Blackburn is a small place so you are unlikely to see thousands of posts from people who know her. However, I know someone who does. Her story is fact. (Colarusso 2009)

> She is definitely the real thing. I have a friend who was actually taught by her sister while at primary school. Susan comes from a large family, and sings in the local pub. What you see is what you get. (Colarusso 2009)

The second body of evidence was amateurish *psychological analysis* of Susan Boyle's behaviour on stage and her subsequent dialogue with the judges. By referring to her seemingly genuine bodily reactions such as nervousness, as well as her seeming innocence and naivety, several users claimed that this provided proof of the TV persona's authenticity:

> Don't think she is a plant. Look at how nervous and befuddled she was before she went on stage. No one is that good at acting as a non-performer. (Colarusso 2009)

> I believe the story. She is said to have learning disabilities and I think that it might explain her innocence and naivete when she speaks with Simon and the other producers. (Colarusso (2009)

The *ideological evidence* was arguments claiming that Susan Boyle is authentic in her role as a talented working-class woman who had been undiscovered by the music industry because of her plain looks. This evidence was based first and foremost on a strong desire to believe that she indeed represented ordinary people, and thus also represented some kind of justice in a

commercial culture industry. In their reading of the performance by Boyle, many users recognized a contrast, or even an antithesis, of what they disliked about the current media culture, and argued that people who claim that Boyle is fake were confused by this superficial culture and its fascination with 'hyperreality':

> Why don't you ask if all those blonde girls with boob jobs, botox, and lip sync songs written for them by marketing agents are the real thing? (Colarusso 2009)

> Shame, shame, shame ... Why does everyone have to be beautiful to be accepted in the world? Why do we always say that someone is fake if they don't look the part we expect. Susan Boyle is not ugly. Plain, yes, but not ugly. (Colarusso 2009)

The negotiation of authenticity in reality TV thus touches upon an ideological debate about celebrity culture, and its increasing commercialism and superficiality. The popularity of Susan Boyle might thus be interpreted as evidence of the search for glimpses of authenticity in contemporary mass mediated communication.

The Authentic Participant

The reality TV genre is in itself an authenticity puzzle, and it is inherently a hybrid of factual and fictional elements. The primary factual element in reality TV is the filming of *real people* rather than actors. As shown in the above analysis, reality TV producers work with real people with actual lives that will carry on after the production period is over, and this simple fact demands certain skills and precautions that are not relevant to actors and fictional stories. For example, Susan Boyle's untamed emotionalism was both an advantage and a disadvantage for the producers. On the one hand, her lack of control served as an effective authenticity illusion, and thus helped the producers to create an appealing narrative. On the other hand, Boyle's lack of emotional control was a disadvantage for the producers, because it made her performance in public unpredictable and thus complicated the TV productions with concerns in addition to the routine production. In retrospect, *Britain's Got Talent* judge Simon Cowell admitted that the producers "did not handle the situation with Susan as well as we could have," and he recalled that at the moment when it was clear that she had not won he looked over at her face and thought: "Christ, she doesn't know how to deal with not winning" (Cowell, 2009). This statement demonstrates that the seemingly most authentic reality

TV participant is perhaps not necessarily the preferred participant, because it is more convenient for the production team to work with people who are willing and able to compromise their authenticity by adjusting their behavior to social norms and format criteria.

The authentic participant is perhaps rather a person who adjusts his or her spontaneity and emotionalism to be compatible with the media format criteria, and is able to, when required by the public surroundings, control feelings accordingly. The authentic participant is, however, not supposed to be too controlled, or seem staged and pre-planned in their performances, as the viewers generally believe that the raw material of these shows is authentic, whatever its later manipulation, and they seek those moments when the emotional authenticity is exposed (Hill, 2005; Aslama & Pantti, 2006). Still, these moments must be produced and manipulated to come across as genuine and engaging; even though the attraction of reality TV is its seemingly unfiltered portrayal of ordinary people or celebrities, the producers know that filmed authentic lives would generally be too uneventful to generate high ratings, and therefore require manipulation. As such, the authentic participant is a product of a joint process, or a negotiation, between the participant and the production team, and for the viewers this real, but the constructed TV persona represents an authenticity puzzle.

A reality TV participant's authenticity as ordinary is however temporary. For Susan Boyle, the status as an ordinariness icon decreased when she became a self-conscious celebrity, and was replaced by a status as a celebrity-formerly-known-as-ordinary. Boyle's career following the reality TV show was, of course, a result of the "ugly duckling" narrative, and her name will always be associated with this narrative, but she has advanced from the anonymous ordinariness and become both a celebrity and a brand name. Transformation from ordinariness to celebrity has become one of the main phenomena in post-modern media culture. The mass media as a catalyst for transformations connects with the classic Cinderella story and related fairy tales, and provides the audience with narratives supporting the idea that everybody has a hidden talent, and can become a celebrity. The key element in the construction of such narratives is authenticity illusions, of which the most important is the raw and untamed "before" image, as this can always be contrasted with a polished "after" image. This contrasting "before" image requires, of course, an authentic participant who is willing to expose his or her less glamorous sides, and producers who are willing to exploit these personal traits. The ethical dilemma is obvious because participation in reality TV has not only exploited

Susan Boyle, but also indeed transformed her life and provided her with opportunities that were previously out of her reach. Accordingly, the role as an authentic participant—a representative for an extraordinary ordinariness—is an ambivalent role for the person involved, and it is paradoxical as a mediated phenomenon.

In the next chapter, I will draw on the above findings about how mass media represent ordinariness in reality TV, and analyse how ordinary people represent themselves in social media and blogs, and to what degree this changes the notion of authenticity.

· 5 ·

FAKE PERSONAS AND BLOG HOAXES

Illusions in Social Media

To be natural is such a very difficult pose to keep up.

—Oscar Wilde

The emergence of the participatory Internet and a collaborative media production culture has made the relation between the media and its audiences more dialogical, interactive, and challenges the distinction between the producers and the audiences (O'Reilly, 2005; Benkler, 2006; Jenkins, 2006b; Enli, 2008; Bruns, 2010). This chapter explores the impact of these changes on the "authenticity contract" and the notion of authenticity in mediated communication.

Like every new media technology, the web has been subject to both great expectations and great fears; in line with, for example, radio and TV, the Internet has been expected to democratize the means of media production and make its representations of reality more authentic (Brecht, 1930/1983; Castells, 2007; Shirky, 2008). Migration of communication to online media has, however, also been argued to undermine editorial quality standards and replace real relationships with pale substitutes (Postman, 1992; Fischer, 1992; Anderson & Milbrandt, 2005; Keen, 2007; Siegel, 2008; Baym, 2010; Morozov, 2011; Stalder, 2012). This chapter will contribute to this discussion

by investigating authenticity illusions in blogs and social media, and how trust relations are established in these arenas.

This chapter has three main parts. The first part will discuss the growth of social media, with emphasis on the dilemmas of online trust and authenticity in online media. The second part analyses authenticity puzzles in social media, drawing on case studies of three blog hoaxes. The third and last part discusses how the authenticity contract is negotiated as a result of miscommunication, and also how factual genre expectations might be reductive as defining features in the authenticity contract.

The Rise of Social Media

The computer was envisioned to become as common to own as a car, with a potential to become an "intellectual Ford or Cadillac" (Licklider, 1960). As a technological innovation, the Internet was a result of a series of visions, and among the most important was the idea of a "Man-Computer Symbiosis," which enabled interpersonal communication, and even "town hall meetings" via home computer terminals[1] (Bush 1991/1933; 1945; Nelson, 1987/1974). The visions were realized from the 1990s onwards, with the launch of the "World Wide Web" as openly available software, supplemented with the web browser Mosaic, which enabled the viewing of images in addition to text (Abbate, 2000; Berners-Lee, 1999; Naughton, 1999; Walker Rettberg, 2013).

The participatory Internet moreover developed as a result of an increased focus on interactivity and user-generated content from the mid-2000s onwards, when the trend was crowned by *Time* magazine's selection of "You" as the Person of the Year in 2006, as an acknowledgment of the new opportunities for ordinary people to participate in the media and other parts of public life (Grossman, 2006). A key factor in this "participatory turn" was social media, which has changed the way we interact, both professionally and privately. I will now turn to discuss the implications of social media on the notion of authenticity

1 Such ideas in turn influenced the US defence research council known as the Advanced Research Projects Agency Network (ARPANET) during the 1960s (Licklider & Taylor, 1968).

in digital communication, first by exploring the trust contract in online interactions, and second by exploring the authenticity illusions in social media.

Dilemmas in Online Trust

Already before digital technology and new web genres had altered how we communicate, inauthentic personas and fake content surfaced as key fears in debates about the Internet. The Internet always seemed to be the perfect medium for constructing reality, and among the dominant conceptions of the Internet in the early 1990s was the so-called "virtual reality" that might replace real-world experiences with a host of computer-simulated imaginary ones (Rheingold, 1991; Turkle, 1995). One of the earliest fears associated with the Internet involved the risk of inauthenticity in online personal communication, in the absence of physical artefacts of these multifarious new relationships. This concern is well illustrated by the popular cartoon captioned "On the Internet, no one knows you're a dog," which was published in 1993, around the time the World Wide Web was invented and the Internet became accessible to the general public.

More recently, the mediated versus real-world experience, or online-offline dichotomy, has become a less dominant perspective in communication studies. Rather, the confusion about what is virtual, meaning what seems real but is ultimately a mere simulation, and what is real, has recently been acknowledged as a part of the online communication discourse. The distinction between offline and online communication has become increasingly blurred, but is still complex. On the one hand, even the most active users tend to contrast their online relationships to what they do "IRL" (In Real Life), lending credence to the perception that the mediated is unreal (Baym, 2010, p. 5). And on the other hand, the online-offline divide is increasingly challenged, because most users do not think of identity as separated between online and offline (boyd, 2004; Palfrey & Gasser, 2008; Baym, 2010). Users communicate in online and offline environments simultaneously, and it becomes hard to define where one communication form ends and another one starts. In a time when communication technology and online interaction is no longer separated from our offline reality, we seem to have become even more oriented towards preserving authenticity in human connection and of ourselves (Baym, 2010, p. 155). Accordingly, digital mediated communication is seemingly more dependent on authenticity illusions and a negotiated authenticity contract than face-to-face communication.

A key reason is that there is an inevitable difference between digital communication and face-to-face communication, namely the lack of physical evidence online and the need to compensate for its absence. Illusions of authenticity in online environments are accordingly often created by references to "IRL" artefacts; online media might borrow credibility from a sponsoring print- or broadcast-based company, if there is one that is affiliated with the digital effort through ownership or collaboration. For example, company websites emphasise the physical nature of the organization, through images of its buildings and employees, and thus attempt to increase the firm's online credibility (Hawley, 2012, p. 84; Fogg et al., 2001). The preference for media outlets with a track record in the physical reality is seen in the fact that media companies such as CNN, the BBC, and *The New York Times* are among the most used and trusted online news sites.

Similarly, a much used authenticity marker in online socializing is images we associate with ourselves, such as photographs or avatars, which might also function as important identity cues (Baym, 2010, p. 109). In social media and user-generated content, photos are used to signalize authenticity and to create an intimacy between the users; photographs are typically required in the social network Facebook, the housing rental website Airbnb, and the dating service Match.com. These social media networks have developed systems for user authentication in order to avoid fake online identities, economic fraud, and emotional deception.

Algorithms in social media networks pressure users towards honesty through, for example, requesting people to register with authentic names, which is perhaps the most important identity signal in social interactions (Bucher, 2012). In fact, a typical trait of social media is that the algorithms engineer self-presentation by providing pre-determined sets of categories through which to build identities. The most common categories are age, place of residence, and special interests, and as shown in studies, users are generally likely to provide trustworthy demographic information (Gross & Acquisti, 2005; Lampe, Ellison, & Stenfeld, 2007). Yet, there are loopholes, and users who are skilled will manage to outmanoeuvre the system; about two in ten have tried to mask their identity or to use fake names, while more than one in ten has provided inaccurate information about themselves (Drake, 2013). Users are aware of these possibilities and are thus more sceptical of online identities than offline identities, even though they do not perceive themselves as less real online (Farquhar, 2009). Accordingly, trust relations in digital communication is characterised by ambivalence, but also a set of authenticity illusions, from which the users navigate when they engage in digital communication as producers or users.

Authenticity in Social Media

The difference between digital communication and face-to-face communication is often argued to be the elimination of non-verbal cues, such as facial expressions, looks, and body language that are generally rich in relational information (Hiemstra, 1982; Trevino & Webster, 1992; Walther, 1996; Walther, 1992; Lüders, 2007; Baym, 2010). The sparse contextual social cues in digital communication require a set of authenticity illusions, of which the above-mentioned portraits of users and images of buildings are important features. Authenticity illusions in social media, however, extend beyond the physical "IRL" manifestations and also include social cues more specific for digital communication.

First of all, social media requires methods for *authenticating feelings* to support the text with social cues. In mediated environments, where there are so many blanks to fill in, people make more out of others' small cues than we might face to face. Currently, the most common form of expressed feelings in digital mediated communication is emoticons such as a variation of "smilies," which enable the user to signal friendliness and to avoid misunderstanding when irony might confuse the reader. In line with this, emotional engagement is expressed through punctuation and capitalization, as if we want to scream and use our hands to illustrate. In fact, informal language and talk-like phonetic spelling is often used to signalize sincerity and to demonstrate that the text is authentic as a heartfelt expression, rather than a calculated report. These textual signifiers of authenticity must however be supported by consistency, because a trust relation often requires a kind of on-going dialogue or a conversation, as this is the key to feelings of empathy and personal attachment. In the digital age, just as in the dawn of writing, media evoke questions about what it means to be authentically human (Ickes, 1993; Ellison, Heino, & Gibbs, 2006; Baym, 2010). In a time when communication technology and online interaction is no longer separated from our offline reality, we seem to have become even more oriented towards preserving authenticity in human connection and of ourselves (Baym, 2010, p. 155). The establishment of trust among online users relies upon faith in the contributions of others, and while face-to-face trust relations have the advantage of a shared presence and physical documents, online trust relies upon substitutes such as photos, images, and even scanned documents such as passports.

A second means to indicate authenticity in digital mediated communication is *self-disclosure*, meaning that users who disclose intimate details from

their lives will often be perceived as more authentic than users who are distanced and impersonal. Self-presentations online are often intended to establish trust in new relationships, and for this purpose we need to disclose our identities (Enli & Thumim, 2012). Self-presentations in digital communication are also in line with the common practice of accentuating certain matters and concealing others in face-to-face communication (Goffman, 1959; boyd, 2004; Ellison et al., 2006; Ellison & boyd, 2007). As in all mediated and face-to-face interactions, we try to manage what other people think of us, and this impression management may involve "outright deception, total honesty, or, most often, a strange balance of sharing, withholding, and distorting information" (Baym, 2010, p. 108). Self-disclosure might thus be genuine confessions from users who find it easier to be honest online than in face-to-face conversations, or they might be deceptive and faked. In both cases, however, personal online communication needs support from authenticity illusion to seem trustworthy enough for the reader to engage emotionally in the self-disclosure.

A third authenticity illusion in digital mediated communication is the *support from networks*, meaning that the authenticity of online identities is supported by their networks, and that the trustworthiness of social media posts is supported by linking practices and various forms of sharing. The linking practice in online media serves as an authenticity marker because it expresses support from the network. Links connect communities via hypertext structures (Bolter, 2001), and thus support an assumed, virtual backing from other social media users and bloggers.[2] Authenticity in social media and blogs is not created in a vacuum, but is strongly based on networks of users and interlinking between webpages. As social media networking has become an integrated part of our everyday life and how we communicate with others, our networks of friends on Facebook have even in themselves become a verifying factor that we can legitimate ourselves with when, for example, renting a house online. As such, our presence in online networks has in itself become an authenticity marker to underwrite our very existence as social, and thus also trustworthy, human beings.

2 Links will also increase a blog's ranking within the Google search engine hierarchy—the more links to the blog from elsewhere, the more popular the search engine will assume the blog to be. It will therefore place the blog among the most prominent alternatives in a given set of search results. In user-generated content, the efforts to seem authentic through design and linking are similarly evident; linking is especially used to gain a higher Google ranking and to seem more legitimate by having support from other online sources. This factor is not least evident in Wikipedia, which gains part of its trustworthiness precisely through an extensive use of links to related entries in the online encyclopaedia.

The support from networks can be divided into a qualitative and a quantitative dimension; support from centrally placed users such as celebrities or news anchors or influential institutions such as global companies or Wikipedia provide a qualitative credibility. Support from a critical mass of other social media users generally provides quantitative credibility (Mendoza, Poblete, & Castillo, 2010, 2011). The support from the user network, in the forms of, for example, retweets or other mentions, is indeed an authenticity illusion because it provides tweets and updates with credibility, and thus makes users less critical than if the support is lacking. Robust authenticity illusions in social media are crafted through a combination of quantitative and qualitative support from networks.

The fourth authenticity illusion is crafted in digital mediated communication through *genre conventions*, meaning that a tweet or a status update seems real because it resembles previous social media postings. This point is illustrated by the way a fake tweet reporting an attack on Barack Obama and the White House temporarily unnerved the US financial market in April 2013: "Breaking: Two explosions in the White House and Barack Obama is injured." The tweet was composed according to the genre conventions for brief news alerts, and posted on the Associated Press Twitter account, @AP, and delivered to the AP's 1.9 million followers. Consequently, the users, as well as the stock market, interpreted the tweet as authentic; it was retweeted almost 5,000 times within the first minute, and the stock market reacted negatively.[3] The miscommunication was, however, soon corrected, when the Associated Press posted the explicatory tweet: "@AP Twitter account has been hacked." The activist group Syrian Electronic Army claimed responsibility for the hack, as they had also done with previous hacks against renowned news organisations (Smith, 2013). Accordingly, genre conventions were used as an authenticity illusion, and made it possible for the activists to sabotage the US public agenda, even though only for a short time.

3 In the event of a real attack, the market would react negatively, because political instability makes economic investments unpredictable. The widespread use of algorithmic trading enables the stock market to respond extremely quickly to market trends and changes in risk factors, so when computers picked up this fake tweet, they automatically responded by selling shares. Bloomberg LLC, which delivers data to stock market terminals, included Twitter feeds on their terminals only weeks before the fake tweet, and the company was thus particularly vulnerable to fake newswire tweets; it has since taken action to limit the chances of a repetition of this short but brutal dip in the stock market.

Following from the above, authenticity illusions in social media might be used to establish trust between users, but they can also be used to deceive other users. In the next section, I will further investigate selected cases in which authenticity illusions have misled users, and in turn, created authenticity scandals. Because the selected cases are three blogs, originating in various phases of the development of blogging, I will start the analysis with a discussion of the history of blogging and the genre's claims to authenticity.

Authenticity Puzzles in Social Media

Blogs might be defined as a genre within the larger umbrella of social media, but blogs have a history of their own and also a unique set of genre conventions. In the earliest phase of blogging, the phenomenon was not even classified as a genre, not least because, in line with other webpages, blogs were difficult to sort into otherwise acknowledged genres and therefore remained stubbornly unclassified as they awaited a critical mass in terms of popular acceptance. "Web logs," later known as blogs, were present on the Internet before 1998, although not yet identified as a genre as such. Rather, they were simply webpages that shared certain characteristics and functions (Crowston & Williams, 2000; Santini, 2007).

From 1999 onwards, a huge growth in blogging arose as a direct result of a shift towards a more user-friendly, and also free, blogging interface,[4] which made the practice accessible not only to techno-savvy experts but also to ordinary people. Only at this point did the genre start to be widely acknowledged: the label "weblog" was coined in 1997,[5] and already in 2004 the label "blog" had become the word of the year, signalling its arrival among the most hyped media phenomena of the era (boyd, 2006; Santini, 2007; Walker Rettberg, 2008). When novel Web phenomena are finally acknowledged and accepted as genres by the aforementioned critical mass of users (as blogs have been since 1999), they become factors in the authenticity contract through their attendant implications as authenticity markers. Audience members must

4 In 1999, the first free web-logging tools, Pitas and Blogger, were released; these interfaces favoured long-form prose rather than the shorter excerpts that characterise some blogs today (Blood, 2000).

5 The term "weblog" had existed previously, however, to refer to a list of unique users to a given website and other data about site traffic. Barger took it over as the name for his blog *Robot Wisdom: A Weblog by Jorn Barger* in 1997 (Blood, 2000).

then decide what it is they expect from the blog genre, and both the blogger and the users conform to a given set of conventions in their encoding and decoding of content.

The idealistic expectations of the Web as potentially more independent, democratic, and participatory—and thus also more authentic—than mainstream media have arisen thanks to, for the most part, user-generated content such as blogs. As the "voice of the people," many felt that blogging could be expected to tell the truth when corporate media companies were silent, because of economic or political interests (Keren, 2006; Carpentier, 2012; McNeill, 2003; Johnson & Kaye, 2004). Blogs are often written by what we can define as media amateurs, and they are thus often thought to express immediate, "pure" reactions rather than rehearsed or calculated statements. Blog users, according to several studies, expect honesty in personal blogs and position them as an alternative to mainstream media sources. In the next section, I will analyse three selected cases of fake blogs between 2001 and 2011, in order to pinpoint how the authenticity illusions have developed historically.

A History of Blog Hoaxes

Blog hoaxes, authored by individuals as well as marketing departments, have existed since the genre's breakthrough around the turn of the century.[6] I will now turn to the empirical analysis of three strategically selected fake blogs,[7] each of which corresponds to a distinct period, trend, or wave in the fairly short history of blogging.

To present the blogs chronologically, the first selected case is the fake blog identity Kaycee Nicole (1999–2001), who was introduced to online users as a high school student who was keeping a diary of the ups and downs in her battle with leukaemia. For more than two years, she shared her story with

6 The main difference between fake blogs and fictional blogs is the intentionality of the author and the degree to which the reader is informed about the blog's fictional features (Thomas, 2006, p. 199).
7 This fake online persona even has an entry in Wikipedia and is referred to as a pioneer among what has been termed "Münchausen by Internet"—a pattern of behavior in which Internet users seek attention by feigning illnesses in various online venues: "Kaycee Nicole was a fictitious persona played by an American woman named Debbie Swenson, in an early case of Münchausen by Internet" ("Kaycee Nicole, n.d.").

her readers through blog posts and also direct communication with some of the blog's readers. The Kaycee Nicole case illustrates clearly how authenticity illusions such as photos of random neighbour girls and staged dialogue triggered the blog readers' empathy with, and trust in, this online character. As an object of study, the Kaycee hoax illuminates an early stage in the process of negotiating online authenticity, and to a degree represents a defining moment for the blogging community. At this time, user-generated content was more text-based and less interlinked than it is in contemporary online media. At this point, social networking sites such as Friendster (2002) and Facebook (2004), for example, did not even exist as potential arenas for the verification of the online persona. This scarcity of social media sources to check the validity of the blog obviously made it easier for the author to construct the fake online persona.

The second case is the fake YouTube video blog "lonelygirl15" (2006), in which the fictitious character Bree, a lonely teenager living with her parents, was introduced as an amateur blogger and soon became a viral hit with a significant fan base. In this fake blog, the authenticity illusions were not limited to still pictures of random people who could have been the author but in fact offered filmed footage of a real person. The scheme incorporated the actor's willingness to delete every online representation of her real identity and replace it with pictures and videos of her new fake online persona. In itself, this play with identities in the realm of popular media is a sign of the times, as the "lonelygirl15" hoax mingled with a new media trend characterised by user involvement, audience engagement, and convergent culture. YouTube was a key driver of the trend of user-generated content, and the amateur video clips downloaded by ordinary people, most often teenagers and young adults, represented a media revolution. The fake video blog by Bree was the perfect illustration of this new trend, where user-generated online media were regarded as tools to democratise the access to mass media, and to empower ordinary people with means to express themselves publicly.

Lastly, "A Gay Girl in Damascus" (2011) claimed to be a blog written by Amina Arraf, who lived as a lesbian in an authoritarian regime where her sexuality was forbidden and communication with the Western world was restricted. The blog's authenticity illusions included regularly updated posts, photos of a girl who looked as if she could have been Amina, and a high degree of resonance with current expectations and myths regarding the "authentic" blogger. As such, the blog was interpreted as a personal story that accurately commented

on the suppression of lesbian, gay, bisexual, and transgendered people (LGBT) in the Middle Eastern country of Syria, and it was picked up by a range of well-reputed Western media outlets. Again, the timing of the fake blog was crucial to its public reception and resonance with the news media, particularly with regard to the Arab Spring and the popular notion of Facebook and Twitter as tools of empowerment in the mobilisation of political revolution.

Taken together, these three blog hoaxes illustrate how online authenticity is constructed in dialogue with the dominant expectations of this particular web genre using certain crucial illusions to communicate authenticity and establish trust with the blog's readers. In the next section, I will more closely investigate these various illusions and how they are manifested, first in the virtual introduction of the individual bloggers, and then in the textual and narrative structure of the blogs themselves. Lastly, I will analyze and discuss how each hoax was unmasked.

Constructing Fake Personas

You never get a second chance to make a first impression, and my analysis indicates that this also goes for fake online presentations of self. The three blog hoaxes had in common that the fake personas were all intended to from the start seem innocent and insecure but also enthusiastic and introspective. See, for example, the very first line of the blog supposedly authored by cancer sufferer Kaycee Nicole: "I'm beginning a new exciting journey ... into my survival. I want to win! I'll fight to the finish!" (Hafner, 2001).

In line with the genre conventions of confessional blogs, the blog is written in the first person, and the tone resembles an online diary. The paradox of an online diary is that it makes its purportedly deeply private disclosures public, as opposed to the classic diary, which is kept hidden away from others. In terms of authenticity, the reader of a confessional blog might well wonder why its author chooses to share these secrets with the audience. The first blog post by Kaycee provides a motive for the confessional blog in the brave and enthusiastic opening sentence. The blog is documenting her fight against cancer and communicating her story to the community of bloggers is thus indirectly presented as a motivation for Kaycee to keep up her struggle. The above introductory sentence is clearly designed to appeal to the reader's empathy and imply a shared struggle, with which readers can engage in the subsequent blog posts.

Similarly, the "lonelygirl15" blog initially presented its blogger as profoundly inexperienced and the project as tentative and amateurish. Bree

introduced herself to the YouTube community with a short written message and an initial video blog which established her as an insecure teenager: "So, I finally got a webcam and got it working (ugh, harder than I thought …). Hope you like it:)" (lonelygirl15, 2006, June 6).

In the video, Bree looks directly into the camera, sitting on what seems like a bed in a teenager's bedroom. This setting serves to authenticate her introductory monologue, through which she communicates that the video blog is a first step for her into the community of YouTube users. Her performance underlines her purported insecurity, as she, after taking a deep breath, hesitantly starts talking to the camera:

> Hi Guys, so this is my first video blog … I have been watching a lot and I really like you guys on here … I didn't really have a plan for this video blog, but I guess I will just do this … My town is really boring. Really, really boring … I guess that's why I spend so much time by my computer. I am a dwarf. (lonelygirl15, 2006, June 6)

Motivating the blog with a feeling of isolation in what she describes as her "boring" home town, and a fascination with the computer, Bree makes her story seem reliable, and provides a framing to her upcoming series of video-blogs.

Self-reflexion, insecurity, and courage were also significant authenticity illusions in the first posts at the blog with the informative and seemingly unpretentious title: "A Gay Girl in Damascus. An out Syrian lesbian's thoughts on life, the universe, and so on." The fake blogger, Amina Arraf, starts off by asking rhetorically if publishing her real name and photo is worth the risk, expressing her doubt about the endeavour: "I live in Damascus, Syria. It's a repressive police state … But I have set up a blog with my name and my photo. Am I crazy?" (A Gay Girl in Damascus, 2011).

This self-reflexive inner dialogue represents a typical blog-associated authenticity marker. The decision to blog using a real name instead of an anonymous account appears to be warranted thanks to a deeply felt, almost heroic interest in fighting the restrictions against free speech in Syria. Along those lines, as well, the use of English made Amina appear authentic as a "bridgeblogger" (Zuckerman, 2008), meaning that her goal was to mediate the concerns of the Syrian people to the English-speaking world through her knowledge of both the US and Syria.[8]

8 "I have to begin by doing something bold and visible," she wrote. "I can because I'm a dual national and have benefits of politically connected relatives" (A Gay Girl in Damascus, 2011).

A common characteristic of these cases of fake blogging is that young girls in their teens and early 20s were all set up as authors, as if this particular gender and age combination also added to the authenticity illusion of the blogs. The real masterminds behind the blogs were mixed gender-wise: the creator of Amina was a 40-year-old man, the team behind Bree was mixed, and the author of Kaycee's blog was a 40-year-old woman. We can speculate that the intention was to connect with a stereotype of girls as more trustworthy, innocent, and less likely to manipulate online content than boys would be. The blog introductions emphasised the authors' innocence, courage, and openness, and thus created an online persona that invited trust and empathy.

Storytelling in Social Media Hoaxes

Once the main character, the self-exposing blog author, was introduced, and the trust relation with the blog users was established, the fundament was laid for storytelling. The storytelling in the three blogs was crafted by authenticity illusions specific for social media, but also general genre features in narrative fiction.

The blogs "Living Colours" (Kaycee Nicole), "lonelygirl15" (Bree), and "A Gay Girl in Damascus" (Amina Arraf) started off as fairly low-key and unpretentious phenomena. "Kaycee Nicole" had appeared in several online debate forums in the role of a young and sporty high school girl struggling with cancer. Subsequently, Kaycee started her blog dedicated to her battle against cancer, and the blog was soon followed by an entire community of Kaycee fans who invested in her story with great empathy and even offered material support (Jordan, 2005). The readers trusted Kaycee's story and, judging by the comments in the blog, many of them appeared to think of her as a real friend or acquaintance—that is, a type of engagement that goes beyond what we feel about the fictional characters we see in movies or on TV. They communicated with her via email, chatted with her in online chatrooms, and even phoned her (Walker Rettberg, 2008, p. 123). Many readers in fact grew extremely close to Kaycee and were devastated when they learned that she had died. They sought ways to express their sorrow, such as sending gifts to her family; some even attempted to attend her funeral.[9] The creator of this hoax blog had manipulated the audience through convincing and regular updates on her condition, all of which contributed to the illusion of authenticity.

9 See "Kaycee Nicole Swenson, 2006" (n.d).

Amina Arraff was similarly gradually established as an online persona, and her blog was fairly mundane and straightforward at first, before it suddenly took a more dramatic turn. The slowly developing narrative enhanced the authenticity illusion of the blog by building trust between Amina and the blog's readers. The storyline was furthermore supported by certain textual features that made the blogging seem more authentic, such as the use of Arabic words mingled with English:

> So you come here to take Amina. Let me tell you something though. She is not the one you should fear; you should be heaping praises on her and on people like her. They are the ones saying alawi, sunni, arabi, kurdi, duruzi, christian, everyone is the same and will be equal in the new Syria; they are the ones who, if the revolution comes, will be saving your mother and your sisters. They are the ones fighting the wahhabi most seriously. You idiots are, though, serving them by saying "every sunni is salafi, every protester is salafi, every one of them is an enemy"? (A Gay Girl in Damascus, 2011).

This illusion of authenticity was also perpetuated through her use of parenthetical asides to explain nuances between Arabic and English, as the following excerpt, taken from a part where Amina tells about how her father defends his daughter against intruders who accuse her of illegal activities, demonstrates:

> "—Did she tell you that she likes to sleep with women?" he grins, pure poison, feeling like he has made a hit. "—That she is one of those faggots who fucks little girls?" (the arabic he used is far cruder ... you get the idea) (A Gay Girl in Damascus, 2011).

Moreover, the textual features intended to signal authenticity included incomplete sentences and the use of exclamation marks and capital letters,[10] as if the blog were a stream of consciousness effort or even a direct transcript of her inner thoughts: "MY DAD had just defeated them! Not with weapons but with words ... My father is a hero; I always knew that ... but now I am sure." (Gay Girl in Damascus, 2011).

Regarding the narrative, these blog excerpts also exemplify a convincing dramatic turn, as they tell of a visit from security service officers who came to

10 This feature is found also in Sony's fake marketing blog "All I want for X-mas is a psp," which bordered on parody in its extensive misspellings, slang, and informal language seeking to imply the authorship of boys rather than marketing professionals (Snow, 2006).

punish Amina for "conspiring against the state, urging armed uprising, working with foreign elements." The narrative about a father defending his daughter against a brutal and oppressive regime is a classic story of good against evil and of the fight for individual freedom in a totalitarian system. This alarming turn, implying that Amina's blogging had become dangerous and threatened her safety, increased the public interest in the "Gay Girl in Damascus," and it was at this point the international press really caught an interest in the blogger (Wilson, 2011). The apparently dangerous situation and the way blogging made her situation more vulnerable, and, in the end, even made her risk her life, contributed to a more intense involvement in Amina's destiny and appealed to the readers' empathy.

Unmasking Fake Bloggers

The above discussion shows that the fake blogs shared a tendency to appeal to the blog readers' empathy. However, because the blog readers inhabited a hybrid role as users and producers, many of them had an urge to partake, respond, or in other ways act out their engagement with the blogs in the physical world. In their efforts to communicate with the bloggers, the producers activated their own online networks, beginning a process that in turn resulted in the eventual unmasking of the fake work.

After Kaycee's seemingly tragic "death," fans who had engaged in her blog confessions over the course of months, or even years, aimed to express grief by giving gifts to the family or attending the funeral. They approached Kaycee's mother, who had also launched her own blog as a spin-off of Kaycee's blog, but she was unwilling to provide any information (Jordan, 2005). As a result, the collective detective work began, and it was found that no one had in fact died in the geographical area that fit the description on Kaycee's profile. The blogger Saundra Mitchell was the first to publish a post pinpointing several inconsistencies in the back story about Kaycee's cancer, as well as the striking haste with which Kaycee's body had been interred, according to the mother. Simultaneously, a user posted a thread on the blog Metafiler titled "Is it possible that Kaycee never existed?" which led to a heated debate, including comments about the lack of physical evidence of her existence, both as a living person (no one had met her) and as a dead person (there was no obituary in the newspaper).[11] Shortly after, Debbie Swenson, a 40-year-old woman from

11 See "Is it possible that Kaycee did not exist?" (2001).

Kansas, confessed that she had invented Kaycee and her mother and had written all of the diary entries herself.

"lonelygirl15" was similarly also revealed as fake through the engagement of Bree's fans, and it was thus the blog's popularity that made the bubble burst. An anonymous young man discovered pictures of "Bree" linking her identity to another name, Jessica Rose, a 19-year-old actor, by searching for her name among deleted MySpace accounts. Even before his discovery, there had been suspicions among fans who, based on minor inconsistencies within the videos, began to wonder if the story was in fact genuine or rather part of a marketing campaign for a TV show or movie. Following these doubts about the blog's authenticity, reporters at *The New York Times* began a journalistic investigation, and with the help of an anonymous blogger, they traced the video blog "lonelygirl15" to the production team Creative Artist Agency. The team included a screenwriter, a filmmaker, an actress, and a software engineer, the latter of whom also assisted in Rose's efforts to hide her online identity while performing as "Bree." The team admitted to the hoax but continued the production of the video blogs, although now as an openly fictional production.

The unmasking of "A Gay Girl in Damascus" followed a similar pattern, from suspicion, via collective investigation, to technological evidence, and, in the end, confession. The arrest of Amina had engaged not only the world press but also many Facebook users, and a "free Amina" movement grew steadily after the news spread.[12] While some users invested themselves in her case against the Syrian authorities, other users invested themselves in the hunt for Amina because they were not totally convinced that she existed. Among the most active in the collective investigation was National Public Radio senior adviser Andy Carvin, who used his corporate backing and his global Twitter network to search for Amina. Immediately upon hearing about

12 The Facebook campaign "Free Amina Arraf" quickly gained 15,000 supporters, and her arrest sparked activity on Twitter, Petitionbuzz, and other social network sites. In turn, this activity was picked up by the mainstream media and used as raw material in editorials, with headlines such as "Let Her Go: Support Grows for Lesbian Blogger's Release. Abduction of Syrian-American Writer in Syria Prompts Online Campaigns for Release." Soon, offline actions were taken as well, such as the investigations initiated by US embassy officials in Syria and the steps taken by the freedom-of-expression organisation Reporters Without Frontiers, who demanded Amina's release (Bennett, 2011, p. 191).

Amina's arrest, Carvin activated his social media network in an attempt to find more facts in the case, or as he explains in his own words:

> During the first 24 hours of her supposed kidnapping, I began asking my Twitter followers if any of them knew her. To my surprise, I couldn't find anyone who had met her in person. People suggested I contact friends of hers she's known for several years, but they too only knew her online, and not in person. (Carvin, 2013)

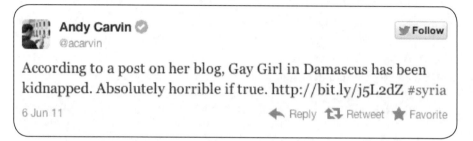

Figure 5.1. Screen shot of tweet by Andy Carvin. Text: "According to a post on her blog, Gay Girl in Damascus has been kidnapped. Absolutely horrible if true. [Link to the Gay Girl in Damascus-blog] # Syria." (6 June 2011).

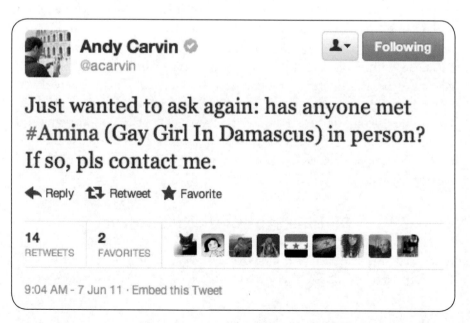

Figure 5.2. Screen shot of tweet by Andy Carvin. Text: "Just wanted to ask again: has anyone met #Amina (Gay Girl in Damascus) in person? If so, pls contact me" (7 June 2011).

The lack of response from his extensive and international network,[13] which encompassed central contacts in Syria itself, heightened Carvin's suspicions about the authenticity of the online identity known as Amina. At this stage, Carvin was joined by both corporate media organisations such as *The Washington Post* and by independent bloggers such as Liz Henry, and the final breakthrough in the investigation came after two journalist-activists at the website Electronic Intifada tracked the blog's IP address and found that it led to a computer in Scotland rather than in Syria. The Electronic Intifada then published a blog post on 12 June claiming that Tom MacMaster, an American postgraduate student at Edinburgh University in Scotland, had falsified the online persona of Amina Arraf.[14] According to Andy Carvin, this evidence was supported by image evidence, which eventually lead to MacMaster's confession:

> At first he denied being involved, but we then traced several photos that had been sent by the Gay Girl persona to her girlfriend in Montreal. They matched photos that had been taken by Tom's wife while on vacation in Damascus one year. We told them of our findings, and they soon confessed it was a hoax. (Carvin, 2013)

In conclusion, the three blog hoaxes analyzed in this chapter demonstrate certain patterns in terms of both how illusions of authenticity are produced online and how they might be exposed by collaborative investigative efforts. We have also seen that the time of exposure has contracted—the Kaycee (2001) persona was only revealed to be fake after more than two years in existence, while "lonelygirl15" (2006) and "A Gay Girl in Damascus" (2011) were each unmasked after approximately four months. This is likely due to better investigations as well as a more suspicious audience, especially when the online personas in question have no footprints in the non-virtual world. In addition, the development of the blog's interactive features, first and foremost in comments, makes the genre more robust with regard to various hoaxes and manipulations.

A Dialogic Authenticity Contract

After analysing selected cases of fake blogs, representing both the initial private "online diary" phase, the subsequent YouTube-fuelled video blog phase,

13 This tweet was distributed to Carvin's almost 75, 000 followers, and it was re-tweeted at least 14 times.
14 See Abunimah (2011, December 6).

and the more recent Arab Spring blogging phase, I found that users can be fooled by a blog's effective exploitation of genre conventions and authenticity illusions. In this concluding part of the chapter, I will investigate what categorises the authenticity contract in online media, and how it is renegotiated in the wake of a hoax.

Obviously, the general reaction from fans is outrage against the creators of the fake blogs, partly because they are seen to have undermined the empowerment potential of user-generated media. Here is one rather unforgiving blog comment on the "lonelygirl15" hoax:

> And no wonder she gets millions and millions of video views, it's cos [sic] she's cheating! And it makes me sick! ... YouTube's not for fake stuff! It's for real stuff! ... Kick her off of YouTube, she does not belong here. (Robinett, 2006, quoted in Walker Rettberg, 2008, p. 126)

In terms of the "A Gay Girl in Damascus" blog, perpetrator Tom MacMaster is also criticised, both for his disruption of the authenticity contract and his impact upon the perceived trustworthiness of bloggers:

> To Mr. MacMaster, I say shame on you!!! There are bloggers in Syria who are trying as hard as they can to report news and stories from the country. We have to deal with too many difficulties than you can imagine. What you have done has harmed many, put us all in danger, and made us worry about our LGBT activism. Add to that, that it might have caused doubts about the authenticity of our blogs, stories, and us. Your apology is not accepted, since I have myself started to investigate Amina's arrest. I could have put myself in a grave danger inquiring about a fictitious figure. Really ... Shame on you!!!
>
> To the readers and the western media I say there are authentic people in the Middle East who are blogging and reporting stories about the situation in their countries. You should pay attention to these people. (Gay Middle East, 13.06.2011)

Attempts were made by the producers of the fake blogs to justify their actions and minimise the negative impact upon readers. MacMaster, for example, argued that his fictitious narrator in fact best communicated the truth about the dangers of being gay in Damascus. His argument corresponds with an understanding of user-generated content produced by amateurs as more authentic than commercial news produced by corporate media, because ordinary people are empowered to tell their stories in an unpolished and unscripted format. Kaycee's creator, Debbie Swenson, apologized but also argued that Kaycee could have been real and represented many people who had suffered

a similar cancer disease.[15] A less apologetic response was given by the team behind "Bree," who, as mentioned above, turned the fake blog into a fictional blog while trying to build upon the success of the initial hoax. As if to punish the producers for their miscommunication, the former "Bree" fans did not support the fictional version. The appeal of the real "Bree" was not transferrable to a fictional "Bree," because the character's main asset and "claim to fame" had been her authenticity.

All of these reactions point to a broken authenticity contract between the online personas, or blog authors, and their audience. In some ways, this disruption resembles the occasional failure of the contract between the mass media and its audience. The difference is that, with user-generated content, the contract is based on *interpersonal or personal trust*, rather than *system trust*, as described by Luhmann (1988). Personal trust involves an emotional bond between individuals, and the emotional pain that each would experience in the event of betrayal serves as the protective basis of the trust, even when it is faced with the possibility of short-term gain if the trust were to be broken. This emotional weight is largely absent in system trust (Lewis & Wiegert, 1985). Yet, there are exceptions to the rule, and some mass mediated authenticity scandals might be experienced as deeply personal by members of the audiences. User-generated content relies on a more personal authenticity contract—one where the hierarchical order between producer and audience that is characteristic of mass media is replaced by a trust relationship between two equal parties. The fake blogs discussed in this chapter succeeded at first because of their sheer familiarity. "lonelygirl15" played heavily on the idea of "Bree" as the "girl next door," and "A Gay Girl in Damascus" addressed readers in an insecure, hesitant voice that instinctively encouraged trust.

One consequence of fake blogs is that the status of user-generated content as more real than the corporate news is devalued, and the "cyberpessimists," in particular, embraced the scandals as proof of their views. The Internet researcher Evgeny Morozov (2011, June 16), for example, characterised the Aminagate scandal as "a wake-up call from a fake Syrian blogger" while arguing that any belief in bloggers as trustworthy was naïve. In this interpretation of the authenticity puzzle, however, it seems to be taken for granted that blogs are supposed to be a news genre and not an art form. If

15 "A lot of people have problems," she told *The New York Times*. "I know I helped a lot of people in a lot of different ways" (Hafner, 2001).

we instead approach blogs as an art form, we might be able to appreciate the value of communicating at the border between fact and fiction, and thereby gain insight into a deeper truth about politics and human life. Philosophers have long seen art as a means of seeking the truth, or, as the Spanish painter Pablo Picasso suggested: "Art is a lie that makes us realize truth." (Zayas, 1923). Art has even been called the avenue to the highest knowledge available to humans and to a kind of knowledge impossible to attain by any other means. From this perspective, we might even find ourselves endorsing Walker Rettberg's (2008, p. 93) claim that on some level it does not really matter whether a blog is "real" or "true" or "authentic" because the reality it seeks to portray is best understood as an artistic expression of a kind of truthfulness that is often covered up in mainstream media. This liberal view of the blog genre is relevant to the understanding of the authenticity contract with regard to social media, because it enables a less rigorous divide between fact and fiction, and an acknowledgement of the authenticity puzzle as a default reception mode.

Accepting this blurring of the boundary between true stories and the imagination as a common feature of user-generated content implies that the authenticity contract, to a larger degree than ever, depends on a critical, interactive, and co-producing audience. Everybody is given a correspondingly greater responsibility as an online media consumer, because we must not only read a blog post, Wikipedia entry, or restaurant review but also evaluate its validity and intentions. Social media and blogs require a dialogical authenticity contract, in which users are empowered with new feedback tools and thus potentially become co-producers of that content, because they become partly responsible for evaluating and improving it. This two-way responsibility stands in sharp contrast to broadcasting, and its authority and responsibility as a social institution.

Throughout the chapters in the book, we have seen a gradual decline in institutional credibility and an increase in personal responsibility as a key historical development in the authenticity contract in mediated communication. In the next chapter, I will explore the role of authenticity in crafting an elite politician, and how mass media and social media work in tandem and thus strengthen the effect of the authenticity illusions. The chapter will analyze Barack Obama's journey to the powerful position as the president of the United States through the prism of mediated authenticity.

· 6 ·

PERFORMED AUTHENTICITY

The Obama Campaigns

Politics will eventually be replaced by imagery.
The politician will be only too happy to abdicate in favour of the image,
because the image is more powerful than he could ever be.
—Marshall McLuhan

Politicians' use of new media technologies has been a recurring theme in the book, and we have seen that the introduction of every new medium has redefined authenticity and therefore also applied new requirements for political campaigning. The previous chapters have demonstrated that the politician who at an early stage understood the potential of the new medium, and had the qualifications, skills, and network to take advantage of its potentials, had the upper hand in the campaigns. Among these pioneers were President Franklin D. Roosevelt, who with his 1930s and 1940s "fireside chats" used broadcast radio to connect intimately with the voters; John F. Kennedy, who in the early 1960s became the first presidential candidate who managed to use TV to his advantage; and Bill Clinton, who was the first to exploit the fragmented TV landscape in the early 1990s by appearing on talk shows targeted at specific audiences. In spite of their different styles and historical premises, these three presidents had in common that they managed to use the media to perform their roles as authentic presidents and to connect with the voters.

A key criterion for being elected as president of the United States is to come across to the voters as a trustworthy and honest person who has good intentions and will lead the country accordingly. Yet those voters' knowledge of the candidates is primarily, if not exclusively, derived from the media; how they perform in the media, how news and satire shows portray them, and how they are promoted in advertisements (Palmer, 2000; Thompson, 2000; Jamieson & Waldman, 2003; Trent, Friedenberg, & Denton, 2011; Sides & Vavreck, 2013). The relation between media and politics is recognized by interdependence, and "the economy is the backdrop from which the great play of modern presidential campaigns is performed" (Vavreck, 2009, p. 166). The presidential candidates will be judged on the basis of their surroundings and allies, of which the most important unit is their families; a seemingly happy and harmonious family life will enhance the candidates' trustworthiness and legitimacy as leaders.

The effect of the political campaigning and the politicians' likeability is difficult to define, because the various factors are often interrelated. Even though the starting point is always the central political and economic structural conditions, the media's reporting can influence the voters' perception of these matters. In election campaigns, political candidates will often attempt to take advantage of the structural conditions, to either support their candidacy or to undermine the candidacy of their opponent. Election campaigns are the crucial moment in the image building of a political candidate, because they are geared to presenting the candidates and their priorities to the voters (Jamieson, 2000; Jamieson & Miller, 2000; Maarek, 2009). This chapter will focus on the two elections won by Barack Obama, of which the first, in 2008, made him the first black president in the USA, and the second, in 2012, extended his presidential period with "four more years." The choice of Obama is not based on a claim that he is more authentic than other presidents, but rather that his campaigns particularly aspired to construct an image of an authentic candidate. This chapter is an examination of the crafting of Obama as authentic, both through his own media performances and the performances of his main allies.

The present chapter has three parts, following this introduction. In the first, I will discuss the main characteristics of an "authentic politician," and how this is central in political marketing and branding. In the second part, I explore the crafting of Obama as an authentic politician, and pinpoint three main strategies used in his major media performances, as well as the effect of Oprah Winfrey and Michelle Obama. Lastly, I explore the paradox of authentic performances in highly professionalized political campaigning.

Performing the Role as an Authentic Politician

Being an honest politician is about speaking the truth and avoiding lies, but being an *authentic* politician is about performing. The philosopher Lionel Trilling (1972) distinguished productively between being *genuine* and being *authentic*—the former is being true to others, while the latter is being true to your inner self. In our current media-saturated culture, I would nuance the definition of authenticity to encompass *performed authenticity*, meaning that the performer seems as though he or she is true to his or her inner self.

Defining authenticity as a *performance* rather than an ethical and psychological dimension, of course, evokes the insights of sociologist Erving Goffman (1959), who demonstrated that human interactions always involve a degree of performance of one's desired persona. Though he never used the term "authenticity" in his writings, Goffman discussed how we play the roles of ourselves in various settings, adjusting all the while to either the "front stage," where a more formal performance is required, or the "backstage," where we can be more relaxed and informal. The useful distinction between "front" and "back" in human interactions falls short in the analysis of broadcast media, however, as noted by Meyrowitz (1985). He pointed out that broadcast media such as television tend to expose back-region behaviour, blurring the distinction. As a result, Meyrowitz concluded that Goffman's twin terms should be extended to a third notion—namely, "middle region behaviour" (Ytreberg, 2002, p. 4). Modern political communication relies on broadcast media and its middle region as a means for politicians to build an ethos, directly addressing voters with messages not only about their opinions but also about their character, assumptions, and core values. A "middle region" behaviour suits politicians who aim to come across as personal and intimate; and the ability to seem authentic is a rhetorical skill.

In recent scholarship on rhetoric, authenticity has even been considered to be a separate dimension of an ethos that is achieved through three principal strategies. The first essential strategy is to seem *spontaneous*, and not staged, prepped, or obviously rehearsed. This can be achieved by a strategic performance that is indeed planned and rehearsed, but that is written to come across as natural, genuine, and unscripted. Presidential candidate Al Gore, for example, was regarded as inauthentic because he wore too much make-up in a TV debate, and because he came across as scripted and cautious. In all, he seemed more like a robot than a human being, according to political commentators (Johansen, 2002, p. 74; Jamieson, 2003, p. 29; Kjeldsen, 2006,

p. 123). Part of the trick, then, is to disguise the strategies, market research, and PR advice in one's interactions—to seem like a real person, not a marionette. Accordingly, politics is not all about the staged and manipulated; even though political performances are systematically orchestrated, the politicians also need to disclose an element of—pre-planned or improvised—spontaneity to be seen as authentic.

Second, authentic performers have to be *intimate*, meaning that politicians need to be personal and seem truly committed to their arguments. They share their thoughts and even confess to their audience in the interests of presenting a genuine inner self and even the possibility of intimate acquaintance. Political communication commonly evokes suspicion, because it is well known that politicians occasionally stretch the truth in order to come across with an appealing message.

Examples of politicians who have claimed to be telling the truth while employing typical back-region behaviours such as intimate confessions accompanied with tears, or looking straight into the camera, include Richard Nixon's Watergate acknowledgment and Bill Clinton's infamous "I did not have sexual relations with that woman," as a statement in the Lewinsky scandal.[1] Politicians will often attempt to play the authenticity card when they are under pressure. In turn, authentic performances based on lies will risk being revealed as fake, to sometimes devastating effect. Although authenticity can be crafted through marketing strategies, it cannot thrive in an atmosphere of distrust or falsehood. For instance, candidates who use borrowed material as if it were their own will be accused of plagiarism and will have reduced chances for a successful political career, particularly in the Internet age.[2]

Third, the authentic politician must be associated with a formidable degree of *consistency* in his or her personality, opinions, and character. People

1 The Lewinsky scandal was a political sex scandal emerging from a sexual relationship between President Bill Clinton and the White House intern Monica Lewinsky in 1998. Clinton first infamously denied the affair, but he later admitted in a grand jury testimony, as well as a televised statement, that he had been involved in an "improper physical relationship" with Lewinsky (Clinton, 1998).
2 Kentucky senator Rand Paul, for example, was considered unlikely to compete for the presidency after plagiarism allegations, or, as he himself said: "The footnote police have been dogging me for months," in response to the accusations by the media about widespread plagiarism in several speeches and his published book (Blake, 2013).

who change views and opinions according to the particular audience will appear to lack a core of inner values. Some experts attribute Al Gore's loss in the 2000 presidential election to his advisers' pressure on him to not mention environmental issues, a decision that "took away from him a considerable share of his authenticity" (Maarek, 2011, p. 53; see also Plouffe, 2009). The 2000 winner, George W. Bush, on the other hand, was called "Mister Consistency," as he, according to commentaries, repeated himself like a parrot throughout the campaign (Johansen, 2002, p. 75). Though Bush came across as less knowledgeable about political issues and facts, he won the authenticity competition because he was consistent and seemed true to himself, and thus also trustworthy. To summarize, the role of an authentic politician is constructed through performances of spontaneity, intimacy, and consistency.

Authenticity in Branded Politics

The current judgement of politicians as authentic or inauthentic is a fairly new phenomenon; from a historical perspective, the virtue of performed authenticity belongs to modern, rather than classical, rhetoric. Authenticity was not a key virtue in ancient Greece, for example, and the impression of "being oneself" was not particularly important—though a speech was supposed to seem natural, it was more important to be prepared, systematic, and capable.

The increased emphasis on authenticity in politics accompanied the growing importance of authenticity in other realms as well, such as the art and entertainment worlds, where a new definition of what constituted skilled acting emerged in the 1950s as part of the push towards authenticity. Previously, actors tended to perform in a broad, melodramatic, almost bombastic style rooted in the necessities of being audible in the acoustic theatre space. With technological advances in amplification and the rise of the film, ideas of realism and "method acting," as well as the Stanislavsky system, began to take root. These innovations, including, in particular, the microphone and broadcasting technology, also brought political speakers much closer to their audiences, and political rhetoric promptly became more personal, open, and conversational in style (Jamieson, 1988). Unlike the grand nineteenth-century rhetoric, as well, this new form of political communication brought with it the issues of "sincerity" and "authenticity." A politician who seems secure and comfortable is judged to be real and true, while the awkward politician appears false and contrived in comparison (Jamieson, 1988;

Jamieson & Waldman, 2003, p. 30). Still, acting is acting, even if it favours realism, and being an *authentic* politician is not the same thing as being a *truthful* politician.

The rhetoric of authenticity is used heavily to market retail goods ranging from blue jeans to coffee. Image building is closely related to contemporary brand culture, the practise of which increasingly shapes not only consumer habits but also political, cultural, and civic customs (Maarek, 2011; Banet-Weiser, 2012). In political marketing, the branding of individual politicians is thought to be key to popularity and votes, first and foremost in the US, where the voting system is highly personalized, but also in more party-centred areas such as the United Kingdom and the Nordic region (Scammell, 2007; Enli & Skogerbø, 2013).

Personalization of politics might turn the politician into a brand, and political communication into branding strategies. Recent literature on branding characterises Barack Obama as a successful political brand, or a "superbrand," with striking similarities between his brand and corporate giants such as Nike, Starbucks, and Apple (Klein, 2010; Scott, 2011, p. 164).[3] Obama introduced a celebrity frame of reference into a political sphere in an unprecedented effort to appear accessible, down-to-earth, and authentic. According to Naomi Klein (2010, p. xxv) Obama went a step further compared to previous presidents in terms of "turning the White House into a kind of reality show starring the lovable Obama clan." Comparing politics to reality TV seems fairly far-fetched but regarding both as arenas where authenticity is a key currency might make the comparison more plausible. The Obama brand is constructed by a humanization of politics where the president is the main brand, while his wife, children, and allies make up a collection of sub-brands.

The Authentic Candidate

The construction of an authentic presidential candidate requires enormous economic resources, to buy expensive airtime and hire top-flight marketers. Barack Obama's campaign team marshalled every tool in the modern marketing arsenal to create and sustain the Obama brand. Voters evaluate politicians on the background of their performance in the media, including both mainstream media and social media. In the case of Barack Obama, mainstream media are accused

3 Obama beat these corporate brands, when in 2008 he won the Associations of National Advertisers' top annual award, "Marketer of the Year" (Creamer, 2008).

of having a "love affair" with Obama during his election campaigns, and being too captivated with his candidacy to report impartially (Goldberg, 2009). In fact, during the first phase of the 2008 Obama campaign, his candidacy was covered more positively than previous presidents' equivalent campaign phases.[4] As with many love affairs, however, this also cooled off, and the media were substantially more critical of Obama during the second election campaign (Sides & Vavreck, 2013). As a parallel development, Obama's job approval ratings decreased steadily after the initial wave of support; between January 2009 and October 2011, the approval ratings dropped from 69 percent to 38 percent. Though Obama was re-elected in 2012, his popularity ratings continued to dip below 50 percent, and in 2013, his approval rating dropped from 52 percent to 41 percent.[5] This steady decline is partly explained by the so-called "second-term curse" upon any president, because politics is about making unpopular decisions (Saad, 2014). Yet Obama's two successful election campaigns in 2008 and 2012 prove that he came across to the public as authentic and trustworthy enough to win the majority of the votes both times.

A key strategy was to infuse the Obama brand with symbolic authenticity, not least visible in the use of social media, user-generated content, and non-corporate media productions. Among the most prominent examples are the "Obama girl" stunt, which tapped into the contemporary "participatory culture," and the works of street artist Shepard Fairey, such as the "Hope" poster, which brought the candidate both hipness and credibility (Klein, 2010; Banet-Weiser, 2012). Credibility is a currency for modern politicians, and their main goal during campaigns is to convince voters through mediated performances that they can be trusted (Westen, 2008; Vavreck, 2009). Next, I will investigate how Obama was constructed as an authentic politician, and to what degree his public performances were characterized by intimacy, consistency, and spontaneity.

Intimacy: Confessions and Storytelling

The crafting of Obama as an authentic politician started with the introduction of his life story and his personal motivations in his two autobiographies, which included compelling and intimate stories from his family background

[4] "In all, 36% of stories about Obama have been positive, vs. 35% that have been neutral. And 29% have been negative" (Pew Research Center's Journalism Project Staff, 2008).
[5] See "Presidential Approval Ratings—Barack Obama" (n.d.).

and formative years. The importance of these contributions is not least clear in light of the controversy about the authenticity of Obama's birth certificate in 2001 (see Kay, 2011), which demonstrates the importance for Obama to at an early stage come across as an authentic American. Political scientists as well as social psychologists pinpoint the importance of compelling and memorable storytelling to political candidates in order to "win the hearts and minds of the voters" (Westen, 2008, p. 423). Evidence from the last 50 years of US presidential campaigns demonstrates that the candidates benefit from telling stories that are easy for them to tell and that show them in the best light (Vavreck, 2009, p. 165). For Barack Obama, his "natural advantage" was his unusual background, which gave him a compelling story that no political advisor could manufacture. The compelling lifestory became Obama's hallmark, and certain carefully chosen events from his past, such as his parent's struggles and hard work underpinned his first years in the public eye.

The foundation of Obama's storytelling consists of his two autobiographies: *Dreams From My Father* (Obama, 1995/2004) and *The Audacity of Hope* (Obama, 2006). The literary genre autobiography provides its author with an autonomous capability to define its narratives, perspectives, and interpretations (Warner, 2013). Without critical interference from journalists or opponents, autobiographical authors decide what parts of their life stories to highlight and what parts to leave out. It is also common that the authors explain in the foreword that certain characters are composites to avoid critique, as did Barack Obama.[6] For these reasons, the autobiography is an attractive genre to politicians and other public figures who seek to control their image. Despite the genre's accepted tendency to draw a flattering picture of the author, its confessional literary form often gives the autobiography an aura of authenticity.

The impact of Barack Obama's autobiographies on the long-term crafting of an authentic politician must be understood in light of their strategic timing: The first autobiography was published in 1995 and had thus been available for nearly a decade when it was relaunched in 2004, in conjunction with Obama's acknowledged breakthrough in national politics.[7] Obama's second book was

6 "For the sake of compression, some of the characters that appear are composites of people I've known, and some events appear out of precise chronology" (Obama, 2004).

7 He had just given the keynote address at the Democratic National Convention in Boston, and "a print run of 75,000 [copies of *Dreams From My Father*] quickly sold out" (Berry & Gottheimer, 2010, p. xix).

likewise published in 2006, just three months before his 2008 presidential election campaign was announced, as if an authenticity ethos should protect him, to a certain extent, from personal attacks during his first campaign. Their layer of credibility arose from his apparently literal embodiment of his political messages of "change" and "hope." *Dreams From My Father* described Obama's childhood as the son of a black African father and a white American mother, and his personal search for identity in the US. Critics evaluated his writing as more trustworthy than that of other contemporary politicians: "What makes him different is he's also a good writer. Most books by today's politicians are glossy, self-serving, sometimes ghost-written puffery, which are designed to be sold as throwaway literature" (Woodard, 2008). This reception made the book seem honest, and strengthened Obama's credibility.

Paradoxically, Obama's exotic background would prove to be less a hindrance than an asset, as he connected his story directly to "The American Dream." Obama introduced himself to the American people as "the unlikely candidate," one without "personal wealth and a famous name," but with a "fire in me for fairness and justice."[8] The anti-elitism that he communicated signalised that his intentions were genuine, and that he was not polluted by money or power-alliances.

Obama's first autobiography, with the subtitle "a story of race and inheritance," addressed the perhaps number one obstacle for his candidacy; his blackness. Political commentators were in doubt about the voters' aim to be "colour-blind" in the election and choose Obama over a white candidate.[9] However, through the linking of his compelling life story to the greater narrative of "The American Dream," without leaving out the potentially difficult parts about ethnicity and heritage, Obama turned his obstacle into his strength, and embodied "hope" and "change," rather than "fear" and "foreignness." By confessing his ethnicity in an intimate and appealing storytelling, linking it to the great American narrative, Obama managed to influence the public agenda about his origin and loyalties at an early stage.

8 Barack Obama later explained that the linkage with the American dream was indeed deliberate: "I know what I want to do. I want to talk about my story as a part of the American story" (Berry & Gottheimer, 2010, p. xxiii).
9 In his blog, *The Washington Post* reporter Erza Klein (2008) argued that: "Barack Hussein Obama was, arguably, the country's most unlikely candidate for highest office. He embodied, or at least invoked, much of what America feared. His color recalled our racist past."

The second autobiography, *The Audacity of Hope*, was more of a political manifesto, and it was clear therein that Barack Obama was positioning himself to be a potential next US president. The volume outlines Obama's political opinions and spiritual beliefs and discusses key challenges for the US, and how they could be solved. Through his autobiographies, Obama introduced himself to the American people as a person *and* a politician, linking the two in a way that seemed seamless and believable.

Consistency: Barack Means "Blessed"

A second step in the construction of Obama as an authentic candidate was a *consistency* in his public performances so that he seemed genuinely grounded in his values and beliefs. The autobiographies had carefully crafted a consistent persona, as they made Obama seem like a man who did not reinvent himself as he had gradually got powerful positions, but rather stayed true to himself along the way.[10] The stories from his autobiographies were recurrently recycled in his subsequent public performances, as repositories for a veritable arsenal of stories.

Let's take one of the signature narratives reused in the 2008 election campaign; the story that explains that the name Barack means "blessed," and thus reduced its foreignness and legitimized Obama's prospects for the US presidency. In a nation still affected by the 9/11 terrorist attacks in 2001, his middle name "Hussein" evoked Saddam Hussein, who had represented a frightening threat to the United States at the time, and online discussions with titles such as "Is Barack Hussein Obama related to Saddam Hussein?"[11] cropped up as soon as he declared his candidacy. Accordingly, the Obama team knew that the name was a vulnerable aspect of their candidate, and they used autobiographical storytelling to frame it in the context of family values and Christianity, in order to make his ethnicity seem less frightening.

10 This quality was, for example, pinpointed by the critic for *The New York Times*, who observed that Obama in *The Audacity of Hope* wrote "movingly and genuinely about himself," and that "the reader comes away with a feeling that Mr. Obama has not reinvented himself as he has moved from job to job…but has instead internalized all those roles, embracing rather than shrugging off whatever contradiction they might have produced." The critic further argued that Obama "speaks to the reader as if he were an old friend from back in the days" (Kakutani, 2006).

11 See "Is Barack Hussein Obama Related to Saddam Hussein and Osama?" (n.d.).

In Obama's case, from early on, he used every opportunity to talk about his name and craft his legend, including the keynote speech at the 2004 Democratic National Convention:

> My father was a foreign student, born and raised in a small village in Kenya. He grew up herding goats, went to school in a tin-roof shack. His father, my grandfather, was a cook, a domestic servant. But my grandfather had larger dreams for his son. Through hard work and perseverance my father got a scholarship to study in a magical place: America, which stood as a beacon of freedom and opportunity to so many who had come before.
>
> They would give me an African name, Barack, or "blessed," believing that in a tolerant America your name is no barrier to success. They imagined me going to the best schools in the land, even though they weren't rich, because in a generous America you should not have to be rich to achieve your potential. They are both passed away now. Yet, I know that, on this night, they look down on me with pride. (Berry & Gottheimer, 2010)

The authenticity of a speech is communicated not only through storytelling and rhetoric, but also by the speaker's intonation and body language. Obama was soon recognized as a speaker with a special appeal to large crowds, as he managed to come across as enthusiastic, while also controlled and true to his own style. Obama's speeches mimicked the rhetorical style and the vignettes of his published work, and thus provided an image of consistency and trustworthiness.

Obama's claim to authenticity through consistency was also evident when he appeared as a guest on the popular talk show *The Oprah Winfrey Show*. There are many interesting aspects of Obama's relationship with Oprah Winfrey, and I will discuss these at length later in this chapter, but for now, I will focus on the re-telling of the "Barack means blessed" story, in the context of an informal chat with the daytime talk show queen Oprah Winfrey. The narrative is adjusted to the talk show format, and the moral in the interview is that unconventional names might be problematic, but that one should never compromise with one's ethnic heritage:

> *Oprah:* I was told when I first started out to change my name to Suzie because nobody would ever ... remember [Oprah].
>
> *Senator Obama:* The same thing happened to me. A political consultant, when we first started thinking about this Senate race, said, "You can have one funny name. You can be 'Barack Smith.' Or you can be 'Joe Obama.' But 'Barack Obama'—that's not gonna work." ("Man of the Moment," 2005)

This name conversation between Oprah and Obama serves to validate them both as authentic in the sense that they are not corrupted by advice from PR agents, as if that would prove that Obama is a trustworthy politician who will not compromise for the promise of popularity. The parallels between the name-stories of the politician and the TV host strengthened the message about Obama as an authentic politician, not least because Oprah was already accepted by the white middle-class. Their stories came across as true and authentic, but they nevertheless were not totally in accordance with the facts, as they both skip the complicated parts of their respective names—Obama's middle name, Hussein, and Oprah's original name, Orpah.[12] A format like *The Oprah Winfrey Show* favours the clear-cut before the complex, and thus gives little room for such details, but if the intention was to reveal the comprehensive truth behind their names, these facts might be relevant.

Spontaneity: Image-building in Social Media

The third essential element in the crafting of Barack Obama as an authentic president was the use of social media to build an image of a candidate who did not restrict his media appearances to the edited and formatted mass mediated images, but also shared more spontaneous and unscripted images with the public. Glimpses of the private arena were distributed through social media such as Facebook and Twitter to a greater extent by the Obama team than by competing campaigns (Hendricks & Denton, 2010; Stromer-Galley, 2014).

At a time when hackneyed images of politicians kissing babies or posing with celebrities had lost some of their appeal, the Obama campaign tapped directly into contemporary trends such as social media sharing and participation. It was a tech-savvy, cutting-edge approach—Obama was the first US presidential candidate on Facebook and purportedly filled out the information on his page himself (Kreiss, 2012). These social media updates were of course pre-planned, but they were designed to seem spontaneous and improvised, and therefore created an illusion of authenticity.

The significance of social media in the Obama campaign was not least evident by the fact that Twitter and Facebook were the chosen media platforms for the first announcement of the victory in 2012. A photo of President

12 Winfrey was named "Orpah" after the biblical character in the Book of Ruth, but people mispronounced it regularly and Oprah stuck. See "Oprah Winfrey" (1991).

Obama and Michelle Obama hugging and a text saying simply "Four more years" was released before any press conference or televised statement. This demonstrates that social media have partly replaced the traditional mass media as the authoritative arena for fast spread of global news, and that the Obama team wanted a glimpse of a seemingly private moment to illustrate the victory rather than a traditional press conference image. The appeal of the tweet is evident by the massive sharing of the photo, making the victory tweet, at the time, the most retweeted message in the history of Twitter:

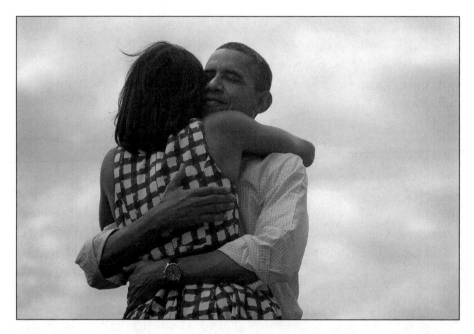

Figure 6.1. Four more years. A photo of Barack and Michelle Obama taken on the campaign trail in Iowa, August 15, 2012, which was tweeted on the election night when Obama was re-elected as US President. Photographer: Scout Tufankjian. Permission holder: Polaris Images.

Even though it was obviously meant to illustrate the couple's happiness after winning the election, the photo was not taken after the election victory but during a campaign rally in Iowa earlier that year. The photo is thus taken out of its original context, but is still authentic as a representation of the couple, because as explained by the campaign photographer, the image has caught the candidate and his wife in a moment of affection. The photographer was surprised to see her photo being used as a victory statement, and was not

informed beforehand (Nanos, 2012). The choice of this image, of course, was done on the basis of the Obama team's knowledge about what kind of images would appeal most instantly and strongly to social media users.

The team knew that the most popular photos posted on their social media accounts had three key features in common: First, they showed Barack Obama in his *private sphere and family settings*, in the role of husband or father or both, evoking the family photo albums rather than the official presidential portrait. The more private a photo seems to be, the more likes, comments, and retweets it seems to get from the users (Skivenes, 2013). Second, the most popular photos are characterised by their *spontaneity and lack of posing*, and a typical trait is that neither Obama nor his family members looks directly at the camera. Rather than posing before a camera, the Obama family is photographed while they are busy doing something else, like talking to each other, dancing, or playing around. The result is a documentary film "fly-on-the wall" aesthetic.

Image building in social media requires authenticity illusions, and in particular when consultants or advisors manage the account, as is the case for most elite politicians on social media. This practise might be termed social-media-ghost-writing, because the advisors post messages to seem like the politicians themselves wrote them, which is common also for politicians' speeches or opinion pieces. Contrasting the image of an active and involved social media politician, Obama did not write any of his tweets in the 2008 election campaign, and only one percent of the tweets posted on his account in the 2012 campaign. To avoid criticism for fraudulent messages, the Obama team launched the signature "bo" in the latter campaign to verify that Barack Obama was the real author of the tweet.

As such, we must assume that the most authentic tweets on Barack Obama's twitter account are the "bo" tweets, and I have therefore analyzed tweets to pinpoint what types of messages the exclusive signature supported. The "bo" tweets were mainly used for the purposes of *team building* and were aimed at strengthening the loyalty to the campaign among volunteers rather than appealing to new voters. As such, social media was used for purposes of internal communication for campaigners and supporters and to create a sense of communality, where the leader acknowledged the work of local campaigners in certain states. The authenticity illusions in Obama's signed tweets was typically *anti-elitist* and recognized by features such as a folksy tone, and mentions of humdrum meals such as "pizza," in addition to the reference to his "hoarse" voice as physical evidence of his *ordinariness*, in line with Roosevelt's request for a glass of water during his radio speech:

"The folks I just met over pizza in Iowa are exactly why I love coming to this state. Thanks for always making me feel at home. -bo" (Obama, 2012, October 24).

"What a great view, Virginia! My voice might be getting hoarse, but the energy out here is going strong. -bo" (Obama, 2012, October 25).

The aim to build alliances with the volunteers and to make sure they stay loyal and motivated until the crucial election day, the signed "bo" tweets during the last 48 hours before the voting closed were characterized by inclusive and *passionate* appeals:

"Thanks to everyone who is knocking on doors and making calls—you inspire me every day. I won't let up if you won't. -bo" (Obama, 2012, November 5).

"We're coming to the end of a long campaign—all that's left to do is get out the vote. Let's win this. -bo" (Obama, 2012, November 6).

"We're all in this together. That's how we campaigned, and that's who we are. Thank you. -bo" (Obama, 2012, November 6).

This way of using social media to communicate the sitting president's engagement for every voter and every campaigner across the nation is in line with how the Obama campaign took into use every media platform to construct the candidate as an authentic politician. Yet, the image of Obama as an authentic candidate was not complete without support from significant allies, who brought with them a set of additional authenticity markers.

Allies in Authenticity

An individual is hardly ever evaluated in a vacuum. Our friends and social networks are as a rule a part of our identity and how other people judge us. This is also the case for politicians, who are often evaluated on the basis of whom they socialize with, both professionally and socially. Of these, the family members, such as parents, spouses, and children are often the most prominent, because they are often regarded as reflections of the politician.

A formal version of the logic of alliances is the practice of endorsements, where political campaigns seek to benefit from the popularity of a celebrity, who publicly announces their support for the candidate. Various celebrities have endorsed presidential candidates, including Frank Sinatra and Bruce Springsteen, but the risk of being associated with the wrong celebrity have also resulted in broken alliances, and the Obama campaign, for example, turned down the offer from Lindsay Lohan because "her brand of tabloid infamy was

not what they were looking for" (Frazier, 2011). The Obama campaign rather chose Oprah Winfrey as a brand they would be associated with, because they thought she would increase Obama's popularity among certain demographic groups. Besides his wife Michelle Obama, Oprah played the most important supporting role in the campaign and its construction of Obama as an authentic president.

Oprah: Queen of Authenticity

Oprah Winfrey has been ranked as the as the most influential woman in the world and the most influential black person of the previous quarter-century. She was therefore considered one of the most lucrative allies for any marketer or campaigner during her heyday. In the 2008 campaign, she supported Obama's candidacy on several levels, of which the endorsement was the most explicit, and her TV interviews with him the most implicit.[13] I will focus mostly on the latter as this served as a public vetting of Obama as a political candidate at an early stage, and might even be seen as the launch of him as a promising young politician.

The Oprah Winfrey Show (1986–2011) was a unique show in that it was not a political show, but yet it had a significant political impact and was an arena where trust was negotiated. The show's popularity was beyond competition, and the show was for many decades among the most watched programs in the US. The show's influence was a result of this audience appeal, but in addition, the influence was related to a certain credibility of the host, which was achieved by Oprah's confessions to viewers, which made them feel that they knew her personally and could trust her judgement. The confessions included intimate and delicate issues such as her childhood poverty, her love life, her struggles with weight, and her difficulties as a celebrity (Parkins, 2001; Smith-Shomade, 2002). Through such confessions, Oprah gained a cult-like status as authentic and her show influenced the US culture in a way that has been termed the "Oprahification of America," which means a belief in authenticity of lived experience as a social truth (Shattuc, 1999, p. 187). In a sense, Oprah had been appointed as the manager of authenticity in the USA, and she could verify or disprove a person during an interview in her studio.

13 Obama was interviewed on the *Oprah Winfrey Show* at various stages in his political career, first as an Illinois senator, second as the newly elected president, and third as the sitting president.

She was the "queen of authenticity," and from this position she performed the role of an eyewitness and a guarantor for the trustworthiness of Barack Obama. This point is illustrated in the following dialogue about Obama's ability to "stay real" and remain authentic as a sitting president:

> Oprah: You know, I just have to say this, you seem so real—and I have spent time with you and your wife, Michelle. Do you think it's possible to remain this authentic and get things done in Washington? Is that possible?
>
> Senator Obama: You know, we're gonna find out ... I mean, listen ... one of the, one of the...
>
> Oprah: I just don't know if you can stay real. Can you stay real? [Shaking her head and changing her sitting position, as if to underscore the gravity of her question].
>
> Senator Obama: One of the things that I think people should know is that the vast majority of people in politics, I think, get in it actually for the right reasons. And I think that they're ... tempted by a couple of things. When you become a senator, for example—I notice that people started treating me differently.
>
> Oprah: How? How so? [Leaning forward, hand supporting her head, in an exaggerated position of attentiveness].
>
> Senator Obama: Well, you know, they are nice to me all the time ... and they pretend that everything you say make sense, which it doesn't, but they will nod and say, "Senator, that's a good point" ... so I think that if you don't have people around you that can remind you that what you just said makes *no* sense ... and, fortunately, I have my wife to do that continuously. (*The Oprah Winfrey Show*, 09.01, 2009)

The studio audience interrupts Obama four times during this sequence, with loud laughter, and the atmosphere seems intimate and relaxed. The president-elect appears comfortable with the talk show and the questions, which are routinely agreed upon beforehand. For the Obama campaign, the association with Oprah Winfrey represented several advantages, of which her iconic status in issues such as blackness, gender, and class background were most crucial, in addition to the fact that she had never before endorsed a candidate and therefore seemed genuine and "pure" (Graff, 2006; Pew Research, 2008; Garthwaite & Moore, 2008). Furthermore, the alliance with Oprah contributed to the crafting of Obama as an authentic politician, because she was America's supreme voice for honesty, moral, integrity, and the authentic self. Oprah's blackness was iconic because she symbolized that black people could achieve success, richness, and glamour if they worked hard, and she had a mainstream crossover appeal. Oprah was even more popular among white

middle-class women than black women and she thus represented an opportunity for Obama to tap into a post-racial credibility that made his blackness less frightening for the voters.

Oprah had her strongest fan base among women and represented a strong feminist voice in the US. Her endorsement of Obama thus made him seem trustworthy when he spoke about gender equality and women's rights. For Oprah, however, the Obama endorsement turned out to be a costly alliance, because taking sides reduced some of her credibility, not least as a feminist, because she chose a male, less experienced, African American politician before a female, more experienced white politician (Hillary Clinton). In turn, *The Oprah Winfrey Show* suffered in the ratings after her endorsement of Obama partly because she had then lost her appeal as the nation's unifying "authenticity queen."

Michelle: Lady of Ordinariness

Michelle Obama has become more popular than the president, partly because her role as a first lady is more ceremonial and invites less criticism compared with the president, and partly because she has an appeal of *ordinariness* that reaches beyond political polarization. Michelle's popularity is important for Barack Obama, and the marriage, and alliance, with her has benefitted his candidacy in several ways.

The alliance with Michelle has contributed to the crafting of Obama as an authentic president by adding a degree of ordinariness to his otherwise fairly intellectual and elitist image. Michelle is the icon of ordinariness in the sense that she symbolizes the working class, family values, and modern femininity. First, the *working class* background has been a key element in the narrative about Michelle, and her class journey from childhood poverty to an elite lawyer was told in many versions both during the 2008 election campaign, and later. Adding to the working-class image is the fact that Michelle is dark-skinned, and as such seen as more "authentic" black, and more rooted in the African American experience than her husband (Remnick, 2010; Smith, 2012; Cashill, 2012). In line with Oprah Winfrey, Michelle has been accused of inventing, or at least exaggerating, the story of a poor background to gain sympathy (Plouffe, 2009; Kelley, 2010; Maraniss, 2012). The accusations are supported by evidence that they were both less underprivileged than the storytelling implies, as the narratives are clearly staged to underline the transformation process, as in the fairytales. Yet, the narrative served the purpose of

providing Obama with a strengthened legitimacy as the voice of the people, because the first couple had both witnessed the struggles of the working class.

Second, Obama needed legitimacy as *a family man* with soft values, to counter the image of him as a "distanced elitist" or a "privileged phony." For this reason Obama frequently referred to his wife and their daughters during his speeches,[14] and they joined him on stage as symbol of his authenticity, but in contemporary politics, the first lady also needs to come across with a personality of her own, in order to sufficiently support her husband. Michelle was therefore invited to give a campaign speech at the Democratic National Convention, so that she could present herself but also legitimize Obama as a committed ordinary family man and soften his image:

> I come here as a mom whose girls are the heart of my heart and the center of my world—they're the first thing I think about when I wake up in the morning, and the last thing I think about when I go to bed at night. Their future—and all our children's future—is my stake in this election (Transcript: Michelle Obama's Convention Speech, 2008, August 25).

Michelle remained in the role as the caring mother and homely wife in the subsequent campaign appearances, such as when in an interview on national TV she told a story about calling her husband at the office and telling him they had ants, and asking him to stop and buy some bug killer on his way home. This story communicated that Obama might be a powerful politician, but that he is above all a family man.

Michelle Obama's third function was as an authentic representative of *modern femininity*. Historically, this is not unusual, and the most obvious example is the style icon Jacqueline Kennedy. As a more modern version of this style icon, Michelle recognizes that the role of first lady involves a female leadership where she engages in issues such as a healthy lifestyle and poverty awareness (Wilhoit, 2013). In her role, Michelle performs authentic leadership, as her athletic body has become a symbol of her genuine engagement in the issues she promotes. Michelle demonstrated her physical abilities by flexing her biceps before photographers, doing 25 push-ups on *The Ellen Show*, and working out on the reality show *The Biggest Loser*. Accordingly, Michelle seems like a superwoman, representing a modern femininity where physical strength, healthy

14 For example: "And the biggest star in the Obama family until the two girls grow up, the love of my life ... Give it up for Michelle Obama. Give it up!" (quoted in Berry & Gottheimer, 2010, p. 34).

eating, higher education, and professionalism is interconnected with family values and feminine appearance. She symbolizes the modern feminine woman.

In sum, Oprah and Michelle represented valuable allies for the Obama campaign, and supported the Obama brand with authenticity in the realm of gender politics, poverty issues, and family values. As such, the appeal of the Obama brand became more complete with the "queen of authenticity" and the "icon of ordinariness" as supportive allies. In the last part, I will explore the construction of Obama as an authentic politician as a negotiating between the candidate, the campaign staffers, the media, and the voters.

Negotiating Authenticity in Political Campaigns

Political campaigns are concerned with building an image of the candidate as trustworthy, likeable, and genuine. Political campaigning has, during recent years, become increasingly professionalized, and based on advanced methods for mobilizing voters (Stromer-Galley, 2014). Professionalization of politics has to a degree reduced the authenticity, because there is less and less space that is not mediated and pre-packaged by the campaign staffers. The politicians seldom appear in any TV debate, press conference, or interview without systematic preparations and rehearsals. To a degree, any space for improvisations, spontaneity, and randomness seems to be eliminated from political campaigning.

The search for authenticity is, however, among the key trends in contemporary culture, and politics is also among the arenas where authenticity is negotiated. The explanation might be nostalgia, in which we long for something that might never have existed, but yet seems like an ideal, such as the innocence of politicians who say what they really mean, and perform naturally as if they did not have media strategists. Voters need to believe that there is a real human being with genuine values and beliefs behind the staffer's spin and the media spectacle, otherwise they would not find it meaningful to vote. This explains, at least in part, why more than 40 percent of the voting age population in the US did not vote in the recent presidential elections. A typical trait of non-voters is that they tend to distrust the politicians and believe they are not genuinely interested in ordinary people.[15]

15 "Nonvoters: Who They Are, What They Think" (2012); "Nonvoters in America 2012," (2012).

The crafting of Barack Obama as an authentic politician was accordingly a key strategy to mobilize voters, including those who are generally sceptical towards politicians. The fact that authenticity can be manufactured is paradoxical, and it is therefore important to explore exactly how a campaign can create an authentic candidate, and to what degree manufactured authenticity is misleading the voters. The case study demonstrates that Obama was crafted as an authentic politician through strategic and pre-planned performances of intimacy, consistency, and spontaneity.

Such crafting of authenticity is made possible only by certain raw materials, which in this case were the candidate himself and his closes allies, Michelle Obama, and Oprah Winfrey. The three of them have all been scrutinized by the media and argued to be fake and adjusting their backgrounds to suit an appealing narrative. They have nevertheless managed to use their personal stories and their personal traits to come across as authentic in crucial performances, such as public speeches, TV interviews, and campaign arrangements. Certainly, there are exceptions to the rule, and in Obama's case he was criticised for being inauthentic when he used black vernacular such as dropping the "g" sound at the end of verbs, and thus diverged from his Standard English, in a speech at the Congressional Black Caucus in 2011. This style change is understandable in light of the accusations of Obama not being "black" in the political and social meaning of the word.[16] Obama has never explicitly claimed to be black because he was less concerned with racial credibility and more concerned with broadening his appeal to all ethnic groups (Rickford & Rickford, 2000; Cashmore, 2012; Smith, 2012). Obama's use of black dialect was of course an attempt to compensate for his lack of credibility as a representative for the Civil Rights tradition, but the lack of consistency backfired as bad publicity, and gave Obama's opponents fuel for the fire about his "phoniness."

The search for authenticity has become a primary concern for the voters, and the *authenticity puzzle* is about identifying evidence of the "real Obama" in the midst of a spin-driven campaign. To a large extent, the viewer is helped by the journalists when solving the puzzle, such as Oprah's interviews with Obama, and investigative journalism such as political talk shows and TV

16 Previously it has been used against Obama that he is not a typical black politician who has engaged in the Civil Rights movement: "Barack is viewed in part to be the white man in blackface in our community" (Remnick, 2008).

debates. Journalists often take on the role of evaluators of the authenticity of a candidate, and their judgements will be a mixture of their own first hand experiences and secondary sources of all kinds. There are moments during the campaign when political journalists might encounter the candidates "in real life," such as in a campaign event, on the road, or in the context of an interview. These are the moments when the journalists will scrutinize the candidates' behaviour and notice personal traits that might reveal a hidden side of the candidate. Along these lines, political journalists who encountered Obama during his election campaigns have argued that he seemed authentic in the role as the next president, and that he was truly motivated for the job (Berry & Gottheimer, 2010). As such, the negotiation of politicians' authenticity is among the key concerns for the candidates, the voters, and the journalists during a political campaign, and in the end it is the combination of the politicians' performances, the journalists' reporting, and the voters' evaluations that determines the candidate's authenticity.

· 7 ·

TOWARDS A THEORY OF MEDIATED AUTHENTICITY

I am half living my life between reality and fantasy at all times.

—Lady Gaga

This book investigates *mediated authenticity* and how the media *construct* reality. The media in this context should be understood as mediated communication, which, by definition, requires some measure of adjustment, refinement, and even manipulation to adequately communicate a message. Mediated communication is a process practiced by media professionals, such as movie producers and news editors, as well as amateurs, such as bloggers and social media users. These groups of media producers have in common their use of specific techniques designed to make them come across as authentic, and thus also trustworthy, believable, and appealing.

Mediated authenticity is a term that signals a certain pragmatism towards the media's construction of reality, as well as an awareness of the pre-planned, formatted, and manipulated aspects of mediated communication. As a term, it is neither relativist nor value free, but it does highlight the paradox whereby a negotiation between producers and audiences is crucial to the success of the communication. A key premise of this book is that mediated communication is our primary source of knowledge about the world and a common point of our navigation within it. Access to relevant, adequate, and trustworthy media

and communication is therefore essential to our quality of life, and it can even be a resource for ensuring the welfare of the citizens (Syvertsen et al., 2014). Thus the *degree* of manipulation in mediated communication is one of the most urgent research agendas in contemporary society.

In this concluding chapter, I will first summarise the main concepts and findings, with an emphasis on the authenticity scandals/puzzles and the renegotiation of authenticity that followed. Next I will discuss the history of mediated authenticity along both a linear and a more cyclical historical axis. Last I will outline a tentative theory of mediated authenticity, and on the basis of the findings in my case studies, I will suggest a set of criteria for and characteristics of mediated authenticity and propose further research in the field of mediated authenticity.

Summary of Main Findings

Mediated authenticity is constructed by *authenticity illusions*, such as the enhancement of raw material through adjustments that make it seem more realistic, genuine, and trustworthy. In a mediation process, as in all communication, reality is often too complex to represent completely. As storytellers, we have all adjusted our own narratives for the purposes of entertaining our audience.

Likewise, we are all aware that the media produces authenticity illusions in order to create a more efficient context for communication, and to reduce a narrative's complexity. We accept this thanks to the *authenticity contract*, an informal agreement regarding where the line is drawn between reality adjustment and outright fakery. Through such contracts, media producers and audiences both acknowledge that authenticity is a currency in mediated communication. Its value is negotiated among key stakeholders in the communication process—the audiences, the producers, and the policy makers. The introduction of new media technologies results in media innovation, migration of users, and new user patterns—and, in turn, new definitions of mediated authenticity.

In the vulnerable phase of new media implementation, the risk of *authenticity scandals*, or miscommunication, is particularly high. The launch of new media technologies often facilitates new ways of both representing and *manipulating* reality, which in turn challenges established audience practices for interpreting the media. Authenticity scandals might result from audience reactions, media coverage, or policy reactions—in whatever case, the

reactions will be significant. Miscommunications without reactions or consequences might be thought of as *authenticity puzzles*, which are teasing versions of authenticity scandals. With authenticity puzzles, producers break the authenticity contract in an attempt to rattle or intrigue audiences, thereby engaging people in a game of separating the real from the fake.

The Case Studies

The introductory phase of every new media technology and its renegotiation of the authenticity contract is a key interest in this book, and it has guided the choice of five case studies that examine mediated authenticity from a range of perspectives, across various stages of media history. In this section, I will summarise the main findings in each case study in order to discuss the historical development of mediated authenticity and to tentatively outline a theory for it.

The case study of the radio play *The War of the Worlds* (1938) analyses an *authenticity scandal* in which a significant share of the audience mistook the innovative use of genre conventions in a radio play for a real news bulletin about an alien invasion. A key finding in this case study is that seemingly *spontaneous* reactions by the reporter were used as authenticity illusions in the news report on the fictive invasion from Mars. A second key finding is that *genres* and conventions are fundamental for mediated authenticity, and that this genre system partially compensates for the void between senders and receivers in mediated communication. A third key finding is that the risk for miscommunication is particularly high in the *innovative phase* when a new medium is introduced to the public, requiring a renegotiation of the authenticity contract. The negotiations following this scandal resulted in stricter and more specific policy regulations for radio broadcasting in the context of a public debate about media effects and the manipulative power of mass media.

The case study of the *quiz show scandals* (1958), in which manipulated competitions were staged to seem authentic, analyses the *authenticity scandal* that occurred when the fraud became publicly known. Rather than causing panic during the transmission, the quiz shows earned producers much ire in the wake of revelations of faked performances by contestants who had been given the correct answers in advance. A key finding is that *spontaneous performances* were used as authenticity illusions, such as when the contestants were instructed to pause and look confused even though they knew the answers. A second finding is that the introduction of TV represented a commercial turn of events that increased pressure on the producers to meet *format criteria*

using manipulated performances. And third, it is clear that the negotiation of authenticity here encompassed a *legal institution*, law enforcement, and partly took place in the courtroom. The negotiations resulted in a long-lasting backlash against the game show genre, new policy restrictions for entertainment TV productions, and a debate about the quality of TV and its role in society.

The case study of Susan Boyle in the reality-TV show *Britain's Got Talent* (2008) analyses how this show's fusion of reality and fiction gave rise to an *authenticity puzzle*, and how it invited the viewers to solve the puzzle. A key finding is that Susan Boyle's *spontaneous performance*—seemingly uncontrolled and emotional rather than controlled and rational—made her seem authentic. A second finding is that the public's interpretation of Boyle as an authentic singer is located in a *nostalgic* desire for unrefined and unspoiled performances in a world dominated by mediated reality. A third finding is that Boyle achieved a level of Internet stardom that was unprecedented for reality-TV participants because of the pioneering effect of the combination of traditional TV and online sharing. The puzzle resulted in a discussion about the ethics of reality TV and the degree to which producers are cynically exploiting vulnerable participants.

In the case study of blog hoaxes, I found that *authenticity puzzles* are among the key activities with which users engage in digital mediated communication. A key finding is that authenticity illusions in the construction of online personas include *intimate disclosure*, but also ambivalence towards this confessional openness. A second finding is that the fake blogs copied contemporary trends and *conventions* in confessional blogs. And a third key finding is that the community of users engages in deconstructing fake personas, and as such, the negotiation of authenticity has become a *collaborative* and ongoing process. These puzzles resulted in a public debate about the validity of user-generated content as news sources and introduced fresh scepticism towards engaging in the tragic life stories of unknown others on the Internet.

The case study of the construction of Barack Obama as an authentic politician showed that media performances are infused by *authenticity puzzles*. In an age where politics is indeed concerned with branding and strategic PR management, the puzzle for the voters is to identify those moments of authenticity when the real politician is exposed. A key finding is that the construction of Obama as an authentic politician involved planned *spontaneity*, in the sense that his media appearances were always pre-planned, but that part of the planning was to make Obama seem unscripted. Second, the construction of Obama as authentic is based on a staged *intimacy* through autobiographical

storytelling and private confessions, as well as social media posts exposing the politician's family relations. Third, Obama is crafted as an authentic politician though his *consistent* performances, and has stayed true to his role as the engaged and dedicated, but always controlled, candidate. This authenticity puzzle resulted in the first election victory for a black president in the history of the United States, and thus a change in what is perceived as an authentic American president.

A History of Mediated Authenticity

From a historical perspective, the notion of authenticity is fairly recent—it evolved as an ideal alongside the development of modernism and industrialization in the latter part of the twentieth century. Typically, authenticity becomes a pressing matter once it is under pressure or threat (Benjamin, 1936; Trilling, 1971; Berman, 2009). This book has limited its scope to an analysis of the history of mediated authenticity over the past century or so, a timeframe in which the notion of authenticity became established in academic fields such as philosophical existentialism and critical theory.

The findings in the case studies could be discussed linearly or cyclically in the interests of informing the debate about historical recurrence. In the *linear history* of mediated authenticity, the focus is on cause and effect, and the cumulative outcome of authenticity scandals is an increased skepticism towards the media as a trustworthy source. In turn, policy makers and media regulators might react through new restrictions, communications laws, or incentives that intend to reduce the media's power. Increased skepticism furthermore results in new interpretative skills among the audience, as people learn to deconstruct authenticity illusions with time and experience. The case studies, for example, demonstrate that the most spectacular authenticity scandal in the history of broadcast media occurred in the first part of the previous century. From this linear perspective, then, the audience becomes more adept and aware with every successive generation. The linear history of mediated authenticity is a narrative of cumulative learning, whereby stakeholders' practices and expectations are perpetually readjusted according to previous experience.

Still, it is clear that with each new development in media technology and production, authenticity scandals again arise, making it tempting, as an alternative, to analyse the history of mediated authenticity *cyclically*. From this perspective, history is regarded as a perpetual recurrence of certain themes,

processes, and events rather than a linear progression through which the effects of one event impact the next and thus create change. In light of the theory of historical reoccurrence, the authenticity scandals could be understood as a reiteration of fairly similar triggers and processes of negotiation, rather than a cumulative and shared learning process. In support of this perspective, one could argue that similarities between authenticity scandals in early broadcasting and recent digital media hoaxes are iterations of the same pattern. As a result of the media producers' constant search for new authenticity illusions, there will continue to be miscommunication with the audience, intentional or unintentional. Accordingly, we might regard authenticity scandals as simply part of the history of the media—a part that is necessary to spur the renegotiation of the authenticity contract, and to stabilize the relationship between producers and audiences.

Towards a Theory of Mediated Authenticity

Scholars of media studies are reluctant to theorise mediated authenticity, as if the concept of authenticity dates exclusively to the era of critical theory (e.g., Benjamin, 1969; Adorno, 1973). On the other hand, the academic debate about media as "real" or "hyperreal" has occupied philosophical thinkers (e.g., Eco, 1986; Baudrillard, 1981). Writings about how the simulated has replaced the real as a rule draw upon examples from the media, such as reality TV and media spectacles, to illustrate arguments about (in)authenticity.

Yet media and communication studies have only investigated the paradox of mediated authenticity to a limited degree. This book aims to compensate for this limitation, and to offer a tentative theorisation of mediated authenticity in mass communication, as well as digital personal communication. The theory is based on the tripartite concept of authenticity illusions, the authenticity contract, and the authenticity scandal/puzzle, which, in sum, describe a process of negotiated authenticity in the media.

Mediated authenticity is a paradoxical phenomenon, and it is difficult to isolate the main markers of authenticity in the media as well. Based on the theoretical discussion in the introductory chapter, and the case studies in the subsequent chapters, there are nevertheless seven characteristics that stand out:

(1) *Predictability*: Mediated authenticity is crafted via a consistent use of genre features and conventions for mediated communication.

Trustworthiness of mediated content is often evaluated on the basis of previous experiences with the media.

(2) *Spontaneity*: Performances are rehearsed, directed, and pre-planned to seem improvised and spontaneous. The aim is to come across as personal, engaged, and emotionally driven rather than calculated and strategic.

(3) *Immediacy*: The immediate is closely related to "liveness" and imparts a sense of togetherness whereby the producers and the audiences are interconnected in a shared "now" in which they construct meaning and authenticity together.

(4) *Confessions*: Mediated authenticity is constructed from confessions and the disclosure of personal secrets or details about oneself that seem plausible because they are recognisable for the audience and resonate with their personal experiences.

(5) *Ordinariness*: The more mundane and ordinary a media persona appears to be, the more authentic and representative of "the people" he or she seems. Plainness or ordinariness is seen as authentic because it contradicts the glamorously mediated.

(6) *Ambivalence*: The ambivalent performance and the hesitant revelation of the "truth" seem more authentic than the unambiguous and confident performer who claims to be authentic in a mediated communication.

(7) *Imperfection*: The authentic performance or mise-en-scène often requires a degree of imperfection. Even the most perfect and polished scenes need an element of contrast where the illusion of authenticity is created by a minor flaw or mistake.

The above characteristics are by no means exhaustive, but in sum they make up a tentative set of criteria for identifying how mediated authenticity is created. Further research is needed to explore more systematically how media constructs its illusions of authenticity, and how the authenticity contract is renegotiated in new media.

REFERENCES

Abbate, J. (2000). *Inventing the Internet.* Cambridge, MA: MIT Press.

Abunimah, A. (2011, December 6). New evidence about Amina, the "Gay Girl in Damascus" hoax. Retrieved from http://electronicintifada.net/blogs/ali-abunimah/new-evidence-about-amina-gay-girl-damascus-hoax

Adorno, T. W. (1973). *The Jargon of authenticity.* Evanston, IL: Northwestern University Press (Original work published 1964).

Adorno, T. W. (1991). *The Culture industry. Selected essays on mass culture.* London, England & New York, NY: Routledge.

Adorno, T. W., & Horkheimer, M. (2002). The culture industry: Enlightenment as mass deception. In T. W. Adorno & M. Horkheimer (Eds.), *Dialectic of enlightenment: Philosophical fragments* (pp. 94–136). Stanford, CA: Stanford University Press (Essay originally published 1944).

Altheide, D., & Michalowski, S. R. (1999). Fear in the news: A discourse of control. *Sociological Quarterly,* 475–503.

Anderson, K. (1978). *Television fraud. The history and implications of the quiz show scandals.* Westport, CT: Greenwood Press.

Anderson, T., & Milbrandt, M. K. (2005). *Art for life: Authentic instruction in art.* Boston, MA: McGraw-Hill.

Aslama, M., & Pantti, M. (2006). Talking alone: Reality TV, emotions and authenticity. *European Journal of Cultural Studies,* 9(2), 167–184.

Aspects of dogma. (2000, December). Retrieved from http://pov.imv.au.dk/Issue_10/section_1/artc1A.html

Banet-Weiser, S. (2012). *Authentic TM. The politics of ambivalence in a brand culture.* New York, NY & London, England: New York University Press.

Barker, H., & Taylor, Y. (2007). *Faking it: The quest for authenticity in popular music.* New York, NY: W. W. Norton and Company.

Barnouw, E. (1970). *A history of broadcasting in the United States. Volume III: The image empire.* New York, NY & Oxford, England: Oxford University Press.

Barnouw, E. (1983). *Documentary: A history of the non-fiction film.* Oxford, England: Oxford University Press.

Barnouw, E. (1990). *Tube of plenty. The evolution of American television* (2nd ed.). New York, NY, & Oxford, England: Oxford University Press.

Barnouw, E. (2004). *The sponsor. Notes on modern potentates.* New Brunswick, Canada & London, England: Transaction (Original work published 1978).

Barthes, R. (1968). The reality effect. In R. Barthes (Ed.), *The rustle of language* (pp. 141–148). Oxford, England: Blackwell (Essay originally published 1968).

Barthes, R. (1977). *Image, music, text.* New York, NY: Hill & Wang.

Bastiansen, H., & Dahl, H. F. (2008). *Norsk mediehistorie* [Norwegian media history]. Oslo, Norway: Universitetsforlaget.

Baudrillard, J. (1981). *Simulacres et simulation.* Paris, France: Editions Galilee.

Baudrillard, J. (1983). *Simulations.* New York, NY: Semiotext(e).

Baudrillard, J. (2008). *Radical alterity.* Los Angeles, CA: Semiotext(e)/Foreign Agents Series.

Bauer, S. W. (2008). *The art of the public grovel: Sexual sin and public confession in America.* Princeton, NJ: Princeton University Press.

Baughman, J. L. (2007). *Same time, same station. Creating American television, 1948–1961.* Baltimore, MD: Johns Hopkins University Press.

Baum, M. A., & Kernell, S. (2001). Economic class and popular support for Franklin Roosevelt in war and peace. *Public Opinion Quarterly, 65*(2), 198–229.

Bauman, Z. (2000). *Liquid modernity.* Cambridge, MA: Polity Press.

Baym, N. K. (2010). *Personal connections in the digital age.* Cambridge, MA & Malden, MA: Polity Press.

Bell, A. (1991). *The language of news media.* Oxford, England: Blackwell.

Bell, A. (1991b). Hot air: Media, miscommunication and the climate change issue. In N. Coupland, H. Giles, & J. M Wiemann (Eds.), *Miscommunication and problematic talk* (pp. 259–282). Newbury Park, CA: Sage.

Benjamin, L. M. (1993). In search of the Sarnoff "radio music box" memo. *Journal of Broadcasting and Electronic Media, 37*(3), 325–335.

Benjamin, W. (1969). The work of art in the age of mechanical reproduction. In W. Benjamin (Ed.), *Illuminations.* New York, NY: Schocken Books (Original work published 1936).

Benkler, Y. (2006). *The wealth of networks: How social production transforms markets and freedom.* New Haven, CT: Yale University Press.

Bennett, D. (2011). A "gay girl in Damascus," the mirage of the "authentic voice"—and the future of journalism. In R. L. Keeble & J. Mair (Eds.), *Mirage in the desert: Reporting the Arab Spring* (pp. 187–195). Bury St. Edmunds, England: Abramis Academic.

REFERENCES

Bennett, J. (2011). *Television personalities. Stardom and the small screen.* London, England & New York, NY: Routledge.

Berman, M. (2009). *The Politics of authenticity: Radical individualism and the emergence of modern society.* New York, NY & London, England: Verso.

Berners-Lee, T. (1999). Realising the full potential of the Web. *Technical Communication: Journal of the Society for Technical Communication, 46*(1), 79–82.

Berry, M. F., & Gottheimer, J. (2010). *Power in words: The stories behind Barack Obama's speeches, from the State House to the White House.* Boston, MA: Beacon Press.

Beverland, M. B. (2005). Crafting brand authenticity: The case of luxury wines. *Journal of Management Studies, 42*(5), 1003–1029.

Biskind, P. (2013). *My lunches with Orson. Conversations between Henry Jaglom and Orson Welles.* New York, NY: Metropolitan Books.

Blake, A. (2013, November 4). Rand Paul's plagiarism allegations, and why they matter. *The Washington Post.* Retrieved from http://www.washingtonpost.com/blogs/the-fix/wp/2013/11/04/rand-pauls-plagiarism-allegations-and-why-they-matter/

Blanchet, R., & Vaage, M. B. (2012). Don, Peggy and other fictional friends? Engaging with characters in television series. *Projections, 6*(2), 18–41.

Blood, R. (2000, September 7). Weblogs: A history and perspective. Retrieved from http://www.rebeccablood.net/essays/weblog_history.html

Boddy, W. (1990). *Fifties television. The industry and its critics.* Urbana, IL & Chicago, IL: University of Illinois Press.

Bolter, D. J. (2001). *Writing spaces: Computers, hypertext, and the remediation of print.* Mahwah, NJ: Lawrence Erlbaum.

Bonner, F. (2003). *Ordinary television. Analyzing popular TV.* London, England & Thousand Oaks, CA: Sage.

Boorstin, D. J. (1987). *The image: A guide to pseudo-events in America.* New York, NY: Atheneum (Originally published as *The image or what happened to the American dream?* in 1961).

Boorstin, D. J. (1995). Consumer's palaces. In R. Boorstin (Ed.), *The Daniel J. Boorstin reader.* New York, NY: Modern Library/Random House.

boyd, d. (2004). Friendster and publicly articulated social networks. *Conference on Human Factors and Computing Systems (CHI 2004).* Vienna, Austria: ACM Press.

boyd, d. (2006). A blogger's blog: Exploring the definition of a medium. *Reconstruction, 6*(4). Retrieved from http://www.danah.org/papers/ABloggersBlog.pdf

boyd, d. (2007). Why youth (heart) social network sites: The role of networked publics in teenage social life. In D. Buckingham (Ed.), *MacArthur Foundation series on digital learning—Youth, identity, and digital media volume.* Cambridge, MA: MIT Press.

Brecht, B. (1930/1983). Radio as a means of communication. In A. Mattelart & S. Siegelaub (Eds.), *Communication and class struggle 2: Liberation, socialism.* New York, NY: International General.

Briggs, A., & Burke, P. (2002). *Social history of the media: From Gutenberg to the Internet.* Cambridge, England: Polity Press.

Brook, Stephen. (2009, June 3). Susan Boyle: press warned to back off Britain's Got Talent star. *The Guardian.* http://www.theguardian.com/media/2009/jun/03/susan-boyle-britains-got-talent-press-warned

Browne, N. (1994). *American television. New directions in history and theory.* Los Angeles, CA: Harwood Academic.

Bruns, A. (2008). *Blogs, Wikipedia, Second Life and beyond: From production to produsage.* New York, NY: Peter Lang.

Bruns, A. (2010). News produsage in a pro am mediasphere. In G. Meikle & G. Redden (Eds.), *News online: Transformations and continuities* (pp. 132–147). London, England: Palgrave Macmillan.

Bucher, T. (2012). The friendship assemblage: Investigating programmed sociality on Facebook. *Television & New Media.*

Buhite, R. D., & Levy, D. W. (1992). *FDR's fireside chats.* London, England & New York, NY: Penguin Books.

Burns, T. (1977). *The BBC: Public institution and private world.* London, England: Macmillan.

Bush, V. (1945, July 1). As we may think. *The Atlantic Magazine.* Retrieved from http://www.theatlantic.com/magazine/archive/1945/07/as-we-may-think/303881/

Bush, V. (1991). The inscrutible "thirties." In J. Nyce & P. Kahn (Eds.), *From memex to hypertext: Vannevar Bush and the Mind's Machine.* London, England: Academic Press (Original work published in *Technology Review* in 1933).

Butler, J. G. (2011). When smoke gets in your eyes: Historicizing visual style in Mad Men. In G. Edgerton (Ed.), *Mad Men. Dream come true TV* (pp. 55–72). New York, NY: I.B. Tauris.

Cashmore, E. (2012). *Beyond Black: Celebrity and Race in Obama's America.* London, England & New York, NY: Bloomsbury.

Cadwalladr, C. (2010, May 30). Susan Boyle: What happened to the dream? *The Guardian.* Retrieved from http://www.theguardian.com/music/2010/may/30/susan-boyle-the-dream

Cantril, H. (1940). *The invasion from Mars: A study in the psychology of panic.* Princeton, NJ: Princeton University Press.

Carpentier, N. (2001). Managing audience participation. The construction of participation in an audience discussion programme. *European Journal of Communication, 16*(2), 209–232.

Carpentier, N. (2012). Bastard culture! How user participation transforms cultural production [Review of the book *Bastard culture! How user participation transforms cultural production*, by M. T. Schäfer]. *European Journal of Communication, 27*(2), 211–212.

Carvin, Andy (2013), qualitative interview conducted by research assistant Anne Nordheim.

Cashill, J. (2012, June 16). Why Barack Obama got married. *WND Commentary.* Retrieved from http://www.wnd.com/2012/05/why-barack-obama-got-married/

Castells, M. (2007). Communication, power and counter-power in the network society. *International Journal of Communication, 1*(1), 238–266. Retrieved from http://ijoc.org/index.php/ijoc/article/viewArticle/46

Chandler, D. (1997). An introduction to genre theory. Retrieved from http://www.aber.ac.uk/media/Documents/intgenre/intgenre.html

Chapman, J. (2005). *Comparative media history. An introduction: 1789 to the present.* Cambridge, England & Malden, MA: Polity Press.

REFERENCES

Clinton, B. (1998, January 26). Response to the Lewinsky allegations. Retrieved from http://millercenter.org/scripps/archive/speeches/detail/3930

Cohen, E. (1988). Authenticity and commoditization in tourism. *Annals of tourism research, 15*(3), 371–386.

Colarusso, D. (2009, April 16). Is Susan Boyle the real thing? *Business Insider.* Retrieved from http://www.businessinsider.com/is-susan-boyle-the-real-thing-2009-4

Coleridge, S. T. (1817). *Biographia literaria: Or, biographical sketches of my literary life and opinions.* London, England: Fenner.

Collins, S. (2007). Traversing authenticities. *The West Wing* president and the activist Martin Sheen. In K. Riegert (Ed.), *Politicotainment: Television's take on the real.* New York, NY: Peter Lang.

Cooper, E., & Jahoda, M. (1971). The evasion of propaganda: How prejudiced people respond to anti-prejudice propaganda. In W. Schramm & D. Roberts (Eds.), *The process and effects of mass communication.* Urbana, IL: University of Illinois Press.

Corner, J. (2003). Introduction: The re-styling of politics? In D. Pels (Ed.), *Media and the restyling of politics: Consumerism, celebrity and cynicism.* London, England; Thousand Oaks, CA; & New Delhi, India: Sage.

Couldry, N. (2000). *The place of media power. Pilgrims and witnesses of the media age.* London, England & New York, NY: Routledge.

Cowell, S. (2009, June 20). After the Britain's Got Talent backlash, Simon Cowell finally admits: 'Sorry, I did make mistakes', in *The Daily Mail:* http://www.dailymail.co.uk/tvshowbiz/article-1194302/After-Britains-Got-Talent-backlash-Simon-Cowell-finally-admits-Sorry-I-did-make-mistakes.html

Creamer, M. (2008, Oct 17). Obama wins!...Ad Age's Marketer of the Year. *Ad Age.* Retrieved from http://adage.com/article/moy-2008/obama-wins-ad-age-s-marketer-year/131810/

Crisell, A. (1994). *Understanding radio* (2nd ed.). London, England & New York, NY: Routledge.

Crisell, A. (2002). *An introductory history of British broadcasting.* London, England & New York, NY: Routledge.

Crook, T. (1999). *Radio drama: Theory and practice.* London, England & New York, NY: Routledge.

Crowston, K., & Williams, M. (2000). Reproduced and emergent genres of communication on the World Wide Web. *Information Society, 16*(3), 201–215.

The Dating Game (ABC, 1965–1973).

Dayan, D., & Katz, E. (1992). *Media Events. Live Broadcasting of History.* Cambridge, MA: Harvard University Press.

DeLong, T. (1991). *Quiz craze: America's infatuation with game shows.* New York, NY: Praeger.

Dettmar, K., & Richey, W. (1999). *Reading rock and roll: Authenticity, appropriation, aesthetics.* New York, NY: Columbia University Press.

Deuze, M. (2012). *Media life.* Cambridge, England: Polity Press.

Deveney, C. (2013). Susan Boyle: My relief that I have Asperger's. *The Guardian.* Retrieved from http://www.theguardian.com/music/2013/dec/08/susan-boyle-autism

Dienst, R. (1994). *Still life in real time. Theory after television.* Durham, NC & London, England: Duke University Press.

Dieter, E. M. (2013). *Enduring character: The problem with authenticity and the persistence of ethos* (Doctoral dissertation, University of Austin, Texas). Retrieved from http://repositories.lib.utexas.edu/handle/2152/23147?show=full

Douglas, S. J. (1999). *Listening in. Radio and the American imagination.* New York, NY: Times Books/Random House.

Dovey, J. (2000). *Freakshow. First-person.* London, England: Pluto Press.

Dovey, J. (2001). Reality TV: Introduction. In G. Creeber, T. Miller, & J. Tulloch (Eds.), *The television genre book* (pp. 134–136). London, England: British Film Institute.

Doyle, G. (2002). *Media ownership. The economics and politics of convergence and concentration in the UK and European media.* London, England & Thousand Oaks, CA: Sage.

Drake, B. (2013, September 5). What strategies do YOU use to protect your online identity? Retrieved from http://www.pewresearch.org/fact-tank/2013/09/05/what-strategies-do-you-use-to-protect-your-online-identity/

Eco, U. (1986). *Travels in hyperreality. Essays* (W. Weaver, Trans.). San Diego, CA: Harvest/Harcourt (Original work published 1973 as *Il costume di casa/Faith in fakes*).

Elam, K. (1980). *The semiotics of theatre and drama.* London, England & New York, NY: Routledge.

Elboghdady, D. (2013, April 24). Market quavers after fake AP tweet says Obama was hurt in White House explosions. *The Washington Post.* Retrieved from http://www.washingtonpost.com/business/economy/market-quavers-after-fake-ap-tweet-says-obama-was-hurt-in-white-house-explosions/2013/04/23/d96d2dc6-ac4d-11e2-a8b9-2a63d75b5459_story.html

Elliott, C. (2003). HUMANITY 2.0. *Wilson Quarterly, 27*(4), 13–20.

Ellis, J. (2000). *Seeing things. Television in the age of uncertainty.* London, England & New York, NY: I.B. Tauris.

Ellison, N., & boyd, d. (2007). Social network sites: Definition, history, and scholarship. *Journal of Computer-Mediated Communication, 1*(13), 210–230.

Ellison, N., Heino, R., & Gibbs, J. (2006). Managing impressions online: Self-presentation processes in the online dating environment. *Journal of Computer-Mediated Communication, 11*(2), 415–441.

Elsaesser, T. (1994). TV through the looking glass. In N. Browne (Ed.), *American television. New directions in history and theory.* Los Angeles, CA: Harwood Academic.

Enli, G. S. (2001). Tromsø inn i TV-alderen. Nærbilde av et tidsskille. In H. G. Bastiansen & Ø. Meland (Eds.), *Fra eidsvoll til marienlyst, studier i norske mediers historie fra Grunnloven til TV-alderen* (pp. 240–257). Kristiansand, Norway: Høyskoleforlaget.

Enli, G. S. (2007). *The participatory turn in broadcast television: Institutional, editorial and textual challenges and strategies* Doctoral dissertation, University of Oslo, Norway). Oslo, Norway: Unipub AS.

Enli, G. S. (2008). Redefining public service broadcasting: Multi-platform participation. *Convergence, 14*(1), 105–120.

Enli, G. S. (2009). Mass communication tapping into participatory culture. Exploring *Strictly Come Dancing* and *Britain's Got Talent. European Journal of Communication, 24*(4), 481–493.

Enli, G. S., & Ihlebæck, K. A. (2011). 'Dancing with the audience': Administrating vote-ins in public and commercial broadcasting. *Media Culture Society*, 2011 33(6), 953–962.

Enli, G., & Thumim, N. (2012). Socializing and self-representation online: Exploring Facebook. *Observatorio (OBS*) Journal*, vol. 6(1), 87–105.

Enli, G. S., Moe, H., Sundet, S. V., & Syvertsen, T. (2013). From fear of television to fear for television. Five political debates about new technologies. *Media History*, 19(2), 213–227.

Enli, G. S., & Skogerbø, E. (2013). Personalized campaigns in party-centred politics. *Information, Communication and Society*, 16(5), 757–774. doi: 10.1080/1369118X.2013.782330

Eriksen, T. H. (2002). *Ethnicity and nationalism* (2nd ed.). London, England: Pluto Press.

Farquhar, L. K. (2009). *Identity negotiation on Facebook.com* (Doctoral dissertation). University of Iowa, Iowa City. Retrieved from http://ir.uiowa.edu/etd/289/

Fine, G. A. (2003). Crafting authenticity: The validation of identity in self-taught art. *Theory and Society*, 32(2), 153–180.

Fischer, C. (1992). *America calling: A social history of the telephone to 1940*. Berkeley, CA & Los Angeles, CA: University of California Press.

Fisher, L. (2009, April 24). Is Susan Boyle the real deal? Retrieved from http://abcnews.go.com/Entertainment/SummerConcert/story?id=7414312&page=1

Fox fires coproducer of *Totally Hidden Video*. (1989, July 13). *The Chicago Tribune*. Retrieved from http://articles.chicagotribune.com/1989-07-13/features/8902170164_1_candid-camera-quantum-media-alan-funt

Franklin, B. (1999). *Social policy, the media and misrepresentation*. London, England & New York, NY: Routledge.

Frazier, J. (2011, December 21). Top 10 celebrity political endorsements from hell. *The Washington Times*. Retrieved from http://www.washingtontimes.com/news/2011/dec/21/top-10-celebrity-political-endorsements-from-hell/

Freidel, F. B. (1973). *Franklin D. Roosevelt, vol. 4: Launching the New Deal*. London, England: Little, Brown & Company.

Frith, S. (1996). *Performing rites: On value in popular music*. Oxford, England: Oxford University Press.

Gallup daily (2013). Obama job approval. Retrieved from http://www.gallup.com/poll/113980/gallup-daily-obama-job-approval.aspx

Gamson, J. (1994). *Claims to fame: Celebrity in contemporary America*. Berkeley, CA: University of California Press.

Gans, H. J. (1979). *Deciding what's news: A study of CBS Evening News, NBC Nightly News, Newsweek, and Time*. Evanston, IL: Northwestern University Press.

Garthwaite, C., & Moore, T. (2008). The role of celebrity endorsements in politics: Oprah, Obama, and the 2008 Democratic Primary. Retrieved from http://www.stat.columbia.edu/~gelman/stuff_for_blog/celebrityendorsements_garthwaitemoore.pdf

Gay Girl from Damascus blog (2011): http://damascusgaygirl.blogspot.no/2011/04/my-father-hero.html, (accessed: 2011). http://www.theguardian.com/world/2011/jun/13/gay-girl-damascus-blog)

Gay Middle East (*13.06.2011*). Syria: 'Gay Girl' hoax: from Damascus with love: Blogging in a Totalitarian State, www.wluml.org, last accessed: 01.08.2014.

Geary, P. (1986). Sacred commodities: The circulation of medieval relics. In A. Appadurai (Ed.), *The social life of things: Commodities in cultural perspective* (pp. 169–191). Cambridge, England: Cambridge University Press.

Geraci, C. (2004). Greg Packer is the "man on the street." *Editor & Publisher*. Retrieved from http://www.editorandpublisher.com/PrintArticle/Greg-Packer-Is-the-Man-on-the-Street.

Gilder, G. (1992). *Life after television. The coming transformation of media and American life*. New York, NY: W. W. Norton.

Gilmore, J., & Pine, J. (2007). *Authenticity: What consumers really want*. Boston, MA: Harvard Business School Press.

Goffman, E. (1959). *The presentation of self in everyday life*. New York, NY: Doubleday.

Goldberg, B. (2009). *A slobbering love affair: The true (and pathetic) story of the torrid romance between Barack Obama and the mainstream media*. Washington, DC: Regnery.

Goldman, R. (2013, January 16). Shocking celebrity confessions. *ABC News*. Retrieved from http://abcnews.go.com/US/shocking-celebrity-confessions/story?id=18222873#2

Golomb, J. (1995). *In search of authenticity*. London, England & New York, NY: Routledge.

Graff, G. M. (2006, December 1). Could Oprah help elect Obama? *The Washingtonian*. Retrieved from http://www.washingtonian.com/articles/people/could-oprah-help-elect-obama/

Grazian, D. (2004). The symbolic economy of authenticity in the Chicago blues scene. In A. Bennett & R. A. Peterson (Eds.), *Music scenes: Local, translocal, and virtual* (pp. 31–47). Nashville, TN: Vanderbilt University Press.

Grindstaff, L. (2002). *The money shot: Trash, class, and the making of TV talk shows*. Chicago, IL & London, England: University of Chicago Press.

Gross, R., & Acquisti, A. (2005). Information revelation and privacy in online social networks. *Proceedings of the ACM WPES'05* (pp. 71–80). New York, NY: AMC Press.

Grossman, L. (2006, December 25). You—yes, you—are TIME's Person of the Year. *Time Magazine*. Retrieved from http://content.time.com/time/magazine/article/0,9171,1570810,00.html

Guignon, C. B. (2004). *On being authentic. Thinking in action*. London, England & New York, NY: Routledge.

Gunning, T. (1989). An aesthetic of astonishment. Early film and the (in)credulous spectator. In M. Cohen & L. Braudy (Eds.), *Film theory and criticism. Introductory readings* (pp. 818–832). New York, NY: Oxford University Press.

Habermas, J. (1984). *The theory of communicative action. Vol. 1: Reason and rationalization of society*. (T. McCharty, Trans.). Boston, MA: Beacon Press.

Hafner, K. (2001, May 31). A beautiful life, an early death, a fraud exposed. *The New York Times*. Retrieved from http://www.nytimes.com/learning/teachers/featured_articles/20010531thursday.html

Hall, S. (1973). *Encoding and decoding in the television discourse*. Birmingham, England: University of Birmingham Centre for Contemporary Cultural Studies.

Hall, S. (1989). The "first" new Left. In S. Hall (Ed.), *The Oxford University Socialist discussion group*. London, England: Verso.

Hand, R. J. (2006). *Terror on the air! Horror radio in America 1931–1952*. Jefferson, NC: McFarland.

Hand, R. J., & Traynor, M. (2011). *Radio drama handbook: Audio drama in context and practice*. New York, NY: Continuum.

Hawley, K. (2012). *Trust: A very short introduction*. Oxford, England: Oxford University Press.

Helland, K. (1993). *Public service and commercial news: Contexts of production, genre conventions and textual claims in television*. Leicester, England: University of Leicester.

Hendricks, J. A., & Denton, R. E. (2010). *Communicator-in-chief: How Barack Obama used new media technology to win the White House*. Lanham, MD: Lexington Books.

Hendy, D. (2000). *Radio in the global age*. Cambridge, England: Polity Press.

Herbert, S. (2004). Introduction. In S. Herbert (Ed.), *A history of early TV* (Vol. 1). London, England & New York, NY: Routledge.

Herring, S. C. (Ed.). (1996). *Computer-mediated communication: Linguistic, social, and cross-cultural perspectives*. Amsterdam, The Netherlands: John Benjamins.

Hess, M. (2005). Hip-hop realness and the white performer. *Critical Studies in Media Communication, 22*(5), 372–389.

Hiemstra, G. (1982). Teleconferencing, concern for face, and organisational culture. In M. Burgoon (Ed.), *Communication yearbook 6* (pp. 874–904). London, England & Los Angeles, CA: Sage.

Hill, A. (2005). *Reality TV: Audiences and popular factual television*. London, England & New York, NY: Routledge.

Hoerschelmann, O. (2006). *Rules of the game. Quiz shows and American culture*. Albany, NY: State University of New York Press.

Holmes, S. (2008). *The quiz show*. Edinburgh, Scotland: Edinburgh University Press.

Horkheimer, M., & Adorno, T. W. (2002). The culture industry: Enlightenment as mass deception. In G. S. Noerr (Ed.), *Dialectic of enlightenment: Philosophical fragments* (pp. 94–136). Stanford, CA: Stanford University Press (Original work published 1944).

Horton, D., & Wohl, R. (1956). Mass communication and para-social interaction: Observation on intimacy at a distance. *Psychiatry, 19*, 215–229.

Hughes, D. Y., Wells, H. G., & Geduld, H. M. (1993). *A critical edition of* The War of the Worlds. *H. G. Wells's scientific romance*. Bloomington, IN: Indiana University Press.

Hustvedt, S. (2013). *Living, seeing, looking: Essays*. New York: Picador.

Ickes, W. (1993). Empathic accuracy. *Journal of Personality, 61*(4), 587–610.

Is Barack Hussein Obama related to Saddam Hussein and Osama? (n.d.). Retrieved from https://answers.yahoo.com/question/index?qid=20080212025219AAynfVx

Is it possible that Kaycee did not exist? (2001, May 18). Retrieved from http://www.metafilter.com/7819/Is-it-possible-that-Kaycee-did-not-exist#84429

Itzkoff, D. & Sisario, B. (2012, May 7). How "Mad Men" landed the Beatles: All you need is love (and $250,000). *The New York Times*. Retrieved from http://artsbeat.blogs.nytimes.com/2012/05/07/how-mad-men-landed-the-beatles-all-you-need-is-love-and-250000/?_php=true&_type=blogs&_r=0

Jamieson, A. (June 4, 2009). "Susan Boyle lost *Britain's Got Talent* votes due to YouTube scam." *The Telegraph*. Retrieved from http://www.telegraph.co.uk/culture/tvandradio/

susan-boyle/5442174/Susan-Boyle-lost-Britains-Got-Talent-votes-due-to-YouTube-scam.html

Jamieson, K. H. (1988). *Eloquence in an electronic age: The transformation of political speechmaking.* Oxford, England & New York, NY: Oxford University Press.

Jamieson, K. H. (2000). *Everything you think you know about politics ...: And why you're wrong.* New York, NY: Basic Books.

Jamieson, K. H., & Miller, M. (2000). Presidential campaigns: Sins of omission. Preface. *The Annals of the American Academy of Political and Social Sciences, 572*(2000), 10–11.

Jamieson, K. H., & Waldman, P. (2003). *The press effect. Politicians, journalists, and the stories that shape the political world.* Oxford, England & New York, NY: Oxford University Press.

Jaramillo, D. L. (2009). *Ugly war, pretty package: How CNN and Fox News made the invasion of Iraq high concept.* Bloomington, IN: Indiana University Press.

Jenkins, H. (2006a). *Fans, bloggers, and gamers: Exploring participatory culture.* New York, NY & London, England: New York University Press.

Jenkins, H. (2006b). *Convergence culture: Where old and new media collide.* New York, NY & London, England: New York University Press.

Johansen, A. (2002). *Talerens troverdighet* [The credibility of the Speaker]. Oslo, Norway: Universitetsforlaget.

Johnson, T. J., & Kaye, B. K. (2004). Wag the blog: How reliance on traditional media and the Internet influence credibility perceptions of weblogs among blog users. *Journalism & Mass Communication Quarterly, 81*(3), 622–642.

Jones, J. M. (2012, May 30). Michelle Obama remains popular in U.S. *Gallup.* Retrieved from http://www.gallup.com/poll/154952/michelle-obama-remains-popular.aspx

Jordan, J. W. (2005). A virtual death and a real dilemma: Identity, trust, and community in cyberspace. *Southern Journal of Communication, 70*(3), 200–218.

Kakutani, M. (2006, October 17). Obama's Foursquare politics, with a dab of Dijon [Review of the book *The audacity of hope,* by B. Obama]. *The New York Times.* Retrieved from http://www.nytimes.com/2006/10/17/books/17kaku.html?_r=0

Katz, E., & Lazarsfeld, P. F. (1955). *Personal influence: The part played by people in the flow of mass communications.* New York, NY: The Free Press.

Katz, E., & Scannell, P. (2009). *The end of television? Its impact on the world (so far).* London, England & Thousand Oaks, CA: Sage.

Kay, J. (2011). *Among the truthers. A journey through America's growing conspiracist underground.* New York, NY: HarperCollins.

Kaycee Nicole. (n.d.). In *Wikipedia.* Retrieved from http://en.wikipedia.org/wiki/Kaycee_Nicole

Kaycee Nicole Swenson. (n.d.). Retrieved from http://www.museumofhoaxes.com/hoax/archive/permalink/kaycee_nicole_swenson

Keen, A. (2007). *The cult of the amateur: How blogs, MySpace, YouTube, and the rest of today's user-generated media are destroying our economy, our culture, and our values.* New York, NY: Doubleday.

Kelley, K. (2010). *Oprah: A biography.* New York, NY: Three Rivers Press.

Keren, M. (2006). *Blogosphere: The new political arena.* Lanham, MD: Lexington Books.

REFERENCES

Kindelan, K. (2011, September 11). Ryan O'Neal blames family drama on Oprah. *ABC News*. Retrieved from http://abcnews.go.com/blogs/entertainment/2011/09/ryan-oneal-blames-oprah-for-conflict-with-tatum/

Kivy, P. (1995). *Authenticities: Philosophical reflections on musical performance*. New York, NY: Cornell University Press.

Kjeldsen, J. (2006). *Retorikk i vår tid: en innføring i moderne retorisk teori* [Contemporary rhetorics: An introduction to modern rhetoric theories] (2nd ed.). Oslo, Norway: Spartacus.

Klein, E. (2008). The most unlikely president [Blog post]. *The American Prospect*. Retrieved from http://prospect.org/article/most-unlikely-president

Klein, N. (2010). *No logo 10th anniversary edition*. London, England: Picador.

Kreiss, D. (2012). *Taking our country back: The crafting of networked politics from Howard Dean to Barack Obama*. New York, NY & Oxford, England: Oxford University Press.

Lacan, J. (2006). Triumf Religije. *Problemi, 44*(3–4), 5–20.

Ladd, J. M. (2012). *Why Americans hate the media*. Oxford, England & Princeton, NJ: Princeton University Press.

Lampe, C., Ellison, N., & Stenfeld, C. (2007). A Familiar Face(book): Profile elements as signals in an online social network. *Proceedings of Conference on Human Factors in Computing Systems* (pp. 435–444). New York, NY: ACM Press.

Lewin, P., & Williams, J. P. (2009). The ideology and practice of authenticity in punk subculture. In P. Vannini & J. P. Williams (Eds.), *Authenticity in culture, self, and society* (pp. 65–86). Farnham, England: Ashgate.

Lewis, J. D., & Weigert, A. (1985). Trust as a social reality. *Social Forces, 63*(4), 967–985.

Lewis, P. M. (2000). Private passion, public neglect: the cultural status of radio. *International Journal of Cultural Studies, 3*(2), 160–167.

Lewis, P. M., & Booth, J. (1989). *The invisible medium: Public, commercial and community radio*. London, England: Macmillan.

Licklider, J. C. R. (1960). Man-computer symbiosis. *IRE transactions on human factors in electronics* (pp. 4–11). Retrieved from http://groups.csail.mit.edu/medg/people/psz/Licklider.html

Licklider, J. C. R. (1965). *Libraries of the future*. Cambridge, MA: MIT Press.

Licklider, J. C. R., & Taylor, R. W. (1968). The computer as a communication device. *Science and technology, 76*(2), 1–3.

Lieberman, L., & Kirk, R. C. (2004). What should we teach about the concept of race? *Anthropology & Education Quarterly, 35*(1), 137–145.

Lindholm, C. (2008). *Culture and authenticity*. Malden, MA: Blackwell.

Lippmann, A. (1998). Andrew Lippmann. Retrieved from http://www.media.mit.edu/people/lip

Lipsitz, G. (1990). *Time passages. Collective memory and American popular culture*. Minneapolis, MN: University of Minnesota Press.

lonelygirl15. (2006, June 6). *First blog. Dorkiness prevails* [Video file]. Retrieved from http://youtu.be/-goXKtd6cPo

Lotz, A. D. (2007). *The television will be revolutionized*. New York, NY: New York University Press.

Lüders, M. (2007). *Being in mediated spaces: An enquiry into personal media practices* (Doctoral dissertation, University of Oslo). Oslo, Norway: Unipub AS.

Luhmann, N. (1988). Trust: Making and breaking cooperative relations. In D. Gambetta (Ed.), *Familiarity, confidence, trust: Problems and alternatives* (pp. 94–107). New York, NY: Basil Blackwell.

Luhmann, N. (2000). *The reality of mass media*, Stanford, CA: Stanford University Press.

Lumière, L. (Director). (1896). *Arrival of a Train*.

Lundby, K. (Ed.) (2009). *Mediatization: Concept, changes, consequences*. New York, NY: Peter Lang.

Lury, K. (2005). *Interpreting television*. London, England: Hodder Arnold.

Luscombe, B. (2009, April 23). Susan Boyle: Not quite out of nowhere. *Time Magazine*. Retrieved from http://content.time.com/time/arts/article/0,8599,1893282,00.html

Maarek, P. J. (2009). *La communication politique de la présidentielle de 2007: Participation ou représentation?* Paris, France: Editions L'Harmattan.

Maarek, P. J. (2011). *Campaign communication & political marketing*. London, England & Malden, MA: Wiley-Blackwell.

MacAskill, E., & Pilkington, E. (2007, July 25). Clinton and Obama clash after YouTube debate. *The Guardian*. Retrieved from http://www.theguardian.com/media/2007/jul/25/digitalmedia.broadcasting

MacCannell, D. (1973). Staged authenticity. Arrangements of social space in tourist settings. *American Journal of Sociology, 79*(3), 589–603.

Man of the moment. (2005, January 19). Retrieved from http://www.oprah.com/oprahshow/Man-of-the-Moment#ixzz2QWksStZK

Maraniss, D. (2012). *Barack Obama: The story*. New York, NY: Simon & Schuster.

Marc, D., & Thompson, R. J. (2005). *Television in the antenna age. A concise history*. Oxford, England & Malden, MA: Blackwell.

McChesney, R. W. (2013). *Digital disconnect: How capitalism is turning the Internet against democracy*. New York, NY: New Press.

McLeish, R. (1978). *The technique of radio production*. London, England: Focal Press.

McLeod, K. (2006). Authenticity within Hip Hop and other cultures threatened with assimilation. *Journal of Communication, 49*, 136–150.

McLuhan, M. (1995). *Understanding media. The extensions of man*. Cambridge, MA: MIT Press (Original work published 1964)

McNair, B. (2009). *News and journalism in the UK* (5th ed.). London, England & New York, NY: Routledge.

McNeill, L. (2003). Teaching an old genre new tricks: The diary on the Internet. *Biography, 26*(1), 24–47.

Meaney, T. (2014, March 21). Intellect is everything [Review of the book *My struggle: 3*, by K. O. Knausgård]. *Times Literary Supplement*. Retrieved from http://www.columbia.edu/~tmm2129/Knaus.pdf

Mencken, H. L. (1924). *Prejudices. Fourth series*. New York, NY: Alfred A. Knopf.

Mendoza, M., Poblete, B., & Castillo, C. (2010). Twitter under crisis: Can we trust what we RT? *Proceedings of the First Workshop on Social Media Analytics* (pp. 71–79). New York, NY: ACM Press.

Mendoza, M., Poblete, B., & Castillo, C. (2011). Information credibility on Twitter. *Proceedings of the 20th International Conference on World Wide Web* (pp. 675–684). New York, NY: ACM Press.

Meyrowitz, J. (1985). *No sense of place. The impact of electronic media on social behavior*. New York, NY: Oxford University Press.

Miller, C. R. (1984). Genre as social action. *Quarterly Journal of Speech*, 70(2), 151–167.

Mittell, J. (2004). *Genre and television. From cop shows to cartoons in American culture*. New York, NY & London, England: Routledge.

Moore, A. (2002). Authenticity as authentication. *Popular Music*, 22(2), 209–223.

Morozov, E. (2011). *The net delusion: How not to liberate the world*. London, England: Penguin Books.

Morozov, E. (2011, June 16). Wake up call from a fake Syrian blogger. *Financial Times*. Retrieved from http://www.ft.com/cms/s/0/7da10046-9848-11e0-ae45-00144feab49a.html#axzz2g5ruB0vm

Morris, E. (2008, April 3). Play it again, Sam (Re–enactments, part one). *The New York Times*, Retrieved from http://opinionator.blogs.nytimes.com/2008/04/03/play-it-again-sam-re-enactments-part-one/?_r=0

Morse, M. (1986). The television news personality and credibility. In T. Modelski (Ed.), *Studies in Entertainment* (pp. 55–79). Bloomington, IN: Indiana University Press.

Murray, S. (2005). *Hitch your antenna to the stars: Early television and broadcast stardom*. London, England & New York, NY: Routledge.

Nachman, G. (1998). *Raised on radio*. New York, NY: Pantheon Books.

Nanos, J. (2012, November 8). How a campaign photographer captured the most liked and most tweeted photo ever. *The Boston Daily*. Retrieved from http://www.bostonmagazine.com/news/blog/2012/11/08/obama-hug/

Naughton, J. (1999). *A brief history of the future: The origins of the Internet*. London, England: Weidenfeld & Nicolson.

Neale, S. (2000). *Genre and Hollywood*. London, England & New York, NY: Routledge.

Negroponte, N. (1995). *Being digital*. London, England: Hodder & Stoughton.

Nelson, T. H. (1987). *Computer lib/Dream machines*. Redmond, WA: Tempus Books of Microsoft Press (Original work self-published 1974).

Nichols, S. (1994). Fathers and literacy. *Australian Journal of Language and Literacy*, 4(17), 301–312.

New York Times (1938, October 31). "Radio Listeners in Panic, Taking War Drama as Fact." Retrieved from http://www.war-of-the-worlds.org/Radio/Newspapers/Oct31/NYT.htm

Nonvoters in America 2012. (2012). Retrieved from http://nonvotersinamerica.com/2012/12/nonvoters-in-america-2012/

Nonvoters: Who they are, what they think. (2012, November 1). Retrieved from http://www.people-press.org/2012/11/01/nonvoters-who-they-are-what-they-think/

Obama, B. (2004). *Dreams from my father: A story of race and inheritance*. New York, NY; London, England; & Edinburgh, Scotland: Canongate Books (Original work published 1995).

Obama, B. (2006). *The audacity of hope: Thoughts on reclaiming the American dream*. New York, NY; London, England; & Edinburgh, Scotland: Canongate Books.

Obama, B. [BarackObama]. (2012, October 24). The folks I just met over pizza in Iowa are exactly why I love coming to this state. Thanks for always making me feel at home.-bo [Tweet]. Retrieved from https://twitter.com/BarackObama/status/261166398418595840

Obama, B. [BarackObama]. (2012, October 25). What a great view, Virginia! My voice might be getting hoarse, but the energy out here is going strong.-bo [Tweet]. Retrieved from https://twitter.com/BarackObama/status/261542001596567553

Obama, B. [BarackObama]. (2012, November 5). Thanks to everyone who is knocking on doors and making calls—you inspire me every day. I won't let up if you won't.-bo [Tweet]. Retrieved from https://twitter.com/BarackObama/status/265517327813074944

Obama, B. [BarackObama]. (2012, November 6). We're coming to the end of a long campaign—all that's left to do is get out the vote. Let's win this.-bo [Tweet]. Retrieved from https://twitter.com/BarackObama/status/265831276437725184

Obama, B. [BarackObama]. (2012, November 6). We're all in this together. That's how we campaigned, and that's who we are. Thank you. -bo. https://twitter.com/barackobama/status/266031109979131904

Olsen, K. (2002). Authenticity as a concept in tourism research. The social organization of the experience of authenticity. *Tourist Studies*, 2(2), 159–182.

Olsson, J., & Spigel, L. (Eds.) (2004). *Television after TV: Essays on a medium in transition*. Durham, NC: Duke University Press.

The Oprah factor and Campaign 2008. Do political endorsements matter? (2007, September 20). Retrieved from http://www.people-press.org/2007/09/20/the-oprah-factor-and-campaign-2008/

Oprah Winfrey. (1991, February 21). Interview. Retrieved from http://www.achievement.org/autodoc/page/win0int-1

The Oprah Winfrey Show, June 22, 2004: Interview with Senator Barack Obama.

The Oprah Winfrey Show, January 9, 2009: Interview with President-elect Barack Obama.

O'Reilly, T. (2005, December 1). What is Web 2.0? Retrieved from http://www.ttivanguard.com/ttivanguard_cfmfiles/pdf/dc05/dc05session4003.pdf

Orr, J. (2006). *Panic diaries: A Genealogy of panic disorder*. Durham, NC: Duke University Press.

Orvell, M. (1989). *The real thing: Imitation and authenticity in American culture; 1880–1940*. Chapel Hill, NC: University of North Carolina Press.

Palfrey, J., & Gasser, U. (2008). *Born digital. Understanding the first generation of digital natives*. New York, NY: Basic Books.

Palmer, J. (2000). *Spinning into control: News values and source strategies*. Leicester, England: Leicester University Press.

Parkins, W. (2001). Oprah Winfrey's change your life TV and the spiritual everyday. *Continuum: Journal of Media and Cultural Studies*, 15(2), 145–157.

Pastel, R. H. (2002). *Collective behaviors: Mass panic and outbreaks of multiple unexplained symptoms*. Retrieved from Army Medical Research Institute of Infectious Diseases Fort Detrick MD website: http://oai.dtic.mil/oai/oai?verb=getRecord&metadataPrefix=html&identifier=ADA400319

Pattie, D. (1999). 4 real: Authenticity, performance, and rock music. *Enculturation*, 2(2).

Paz, G. (2009, June 1). Final results of *Britain's Got Talent*: Voting percentages. *Series & TV.* Retrieved from http://seriesandtv.com/final-results-of-britains-got-talent-voting-percentages/1964

Peck, J. (2008). *The age of Oprah. A cultural icon for the Neoliberal era.* Boulder, CO: Paradigm.

Pels, D. (2003). *Media and the restyling of politics: Consumerism, celebrity and cynicism.* London, England; Thousand Oaks, CA; & New Delhi, India: Sage.

Perkins, F. (1946). *The Roosevelt I knew.* New York, NY: The Viking Press.

Peters, J. D. (2000). *Speaking into the air. A history of the idea of communication.* Chicago, Il: University of Chicago Press.

Peterson, R. A. (1997). *Creating country music: Fabricating authenticity.* Chicago, IL: University of Chicago Press.

Pew Research. (2008). Barack Obama. Retrieved from Pew Research Center's Journalism Project Staff, 2008. http://www.pewresearch.org/data-trend/political-attitudes/presidential-approval/

Plouffe, D. (2009). *The audacity to win. How Obama won and how we can beat the party of Limbaugh, Beck, and Palin.* New York, NY: Penguin.

Postman, N. (1992). *Technopoly: The surrender of culture to technology.* New York, NY: Vintage House/Random Books.

The president broadcasts: Confronted with mikes, cameras, and radio engineers, Roosevelt pauses for a glass of water. (1933). *Broadcasting,* 5(3), 8.

Presidential approval ratings—Barack Obama. (n.d.). Retrieved from http://www.gallup.com/poll/116479/barack-obama-presidential-job-approval.aspx

Priest, P. J. (1994). *Public intimacies: Talk show participants and tell-all TV.* Cresskill, NJ: Hampton Press.

Real, M. (1996). *Exploring media culture. A guide.* London, England & Thousand Oaks, CA: Sage.

Remnick, D. (2008, November 17). The Joshua generation. Race and the campaign of Barack Obama. *The New Yorker.* Retrieved from http://www.newyorker.com/reporting/2008/11/17/081117fa_fact_remnick?currentPage=all

Remnick, D. (2010). *The bridge: The life and rise of Barack Obama.* New York, NY: Vintage Books.

Rheingold, H. (1991). *Virtual reality: Exploring the brave new technologies.* New York, NY: Simon & Schuster Adult Publishing Group.

Rickford, J. R, & Rickford, R. J. (2000). *Spoken soul: The story of Black English.* Hoboken, NJ: John Wiley & Sons.

Roman, J. (2005). *From daytime to primetime. The history of American television.* Westport, CT: Greenwood Press.

Rosenman, S. I. (1952). *Working with Roosevelt.* New York, NY: Harper.

Ryfe, D. M. (1999). Franklin D. Roosevelt's fireside chats. *Journal of Communication* 49(4), 80–103.

Ryfe, D. M. (2001). From media audience to media public: A study of letters written in reaction to FDR's fireside chats. *Media Culture & Society* 23(6), 767–781.

Saad, L. (2014). Obama's job approval declined steadily throughout 2013. Retrieved from http://www.gallup.com/poll/166727/obama-job-approval-declined-steadily-throughout-2013.aspx

Santini, M. (2007). Characterizing genres of Web pages: Genre hybridism and individualization. *HICSS '07: 40th Annual Hawaii International Conference on System Sciences* (pp. 71–81). New York, NY: ACM Press.

Sarnoff, D. (1936, June 29). Television in advertising. In *The Message of Radio* [Stencil copy of a speech addressed to the Advertising Federation of America]. Princeton, NJ: David Sarnoff Library.

Scammell, M. (2007). Political brands and consumer citizens: The rebranding of Tony Blair. *The Annals of the American Academy of Political and Social Science*, 611(1), 176–192. doi: 10.1177/0002716206299149

Scannell, P. (1996). *Radio, television, and modern life: A phenomenological approach*. Oxford, England: Blackwell.

Scannell, P. (2002): "Television and the meaning of *live*", paper for The Broadcast Talk Seminar, Ross Priory, Scotland.

Schlesinger, P. (1987). *Putting "reality" together: BBC News* (2nd ed.). London, England: Methuen.

Schudson, M. (1995). *The power of news*. Cambridge, MA & London, England: Harvard University Press.

Scott, D. M. (2011). *The new rules of marketing and PR: How to use social media, online video, mobile applications, blogs, news releases, and viral marketing to reach buyers directly*. Hoboken, NJ: John Wiley and Sons.

Shattuc, J. M. (1999). Talk shows and the public sphere. In M. B. Haralowich & L. Rabinovitz (Eds.), *Television, history, and American culture. Feminist critical essays* (pp. 168–180). London, England & Durham, NC: Duke University Press.

Shirky, C. (2008). *Here comes everybody: The power of organizing without organizations*. London, England: Penguin Books.

Sides, J., & Vavreck, L. (2013). *The gamble: Choice and chance in the 2012 Presidential election*. Princeton, NJ: Princeton University Press.

Siegel, L. (2008). *Against the machine: Being human in the age of the electronic mob*. New York, NY: Spiegel & Grau/Random House.

Sjørslev, I. (2013). Is form really primary or, what makes things authentic? Sociality and materiality in Afro Brazilian ritual and performance. In T. Filitz & A. J. Saris (Eds.), *Debating authenticity: Concepts of modernity in anthropological perspective*. New York, NY: Berghahn Books.

Skeggs, B. (1997). *Formations of class and gender: Becoming respectable*. London, England & Thousand Oaks, CA: Sage.

Skeggs, B. and Wood, H. (2011). Turning it on is a class act: Immediated object relations with TV. *Media, Culture and Society*, 33(6): 941–953.

Skivenes, H. M. (2013). *Tostegshypotesen 2.0—Politisk merkevarebygging og sosial påvirkning på Facebook* [The Two-Step Flow Theory 2.0—Political Branding and Networked Influence on Facebook] (Master's thesis), University of Oslo, Norway.

Smith, G. (2013, April 23). Syrian electronic army's AP hack just the latest phishing attack on a major news organization. *The Huffington Post*. Retrieved from http://www.huffingtonpost.com/2013/04/23/syrian-electronic-army-ap-twitter-hack_n_3140849.html

Smith, L. (2009, April 29). Hairy angel *Britain's Got Talent* star Susan Boyle gets a £100 makeover. *The Daily Mail*. Retrieved from http://www.dailymail.co.uk/tvshowbiz/article-1172203/Hairy-angel-Britains-Got-Talent-star-Susan-Boyle-gets-100-makeover.html

Smith, L. (2009, August 5). 'I feel like a movie star': Susan Boyle gets an incredible makeover by prestigious style bible Harper's Bazaar. http://www.dailymail.co.uk/tvshowbiz/article-1204569/Susan-Boyle-transformed-gets-glamorous-Hollywood-make--loves-it.html#ixzz3EA2gABTu

Smith, T. (2012). *Barack Obama, post-racialism, and the new politics of triangulation*. Basingstoke, England: Palgrave Macmillan.

Smith-Shomade, B. E. (2002). *Shaded lives. African-American women and television*. London, England & New Brunswick, NJ: Rutgers University Press.

snatcher73. (2008, January 13). *Die Wahrheit—Ich bin ein Star holt mich hier raus* [Video file]. Retrieved from http://www.youtube.com/watch?v=FSE0L0ZsyhY

Snow, B. (2006, December 11). Sony marketers are horrible liars, pretend to run fansite. *Joystiq*. Retrieved from http://www.joystiq.com/2006/12/11/sony-marketers-are-horrible-liars-pretend-to-run-fansite/

Spigel, L. (1992). *Make room for TV. Television and the family ideal in the postwar America*. Chicago, IL & London, England: The University of Chicago Press.

Spotted on Ryan O'Neal's wall...the lost £20m Andy Warhol portrait of Farrah Fawcett. (2011, June 24). *The Daily Mail*. Retrieved from http://www.dailymail.co.uk/tvshowbiz/article-2006903/Ryan-ONeal-investigated-missing-30m-Farrah-Fawcett-Andy-Warhol-painting.html

Stalder, F. (2012). Between democracy and spectacle: The front-end and back-end of the social web. In M. Mandiberg (Ed.), *The social media reader* (pp. 242–256). New York, NY: New York University Press.

Street, J. (2003). The celebrity politician: Political style and popular culture. In D. Pels & J. Corner (Eds.), *Media and the restyling of politics: Consumerism, celebrity and cynicism* (pp. 85–98). London, England & Thousand Oaks, CA: Sage.

Stromer-Galley, J. (2014). *Presidential campaigning in the Internet age*. Oxford, England and New York, NY: Oxford University Press.

Syvertsen, T. (2004). Citizens, audiences, customers, and players—a conceptual discussion of the relationship between broadcasters and their publics. *European Journal of Cultural Studies*, 7(3), 363–380.

Syvertsen, T., Enli, G., Mjøs, O. J., & Moe, H. (2014). *The Media Welfare State. Nordic Media in the Digital Era*. Ann Arbor: University of Michigan Press.

Talent star Boyle taken to clinic. (2009, June 1). Retrieved from http://news.bbc.co.uk/2/hi/entertainment/8076413.stm

Taylor, J. P. (2001). Authenticity and sincerity in tourism. *Annals of tourism research*, 28(1), 7–26.

Testimony of Charles Van Doren, accompanied by his attorney, Carl J. Rubino. (1959). Retrieved from http://historymatters.gmu.edu/d/6566/

Thomas, A. A. (2006). Fictional blogs. In A. Bruns & J. Jacobs (Eds.), *Uses of blogs* (pp. 199–210). New York, NY: Peter Lang.

Thompson, J. B. (2000). *Political scandal: Power and visibility in the media age*. Oxford, England & New York, NY: Wiley-Blackwell.

Todorov, T. (1990). *Genres in discourse*. Cambridge, England: Cambridge University Press.

Toffler, A. (1981). *The third wave*. New York, NY: Bantam Books.

Transcript: Michelle Obama's convention speech. (2008, August 25). Retrieved from http://www.npr.org/templates/story/story.php?storyId=93963863

Trent, J. S., Friedenberg, R. V., & Denton R. E. (2011). *Political campaign communication. Principles and practices* (7th ed.). Lanham, MD: Rowman & Littlefield.

Trevino, L. K., & Webster, J. (1992). Flow in computer-mediated communication. Electronic mail and voice mail evaluation and impacts. *Communication Research, 19*(5), 539–573. doi: 10.1177/009365092019005001

Trilling, L. (1972). *Sincerity and authenticity*. Boston, MA: Harvard University Press.

Tuchman, G. (1978). *Making news: A study in the construction of reality*. New York, NY: The Free Press.

Turkle, S. (1995). *Life on the screen. Identity in the age of the Internet*. New York, NY: Touchstone.

Turner, G. (2004). *Understanding celebrity*. London, England & Thousand Oaks, CA: Sage.

Underwood, D. (2008). *Journalism and the novel: Truth and fiction, 1700–2000*. Cambridge, England: Cambridge University Press.

Van den Bulck, H., & Enli, G. S. (2013). Bye Bye "Hello Ladies?" In-vision announcers as continuity technique in a European postlinear television landscape: The case of Flanders and Norway. *Television & New Media, 14*(3).

Van Leeuwen, T. (2001). What is authenticity? *Discourse Studies, 3*(4), 392–397.

Vannini, P., & Williams, J. P. (Eds.). (2009). *Authenticity in culture, self, and society*. Farnham, England: Ashgate.

Vavreck, L. (2009). *The message matters: The economy and presidential campaigns*. Princeton, NJ: Princeton University Press.

Venanzi, K. (1997). An examination of television quiz show scandals of the 1950s. Retrieved from http://www.plosin.com/beatbegins/projects/venanzi.html

Vertov, D. (1984). Kinopravda & Radiopravda. In A. Michelson (Ed.), *Kino-Eye: The writings of Dziga Vertov*. London England & Berkeley, CA: University of California Press (Original work published 1925).

Vianello, R. (1994). The rise of the telefilm. In N. Browne (Ed.), *American television. New directions in history and theory*. Los Angeles, CA: Harwood Academic.

Walker Rettberg, J. (2008). *Blogging*. Cambridge, England: Polity Press.

Walker Rettberg, J. (2013). *Blogging* (2nd ed.). Cambridge, England: Polity Press.

Walther, J. B. (1992). Interpersonal effects in computer-mediated interaction. *Communication Research 19*(1), 52–90.

Walther, J. B. (1996). Computer-mediated communication: Impersonal, interpersonal, and hyperpersonal interaction. *Communication Research, 23*(1), 3–43.

Wang, N. (1999). Rethinking authenticity in tourism experience. *Annals of tourism research, 26*(2), 349–370.

Warner, C. (2013). *The pragmatics of literary testimony. Authenticity effects in German social autobiographies*. New York, NY & London, England: Routledge.

Watts, A. (2006). Queen for a day: Remaking consumer culture, one woman at a time. In D. Heller (Ed.), *The great American makeover: Television, history, nation* (pp. 141–157). New York, NY: Palgrave Macmillan.

Weaver, P. H. (1994). *News and the culture of lying*. New York, NY: The Free Press.

Weisethaunet, H., & Lindberg, U. (2010). Authenticity revisited: The rock critic and the changing real. *Popular Music & Society, 33*(4), 465–485.

Welles, O. (1938, October 30). The war of the worlds [Audio file]. Retrieved from http://sounds.mercurytheatre.info/mercury/381030.mp3

Westen, D. (2008). *Political brain: The role of emotion in deciding the fate of the nation*. New York, NY: Public Affairs.

White, D. M. (1950). The "gate keeper": A case study in the selection of news. *Journalism Quarterly 27*, 383–391.

Wilhoit, E. D. (2013). Michelle Obama's embodied authentic leadership: Leading by lifestyle. In L. Melina (Ed.), *The embodiment of leadership*. San Francisco, CA: Jossey-Bass.

Williams, R. (1990). *Television. Technology and cultural form*. London, England & New York, NY: Routledge (Original work published 1975).

Wilson, J. (2011, May 10). A gay girl in Damascus: Lesbian blogger becomes Syrian hero. *Time Magazine*. Retrieved from http://newsfeed.time.com/2011/05/10/a-gay-girl-in-damascus-lesbian-blogger-becomes-syrian-hero/#ixzz2g5j0eVNf

Winston, B. (1986). *Misunderstanding media*. Cambridge, MA: Harvard University Press.

Winston, B. (1998). *Media technology and society. A history: From the telegraph to the Internet*. London, England & New York, NY: Routledge.

Woodard, R. (2008, November 5). Presidents who write well, lead well. *The Guardian*. Retrieved from http://www.theguardian.com/books/booksblog/2008/nov/05/obama-writer-dreams-from-my-father

Ytreberg, E. (2002). Erving Goffman as a theorist of the mass media. *Critical Studies in Media Communication, 19*(4), 481–497.

Ytreberg, E. (2004). Formatting participation within broadcast media production. *Media, Culture & Society, 26*(5), 677–692.

Ytreberg, E. (2008). Om det planlagt spontane [On planned spontainity]. *Norsk Medietidsskrift, 15*(1), 22–37.

Zayas, M. d. (1923). *The Arts*. New York. www.gallerywalk.org/PM_Picasso.html. Last accessed: 14.06.2014.

Zelitzer, B. (1993). Journalists as interpretive communities. *Critical Studies in Media Communication, 10*(3), 219–237.

Zuckerman, E. (2008). Meet the bridgebloggers. *Public Choice, 134*(1–2), 47–65.

INDEX

A

Adorno, Theodor, 38
Airbnb (housing rental website), 90
All the President's Men (film), 5
American Family, An (documentary), 69–70
Anna Nicole Show, The (2002–2003), 72–73
Arraff, Amina. *See* "Gay Girl in Damascus, A" (2011)
Arrival of a Train (Lumière), 50
Arsenio Hall (show), 71
Associated Press Twitter account (@AP), 93
Astaire, Fred, 54
Audacity of Hope, The (Obama), 116–118
audio-visual broadcasting, 46, 51–52

B

Baird, John Logie, 47
Banet-Weiser, Sarah, 3
Barthes, Roland, 15, 39–40
Baudrillard, Jean, 8
Bauman, Zygmunt, 3
Benjamin, Walter, 7, 23
Big Brother, 68
Blair Witch Project, The (film), 70
blogs, 94–104
 See also under social media, authenticity puzzles in
Boorstin, Daniel, 5, 7–8
Boyle, Susan, 20, 74–76
 See also under reality TV, Susan Boyle
"Bree," 96–99, 102, 106
Britain's Got Talent (ITV), 74, 78–80, 82–84

British Press Complaints Commission (PCC), 78
Browne, Gordon, 78
Bush, George W., 113

C

canned laughter, 1–2
Cantril, H., 40n
Carvin, Andy, 102–104
celebrity, 60–62, 72–74, 76, 78–79, 84–85, 114, 123–124
cinéma vérité—truthful cinema, 69–70
Clinton, Bill, 71–72, 71nn7–8, 109, 112
Cobain, Kurt, 13
Coca Cola Company, 6
Communications Act of 1934, 46
Couldry, Nick, 9
Cowan, Louis G., 56, 63n3
Cowell, Simon, 84
Creative Artist Agency, 102
Culture Industry, The (Adorno and Horkheimer), 7
culture of lying, 6

D

Dating Game, The (ABC, 1965–1973), 10
David Letterman Show (talk show), 73
Deuze, Mark, 4
Dickens, Charles, 15
Didion, Joan, 15
Disneyland, 8
docusoaps, 70, 72–73
dogme films (Danish), 70n5
Downton Abbey (BBC drama), 15–16
Dreams From My Father (Obama), 116n7, 117

E

Eco, Umberto, 8
Eisenhower, Dwight D., 62

emoticons, 91
ethics, 11, 69, 72–73, 78–79, 85, 111
existentialism, 11

F

Facebook, 74, 90, 92, 96–97, 102–103, 102n, 120
facelifts, 11
Fairey, Shepard, 115
"Faith in Fakes" (Eco), 8
fake bloggers, 101–104
Fawcett, Farrah, 73
FCC (Federal Communications Commission), 43, 48, 63
Fireside chats, 29–31
Fox News Channel, 6
Frankfurt School, 7, 38–39
Freud, Sigmund, 7
Friends (sitcom), 15
Friendster (2002), 96

G

"Gay Girl in Damascus, A" (2011) (fake blog), 96, 98–106
genre, 15–17, 41, 44, 53, 55, 66–68, 70, 81–82, 93–94, 133, 136–137
Goffman, Erving, 10, 111
Gore, Al, 111, 113

H

hacking, 93
Hall, Stuart, 16–17, 41
Hegel, Georg Wilhelm Friedrich, 7
Henry, Liz, 104
Hilton, Paris, 72
hip-hop artists, 12
hoax, 95–100, 104–106, 134
Horkheimer, Max, 7, 23
Houston, Whitney, 73n9

INDEX

Hunting Big Game (documentary), 67
Hustvedt, Siri, 14
hyperreality, 8, 84, 136

I

I Love Lucy (sitcom), 49
I'm a Celebrity…Get Me Out of Here!, 67n1
Invasion From Mars, The (Cantril) (research project), 40–41, 40n

J

Jaramillo, Deborah, 6
Jarvis, Jeff, 74n11
Jay-Z, 12
journalism, 5–6, 14, 78, 102–104, 114, 129–130

K

Kaufman, Andy, 10–11
Kaycee Nicole, (1999–2001) (fake blog), 95–97, 99, 101–102, 104–105
KDKA (America's first radio station, 1922), 25
Kennedy, John F., 64, 109
Kennedy-Nixon debates, 64
Kierkegaard, Søren, 11
Knausgård, Karl-Ove, 14–15

L

Lacan, Jacques, 17
Lachey, Nick, 72
Lady Gaga, 3, 131
lawsuits, 43, 61, 134
Lewinsky, Monica, 71n8, 112n1
Lippmann, Walter, 62
liquid modernity, 3

liveness, and illusion of authenticity, 53–54
"Living Colours" *See* Kaycee Nicole
Lohan, Lindsay, 123
"lonelygirl15" (2006) (fake blog), 96–98, 102, 105–106
Lumière, Louis, 50

M

MacMaster, Tim, 104–105
Mad Men (drama), 16, 53
Major Bowes' Original Amateur Hour (1935–1945, 1948–1952), 54–55
Marconi, Guglielmo, 24, 25n, 29
Match.com, 90
mediated communication, defined, 131
media tourism, 9
Mercury Theatre on the Air, The, 43
miscommunication, 18, 32, 39–41, 44
modernism, 11
Morozov, Evgeny, 106
music studies, 12–13
My Struggle (Knausgård), 14–15

N

National Public Radio (NPR), 102
news studies, 4–6
Nirvana (grunge band), 13
Nixon, Richard, 64, 112

O

Obama, Barack, 109–130
 See also Obama, Michelle; Winfrey, Oprah
Obama, Barack: authentic candidate, 114–123
 and autobiographies, 115–18
 and birth certificate controversy, 116
 and economic resources, 114
 and linkage with American dream, 117n8

and *Oprah Winfrey Show*, 119–120n
and social media for image building,
 120–123
Obama, Barack: role of authentic politician,
 111–114
 and broadcast media, 111
 and rhetoric of authenticity, 114
Obama, Michelle
 and Obama's image, *121*, 127
 and ordinariness, 126
 as representative of modern femininity,
 127–128
Oprah Winfrey Show, The
 and Barack Obama, 119–120
 and Bill Clinton, 71–72, 71n7
 political impact of, 124
 See also Winfrey, Oprah
ordinariness, 52, 67–69, 72–73, 126
originality, authenticity as, 6–8
 and advertising perfectionism, 7–8
 and Coca Cola Company, 6
 and deceptiveness of reproduction, 7
Osbournes, The (MTV, 2003–2005), 72

P

Packer, Greg, 14
paradoxes
 and death of Cobain, 13
 of media manipulation, 1, 10
 of online diary, 97
 of travel industry, 9
Peters, John Durham, 26
Picasso, Pablo, 107
political campaigns: negotiating authenticity,
 128–130
postmodernist philosophy (1970s/1980s), 8
Potts, Paul, 81
product placement, 15
Prozac, 12
"pseudo-event" (defined), 5
punk, 13

Q

Queen for a Day (NBC/ABC, 1956–1964),
 68–69
quiz show scandals. *See* television quiz
 show scandals

R

radio broadcasting, 24–32
 See also "fireside chats"; entries beginning
 with *War of the Worlds*
reality TV, 65–73
reality TV, Susan Boyle: authenticity puzzle,
 74–79, 74n12
reality TV, Susan Boyle: ethics
 and exposure of ordinary people,
 78–79
 and mental breakdown of Boyle, 78
 and vulnerabilities of Boyle used as
 authenticity illusions, 79
reality TV, Susan Boyle: negotiation,
 84–86
 and debate on Boyle as authenticity
 puzzle, 79–86
 and defending authenticity illusions,
 83–84
 and demolishing authenticity illusions,
 80–82
reality TV, Susan Boyle: summary of main
 findings, 134
Real World, The (1992–), 71
repetitiveness, and illusion of authenticity,
 53
Rettberg, Walker, 107
Romanticism, 11
Roosevelt, Franklin D.
 and "fireside chats," 29–31, 109
 first president on TV, 48
Rorty, James, 46
Rose, Jessica, 102

INDEX

S

Sarnoff, David, 25n
Sartre, Jean-Paul, 11
scandals and puzzles, defined, 18
Schudson, Michael, 5
Seinfeld (sitcom), 4, 15
Sex and the City (drama), 15
Simple Life, The (Fox, 2003–2005), 72
Simpson, Jessica, 72
simulacra and *simulation*, 8
social media, authenticity puzzles in, 87–108
spontaneity, authenticity as, 10–12
Stempel, Herbert, 58–61
storytelling, 5–6, 12, 14, 99–101, 115–119, 126, 135
Survivor, 68
suspension of disbelief, 17
Swenson, Debbie (Kaylee's creator), 101, 105–106
Syrian Electronic Army, 93

T

Take It or Leave It (1940–1947), 56
television, authenticity scandals in, 45–64
television, use of term, 47n
television industry, rise of, 46–54
 and audience's belief in characters, 52n
 and audio-visual authenticity, 51–52
 and British BBC, 48
 and CBS and NBC, 48
 and commercialization of airwaves, 46
 See also television quiz show scandals
television quiz show scandals, 54–60, 62–63, 133–134
 overview, 54–56
 and authenticity illusions in, 57–60
 and big-money shows, 56–57
television quiz show scandals: negotiating authenticity

 and FCC "Wasteland Speech," 63
 and House Commerce Committee, 61
Time magazine, 60, 88
Titanic, 25
Today Show, The, 60
Totally Hidden Video (Fox, 1989–1996), 68n
tourism studies, 8–9
travel industry, paradoxes of, 9
Travels in Hyperreality (Eco), 8
Trilling, Lionel, 111
trustworthiness
 of bloggers, 105
 of candidates, 110
 illusions of, 21
 of media, 3–6, 8
 of mediated content, 137
 of Obama, 119, 125
 of social media, 92
Twain, Mark, 14
tweets, 93, *103*, 104n13, 121–123
Twenty-One (1956–1958), 57–58
Twitter, 74, 93, 97, 120–123

U

Uncle Jim's Question Bee (1936–1941), 55
unmasking, 101–102, 104
US Supreme Court, 56

V

Van Doren, Charles, 58–62
Vertov, Dziga, 47

W

Warhol, Andy, 3, 65
War of the Worlds, The (1938): authenticity scandal, 32–44

overview, 19, 32–33
advertised as fiction, 32
and authenticity illusions identified, 33
and eyewitness accounts, 35–36
and miscommunication, 32, 39
See also Welles, Orson
War of the Worlds, The (1938): interpretation, 32, 38–41, 133
and Cantril's study (1940), 40, 40n
and defense by Welles, 41
War of the Worlds, The (1938): negotiation, 41–44
and CBS disclaimers, 43n
and FCC regulations, 43–44
and lawsuits, 43
and police involvement, 43
Watergate scandal, 5
Welles, Orson, 30, 32, 34, 41, 43
See also *War of the Worlds, The* (1938)
Wikipedia, 92n, 93, 107
Williams, Raymond, 26
Winfrey, Oprah
cult-like status of, 124–125
as Obama ally, 125–128
as feminist voice, 126
See also *Oprah Winfrey Show, The*
Winston, Brian, 24
"wireless" (radio in transition), 25
Work of Art in the Age of Mechanical Reproduction, The (Benjamin), 7
World Wide Web, 20, 88–89, 94

Y

YouTube, 74, 96

Z

Zen of listening, 27–28, 31